C O L
O U R

Documents of Contemporary Art

Co-published by Whitechapel and The MIT Press

First published 2008
© 2008 Whitechapel Ventures Limited
All texts © the authors or the estates of the authors,
unless otherwise stated

Whitechapel is the imprint of Whitechapel
Ventures Limited

ISBN 978-0-85488-160-4 (Whitechapel)
ISBN 978-0-262-52481-0 (The MIT Press)

A catalogue record for this book is available from
the British Library

Library of Congress Cataloging-in-Publication Data

Colour / edited by David Batchelor.
 p. cm. – (Documents of contemporary art)
Includes bibliographical references and index.
ISBN 978-0-262-52481-0 (pbk. : alk. paper)
1. Color in art. 2. Art, Modern.
I. Batchelor, David, 1955–
N7432.7.C63 2008
701'.85—dc22
 2007037355

10 9 8 7 6 5 4 3 2 1

Series Editor: Iwona Blazwick
Commissioning Editor: Ian Farr
Project Editor: Hannah Vaughan
Designed by SMITH
Printed in Slovenia

Cover: Jim Lambie, *Acid Perm*, 2002 © Jim Lambie.
Courtesy of Sadie Coles HQ, London

Whitechapel Ventures Limited
80-82 Whitechapel High Street
London E1 7QX
www.whitechapel.org
To order (UK and Europe) call +44 (0)207 522 7888
or email MailOrder@whitechapel.org
Distributed to the book trade (UK and Europe only)
by Art Books International
Tel +44 (0) 23 9220 0080
www.art-bks.com

The MIT Press
55 Hayward Street
Cambridge, MA 02142
MIT Press books may be purchased at special
quantity discounts for business or sales
promotional use. For information, please email
special_sales@mitpress.mit.edu or write to Special
Sales Department, The MIT Press, 55 Hayward
Street, Cambridge, MA 02142

Whitechapel

Documents of Contemporary Art

In recent decades artists have progressively expanded the boundaries of art as they have sought to engage with an increasingly pluralistic environment. Teaching, curating and understanding of art and visual culture are likewise no longer grounded in traditional aesthetics but centred on significant ideas, topics and themes ranging from the everyday to the uncanny, the psychoanalytical to the political.

The Documents of Contemporary Art series emerges from this context. Each volume focuses on a specific subject or body of writing that has been of key influence in contemporary art internationally. Edited and introduced by a scholar, artist, critic or curator, each of these source books provides access to a plurality of voices and perspectives defining a significant theme or tendency.

For over a century the Whitechapel Gallery has offered a public platform for art and ideas. In the same spirit, each guest editor represents a distinct yet diverse approach – rather than one institutional position or school of thought – and has conceived each volume to address not only a professional audience but all interested readers.

Series editor: Iwona Blazwick; Commissioning editor: Ian Farr
Editorial Advisory Board: Roger Conover, Neil Cummings, Mark Francis, David Jenkins, Gilane Tawadros

Colour is the first revelation of the world

Hélio Oiticica, 'Colour, Time and Structure', 1960

WHY CAN'T WE IMAGINE A GREY— HOT?

Ludwig Wittegstein, *Remarks on Colour*, 1950

David Batchelor
Introduction//On Colour and Colours

Colour is single ... (Walter Benjamin)
Colour is the shattering of unity (Julia Kristeva)
Colour exists in itself (Henri Matisse)
Colour cannot stand alone (Wassily Kandinsky)
Colour ... is new each time (Roland Barthes)
Colour is the experience of a ratio (William H. Gass)
Colour is a poor imitator (Bernard Berenson)
Colour deceives continuously (Josef Albers)
Colour is an illusion, but not an unfounded illusion (C.L. Hardin)
Colour is like a closing eyelid, a tiny fainting spell (Roland Barthes)
Colour must be seen (Walter Benjamin)
Colour ... is the peculiar characteristic of the lower forms of nature (Charles Blanc)
Colour is suited to simple races, peasants and savages (Le Corbusier)
Colour is accidental and has nothing in common with the innermost essence
 of the thing (Naum Gabo and Anton Pevsner)
Colour seems to have a Queer bent! (Derek Jarman)
Colour can appear an unthinkable scandal (Stephen Melville)
Colour has always been seen as belonging to the ontologically deficient categories
 of the ephemeral and the random (Jacqueline Lichtenstein)
Colour is the concrete expression of a maximum difference within identity
 (Adrian Stokes)
Colour ... emphasizes the outward and simultaneous otherness of space
 (Adrian Stokes)
Colour to continue had to occur in space (Donald Judd)
Colour becomes significant only when it is used as an attribute of form (Clive Bell)
Colour ... even more than drawing, is a means of liberation (Henri Matisse)
Colour is enslaved by line that becomes writing (Yves Klein)
Colour has not yet been named (Jacques Derrida)
[Colour is] a pleasure that exceeds discursiveness (Jacqueline Lichtenstein)
Colour precedes words and antedates civilization ... (Leonard Shalin)
Colour is knowledge (Donald Judd)
Colour ... is a kind of bliss (Roland Barthes)
Colour is the first revelation of the world (Hélio Oiticica)
Colour must be thought, imagined, dreamed ... (Gustave Moreau)
Colour is not an easy matter (Umberto Eco)[1]

The process of collecting texts for this volume confirmed to me that, at least over the last century and a half, the discourse on colour has been, for the most part, a discourse of reflections, observations, asides and remarks. Polyphonic and fragmentary, it exists in the comments of artists, critics and art historians, but also in the reflections of philosophers, scientists, anthropologists, psychologists, novelists, filmmakers, architects, designers, poets and musicians. It is diverse and divergent; fluid, elliptical and contradictory; often obscure, esoteric or strange; sometimes funny, and altogether fascinating. It is difficult to generalize in any simple way about the nature of these reflections except to say that a great many of them are made in and through practice. That is to say, the discourse on colour is not largely an academic discipline; rather it is generated in the course of making things – paintings, sculptures, photographs, installations, films, buildings, novels, songs and poems. It is constituted for the most part in those works and in reflections on those works, both by the people who made them and by others who came into contact with them. And while it has a rightful place in various academies, it is at the same time never limited to the concerns of those institutions or subject areas. Colour belongs both to the arts and to the sciences, both to high culture and to popular culture, both to theory and to story telling. Within the arts vivid accounts of colour occur as much in literature as they do in the remarks of painters, sculptors and filmmakers. Colour has been addressed or ignored both by modernists and postmodernists; and those who loathe colour have had as much to say as those who love it. Colour is truly fluid: it spills over subjects and seeps between disciplines; and no one area can mop it up and claim a privileged or proprietorial relationship with the subject.

As far as the visual arts are concerned the discourse on colour has been episodic: there have been moments when the exchange of ideas concerning colour has been urgent and intense, and times when it has been all but dormant. The emergence of Symbolist ideas in the late nineteenth century, notions of Expressionism in the early twentieth, and debates around the idea of a fully abstract art, are instances when colour became a key subject for discussion. At other times the exchange is really more a set of loosely connected monologues sustained by individual artists – such as Yves Klein, Hélio Oiticica, Bridget Riley or Donald Judd – more or less in isolation. And then there are periods of extended silence, such as occurred in the aftermath of conceptual art in Europe and the United States. To some extent that silence can still be heard today, especially in the writings of critics and academics whose critical priorities were formed during that period. Lying behind this silence there is often, I think, the assumption that colour somehow belonged to modernism, formalism and to certain kinds of abstract art; and that as the prominence of those concerns was undermined during the 1960s and overthrown in the seventies, so the issue of

colour withered away as a result. This assumption doesn't stand up to very much scrutiny. Certainly the types of art admired by formalist critics in the fifties and sixties were often abstract and colourful but, first, those critics rarely had much to say on the subject of colour itself; and, second, much of the work these critics often despised – work associated with Minimalism and Pop – was equally if not more colourful, but colourful in entirely different ways. There is also the irony that many of the philosophers and critical theorists most closely identified with the emergence of postmodernism in the arts have themselves written on the subject of colour, and often in rich and vivid ways. Among them are Walter Benjamin, Ludwig Wittgenstein, Claude Lévi-Strauss, Roland Barthes, Julia Kristeva, Jacques Derrida and Umberto Eco – all of whom have texts included in this volume. One of the aims of this book, then, is to help rescue the discourse on colour from this casual association with modernism and formalism, and to suggest it has a far more complex relationship both with art and with modernity. If some critics have found it difficult to acknowledge the presence of colour as a worthwhile subject, this has clearly not been a problem for many contemporary artists. Over the last decade or more there have been numerous instances of artists experimenting with old and new forms of colour; bringing strange and exotic hues and materials into the traditional mediums of art; and introducing practical and theoretical concerns with colour into installation, photography, film and video. It is with this in mind that, in addition to the published texts collected here, I have invited a number of contemporary artists to participate in this volume by writing on their experience and use of colour.

As far as this book is concerned, having declared the boundlessness of colour, my first task was to impose some practical limits on the subject. I decided the starting point for the volume would be circa 1850, a somewhat artificial date but not an entirely arbitrary one. It is at least convenient in that it coincides with what are generally taken to be the early moments of modernism in the arts. More specifically it allowed me to begin with the writings of Charles Baudelaire and, soon after, Herman Melville, two writers who have, in different ways, made some of the most vivid and enduring remarks on the subject of colour, ones that still cast their shadows across the subsequent years. The end point of the book coincides with another artificial date: the publisher's deadline, early 2007, which means both that the most recent texts are from around this time, and that this was the date when I had to give up looking for material, new or old. To end the search in this way only leaves me with the certain knowledge that I have missed as much as I have found, but that will never change. By limiting the historical range of the book in this way I have had to exclude a large body of highly influential writing from the early nineteenth century – from Goethe's theory of colours, the *Farbenlehre*, to the chemistry of Chevreul, Rood and others – but this

work is generally well known and readily available in other publications. As well as setting some chronological boundaries, I have also settled for some more rough and ready exclusions. I have, for example, mainly avoided extended art-historical narratives about the changing use of colour over the period in question, preferring accounts by the artists themselves or by their contemporaries or near contemporaries. And I have altogether excluded the numerous studies of the psychological effects of colour in the home or workspace, and the related proposals for the harmonious use of colours in such environments. This is simply because, in the end, this work seems to me to be largely at odds with, and it is certainly a lot less interesting than, the more speculative and reflective discussions which are at the heart of this volume. What remains is an unruly assortment of around a hundred and fifty texts. In order to include and convey the range and diversity of writing on colour, I decided to edit each text and cut it, often substantially, sometimes quite viciously. The extracts range from almost complete essay-length arguments to just a single sentence or two. As a rule I have paid little or no attention to the original context of the work; but then I've always felt that, in art, the injunction to respect context is often a little overrated.

It is better to think of these pages as the basis of a large and expanding collage, rather than an orderly narrative. The tone and form of the contributions vary as much as their lengths. And all of this presented certain problems when it came to devising suitable ways of dividing the texts into sections. Originally I had planned to organize the texts in clusters, sometimes because they resembled one another, sometimes because they resembled a crowd gathered around a traffic accident. But I found it impossible to come up with anything more than approximate categories within which to contain the various texts; some were always left out at the end while others could have fitted into several different groups at once; and it always felt like it could easily have been done differently. So, finally, I opted for the more unimaginative solution of arranging the texts in broad chronological order, within this trying to keep together those texts which have affinities with each other. By doing this I do not mean to suggest there are no links to be made between various texts separated by decades, and no shared or contested positions amongst the authors. On the contrary, there are a great many, but in the end I thought it was better to point to some of those clusters in this introduction rather than impose them on the texts themselves. And this will I hope leave readers freer to find (aided by the index of colours and colour subjects) their own clusters of ideas and routes between different essays, statements, remarks and observations.

One distinction I began to notice as I was collecting the various texts was between those comments that discussed colour and those that dealt with colours. The former category tends towards the general and the universal, the latter tends

towards the specific and the particular; the former treats colour as a concept, the latter addresses the contingencies of perceptual experience. It is not that one is more important than the other; they are simply different. And while some texts deal exclusively with one mode of address or the other, some of course shift between the two, and thus threaten to mess up even this simple formulation. Within the texts that deal with colours, it is possible to separate out those that refer to black or white or grey – a significant majority – from those that deal with other colours.[2] This is perhaps because within the sphere of colours, these achromatic hues (if that is what they are) are themselves often treated as abstractions, and thus open to more generalized statements about their meaning or symbolic value. Nevertheless, colours are often discussed by way of metaphor and association, in terms of what they are like, whereas colour is often discussed in relation to what it may be distinguished from, in terms of what it is not like. Thus within colours, as well as white, black and grey, there are clusters that make associations, sometimes quite casually, sometimes in the name of a deeper synaesthesia, with, amongst other things, music, dreams and unconsciousness, drugs, sex and pleasure.[3] There are also those texts, written for the most part by artists, which deal with specific practical and technical issues concerned with using and mixing colours in painting, sculpture, photography, film and video;[4] and there are those, often by critics and poets, that attempt to convey something of the specificity of complex colour combinations, in a work of art or in the world of objects.[5] And, occasionally, there is an essay that attempts almost the opposite: to indicate something of the infinitely rich variety of experience and association that is hidden under a simple colour term, such as 'blue'.[6]

Amongst the colour texts, by far the two largest clusters are those that have sought either to distinguish colour from language, or to set colour in opposition to line or form. The reflections on language and colour have taken place, for the most part, in the realms of philosophy and anthropology, whereas the consideration of colour and line or form has been more closely associated with the visual arts. For both, however, colour has often been viewed as something of a problem. There are a number of reasons for this and, for me, these perceived problems are some of the things that make colour such a complex and revealing subject. One of the paradoxes of colour is that is at once truly universal and unaccountably particular; it is something vividly experienced by almost all people almost all of the time, and yet our understanding of the nature of this experience remains rudimentary and contested. Above all, it is almost impossible to put the experience of colour into words in anything but the most bland and general ways: of the several million different hues that the average human eye is able to discern, most languages have less than a dozen basic colour terms, and several languages have no term for colour at all. As such colour is,

arguably, in a unique position to show us some of the limits of our descriptive powers, which, for the most part, are also the limits of language. And this in turn may be what has made colour so attractive to some artists and writers, and so offensive to others.[7]

For many who have written on the relationship of colour to form, the problem of colour is often its unreliability, its seeming randomness and its apparent autonomy. While almost always connected to objects, located in forms and bound by shapes, colour nevertheless doesn't seem quite to belong to these objects. Unlike form and shape, the visual experience of colour cannot be verified by the other senses. We cannot touch colour, even though it constantly surrounds us and we are in some ways touched by it. Furthermore, for many, the use value of colour is distinctly questionable – after all, many drawings, paintings, photographs and films appear to survive perfectly well without colour. For these and other reasons colour has often been regarded as the least valuable of artistic resources and the least relevant subject for the critic. Typically colour has often been regarded as superficial, supplementary and cosmetic; attractive to children perhaps, but a potential distraction, or worse, for adults. Often regarded as feminine, as too connected to the senses and the emotions, to the body and to pleasure, colour threatens to get in the way of the more serious, intellectual and masculine business of drawing and forming. Although, having said that, there are always those for whom the disorderly, disruptive and occasionally narcotic character of colour has been its principle asset.[8]

If language and form have been the main points of reference for many discussions of the nature and value of colour, there are other clusters of writings that have, in one way or another, sought to place colour in the world. One of the most intriguing is the way in which colour has been mobilized within a variety of myths of origins, stories of how and in what order the gods made the world. Put at its simplest, these myths of origins have taken two basic types. In the first, the world begins as colourless form, onto which colour is added at a later stage, sometimes as an afterthought, sometimes as a result of an accident, often involving parrots. Its distribution through the world is random, but nonetheless pleasurable. In the second group, the world emerges first as formless colour, an undifferentiated haze of dazzling light, that is gradually and incrementally divided, categorized, classified and repressed in the development of language, line and shape. Here colour is primary, not secondary; in the beginning the world is colour and step by step is made increasingly grey, dull and orderly.[9] At the other end of the world, so to speak, are a number of reflections on the relationship of colour with modernity. These have often taken place within the discourse of architecture and design, or in the comments of artists with related interests and, again, they vary widely. On the one hand there are those who have

imagined modernity entirely stripped of colour and reduced to a pure, antiseptic field of white; on the other hand there are those for whom the production of new materials such as plastics have, for better or worse, made our cities replete with a vast array of vibrant new shiny, glowing, luminous coloured surfaces.[10] Finally, there are several smaller clusters of texts that have sought to place colour in the world in a number of other ways. Some view colour as belonging to childhood; some associate colour with a primitive or undeveloped culture; for others colour is allocated a home in the Orient rather than the West. In another group colour is located in the realm of the artificial and cosmetic, and in yet another, colour is like a descent into dream or unconsciousness. Then there are those for whom the value of colour is in its autonomy, independent from any functional or utilitarian concern.[11] Inevitably there are some texts that don't fit into any of these groups; they are included for their own sake, simply because what they say about colour is worth hearing.

Finally, it should be said that, contrary to appearances, this is not a book about colour. Rather it is a book about ideas about colour: what colour is, where it belongs, when it occurs, what it does, and whether it matters. Clearly I'm not neutral on this last point. I wouldn't have spent my time putting together these pages – and the rest – if I hadn't been convinced that colour does matter, if I hadn't come to believe that, in looking at colour and at the ways we place it in our minds and in our worlds, we can in turn find out something about ourselves. Colour lets us look at some of the ways we grade, order and group our experiences, our sensory experiences in particular, at some of our often unstated habits of thought, some of our preferences and some of our cultural prejudices. If the texts in this volume tell us anything in general it is that our relationship with colour is truly ambivalent. That is implicit in what I wrote in my earlier essay on colour, *Chromophobia* (2000), but perhaps I didn't state it very clearly back then. By ambivalence I mean a simultaneous and powerful attraction to and repulsion from the same thing, a coexistence of contrary emotions. So if there are many texts that display an overt love of colour and equally many that can't contain a loathing for the subject, there are as many others that display this more complex relationship, in one way or another. These may be some of the most interesting and insightful comments about this strange and unverifiable fact of our sensuous world.

1 Benjamin, notes, in *Selected Writings, vol. 1: 1913–1926*, 50; Kristeva, 'Giotto's Joy', *Desire in Language*, 37; Matisse, in *Matisse on Art*, 116; Kandinsky, *Concerning the Spiritual in Art*, 28; Barthes, *The Responsibility of Forms*, 166; Gass, *On Being Blue*, 67; Berenson, *Aesthetics and History*, 78; Albers, *Interaction of Colour*, 1; Hardin, *Unweaving the Rainbow*, 159; Barthes, op. cit, 166; Benjamin, op. cit, 50; Blanc, *Grammar of Painting and Engraving*, 4; Le Corbusier, *The Decorative Art of Today*, 135; Gabo and Pevsner, 'The Realistic Manifesto', *Art in Theory*, 298; Jarman, *Chroma*, 58; Melville, 'Colour has not yet been named', 141; Lichtenstein, *The Eloquence of Colour*, 63; Stokes, *Colour and Form*, 27; Stokes, op. cit, 19; Judd, 'Some Aspects of Colour in General and Red and Black in Particular', 113; Bell, *Art*, 12; Matisse, op. cit, 100; Klein, *Yves Klein*, 50; Derrida, *Truth in Painting*, 169; Lichtenstein, op. cit; 154; Shalin, quoted in Riley, *Colour Codes*, 6; Judd, op. cit., 114; Barthes, op. cit, 166; Oiticica, *The Body of Colour*, 202; Moreau, quoted in Benjamin, Matisse's 'Notes of a Painter', 29; Eco, 'How Culture Conditions the Colours We See', 157; please see individual texts in this anthology for the full bibliographic references.

2 On white, see especially the texts on pages 37–8, 82–4, 88, 118, 126–7, 211–12, 216. On black, see pages 100, 107, 135–6, 151–2, 157–8. On grey, see pages 35, 107, 145–6, 166–7, 210. See also the index for further references to individual colours and colour-subjects.

3 On colour and synaesthesia, see pages 18, 31–2, 38–9, 57–62, 73, 142–4, 153, 201. On colours and emotions, see pages 54–5, 151–2, 215–16. On colours and music, see pages 31–2, 57–62, 142–4, 157–8.

4 On colour and painting see pages 24–7, 31–2, 32–4, 35, 44–7, 48–9, 50–1, 51–2, 53, 55–6, 57–62, 66–8, 68–9, 69–72, 72–4, 75–6, 76–7, 77–8, 79–81, 88, 89–91, 93–4, 100, 112–14, 118–22, 125–6, 128–30, 131–3, 134, 135–6, 136, 137, 138–40, 142–4, 166, 167–71, 175–8. On colour and sculpture, see pages 65, 135, 166, 168-9, 195-8. On colour and photography, see pages 44, 89–91, 107, 108, 174. On colour and film, see pages 101–3, 175. On Colour, sex and pleasure, see pages 62, 158–62, 163–4.

5 On the specificity of colour combinations, see pages 24–7, 32–4, 39–42, 51–2, 65, 72–4.

6 On the diverse associations of single colours, see pages 152–5, 111–12.

7 On colour and language, see pages 18, 38–9, 103–8, 121, 158–62, 164, 175–8, 178.

8 On colour, line and form, see pages 24–7, 27–9, 31–2, 32–4, 50–1, 51–2, 54, 55–6, 65–6, 76–7, 77–8, 79–81, 92, 108–10, 110–12, 112–14, 118–20, 122–3, 126–7, 134, 135, 138–40, 142–4, 172, 201–7.

9 On colour and myths of origins, see pages 19, 144–5, 145–6.
 On colour and primitivism, see pages 62, 83, 98, 221.
 On colour and orientalism, exoticism, see pages 34, 39–42, 46, 49, 85, 98, 108–9, 202, 221, 233.

10 On colour and modernity, see pages 20, 55–6, 79–81, 82–4, 84–8, 88, 89–91, 94–7, 124, 144, 147–9, 172–3, 199–201, 219–20.

11 On colour and childhood, see pages 28, 31, 63–5. On colour and artifice, see pages 39–42, 163. On colour, dreams and the unconscious, see pages 31, 39, 57–8, 91, 140–2, 158–62. On colour and autonomy, see pages 19, 65, 75–6, 110–12.

COLOUR MUST BE THOUGHT IMAGINED DREAMED

Gustave Moreau, Statement, 1893

ON COLOUR AND COLOURS 1846–2007

Charles Baudelaire
The Salon of 1846//1846

[...] Let us imagine a beautiful expanse of nature where the prevailing tones are greens and reds, melting into each other, shimmering in the chaotic freedom where all things, diversely coloured as their molecular structure dictates, changing every second through the interplay of light and shade, and stimulated inwardly by latent heat, vibrate perpetually, imparting movement to all the lines and confirming the law of perpetual and universal motion. Beyond, a vast expanse, sometimes blue and very often green, stretches to the horizon; it is the sea. The trees are green, the grass is green, the moss is green; green meanders in the tree trunks, the unripe stalks are green; green is nature's basic colour, because green marries easily with all the other colours.[1] What strikes me first of all is that everywhere – poppies in the grass, garden poppies, parrots etc. – red is like a hymn to the glory of the green; black, when there is any – a solitary and insignificant zero – begs for help from blue and red. Blue, the sky in other words, is cut into by light white flakes or by grey masses, which pleasingly soften its monotonous harshness, and since the seasonal haze, winter or summer, bathes, softens or engulfs the outlines, nature resembles a top, which, when spinning at high speed, looks grey, although it incorporates all colours within itself.

The sap rises and, itself a mixture of elements, flowers in a mixture of tones; the trees, the rocks, the granites cast their reflections in the mirror of the water; all the transparent objects seize and imprison colour reflections, both close and distant, as the light passes through them. As the star of day moves, the tones change in value, but always they respect their mutual sympathies and natural hatreds, and continue to live in harmony by reciprocal concessions. The shadows move slowly and drive before them or blot out the tones as the light itself, changing position, sets others vibrating. These mingle their reflections, and, modifying their qualities by casting over them transparent and borrowed glazes, multiply to infinity their melodious marriages and make them easier to achieve. When the great ball of fire sinks into the waters, red fanfares fly in all directions, a blood-red harmony spreads over the horizon, green turns to a deep red. But soon vast blue shadows chase rhythmically before them the crowd of orange and soft rose tones, which are like the distant and muted echoes of the light. This great symphony of today, which is the eternally renewed variation of the symphony of yesterday, this succession of melodies, where the variety comes always from the infinite, this complex hymn is called colour.

In colour we find harmony, melody and counterpoint.

Now examine the detail within the detail in an object of medium dimensions – a woman's hand, for example, slightly reddish in tone, rather thin and with skin as delicate as silk; you will see the perfect harmony between the green tracery of the prominent veins and the blood-red tones of the knuckles; the pink fingernails contrast with the first joint where a few grey and brown tones are discernible. In the palm, the life lines of a darker rose or wine colour are separated from each other by the intervening system of green or blue veins. The study of the same object under a magnifying glass will show in however small an area a perfect harmony of tones, grey, blue, brown, green, orange and white, warmed with a touch of yellow, a harmony which, with the interplay of the shadows, produces the sense of structure in the work of colourists, different in nature from that of the draughtsmen, whose problems amount to no more than those of copying from a plaster cast.

Colour, then, means the balance of two tones. A warm tone and a cold tone, the contrast between them constituting the whole theory, cannot be defined absolutely; they exist only in relation to each other.

The eye of the colourist is the magnifying glass. I do not mean to conclude from all this that a colourist should build up his picture by the minute study of the intermingled tones in a very limited space. For if we were to admit that each molecule were endowed with a particular tone, matter would then have to be infinitely divisible; moreover, art being only an abstraction and a sacrifice of detail to the whole, the important thing is to concentrate attention particularly on masses. What I was concerned to show was that if such a thing were possible, the tones, however numerous they might be, provided always they were in logical juxtaposition, would merge naturally, in virtue of the law that governs them.

Chemical affinities are the reason why nature cannot make mistakes in the arrangement of these tones; for in nature form and colour are one.

Nor can the true colourist make mistakes; he may do anything he likes because he knows by instinct the scale of tones, the tone-value, the results of mixing, and the whole science of counterpoint, and, as a result, he can create a harmony of twenty different reds.

This is so true, that if for example some anti-colourist landowner had the notion of repainting his country house in some absurd way and with a discordant scheme of colours, the thick and transparent glaze of the atmosphere and the trained eye of a Veronese would between them restore harmony and produce a satisfying canvas, conventional no doubt, but logical. That explains why a colourist can be paradoxical in his way of expressing colour and why the study of nature often leads to a result quite different from nature.

The air plays such a big part in the theory of colour that, if a landscape artist were to paint the leaves of a tree as he sees them, he would get a wrong tone,

because there is a much narrower air space between a man and the picture he is looking at than between him and nature.

Falsehoods are constantly necessary even to get *trompe-l'oeil* effects.

Harmony is the basis of the theory of colour. Melody means unity of colour, in other words, of a colour scheme.

A melody needs to be resolved, in other words, it needs a conclusion, which all the individual effects combine to produce.

By this means a melody leaves an unforgettable memory in the mind. Most of our young colourists lack melody.

The right way of knowing whether a picture is melodious is to look at it from far enough away to make it impossible for us to see what it is about or appreciate its lines. If it is melodious, it already has a meaning, and has already taken a place in our collection of memories.

Style and feeling in colour come from choice, and choice comes from temperament. Tones may be gay and playful, or playful and sad, or rich and gay, or rich and sad, commonplace, melancholy or original.

Thus, Veronese's palette is calm and gay, Delacroix's is often melancholy and that of M. Catlin[2] is often awe-inspiring.

For a long time, I had opposite my windows a tavern painted half in green and half in a harsh red, a mixture which for my eyes was a source of exquisite pain. I do not know whether any analogist has drawn up a well authenticated scale of colours and their corresponding feelings, but I remember a passage in Hoffmann[3] that exactly expresses my idea and will please all who sincerely love nature:

> Not only in dreams and in the free association of ideas (which phenomenon often comes just before sleep) but also when fully awake, listening to music, I find an analogy and a close union between colours, sounds and scents. I have the impression that all these things have been created by one and the same ray of light, and that they are destined to unite in a wonderful concert. The scent of brown and red marigolds especially produces a magical effect on my being. I fall into a profound reverie and then hear as though from afar the solemn, deep notes of the oboe. (*Kreisleriana.*)

The question is often asked whether the same man can be both a great colourist and a great draughtsman? Yes and no; for there are different sorts of drawing.

The essential quality of a pure draughtsman is delicacy, and delicacy excludes characteristic touch; now touches can often be felicitous, and the colourist, whose destiny it is to express nature in colour, would often stand to lose more by sacrificing felicitous touches than he would gain by seeking greater astringency in drawing.

Colour assuredly does not exclude great draughtsmanship, that of Veronese for example, who always sees his subject as a whole and by masses; but colour does exclude the drawing of details, of shapes in a section of a picture studied by themselves, because a bold touch always swallows up line.

The love of atmosphere, the choice of subjects in movement, demand the technique of a disjointed multiplicity of lines.

Pure draughtsmen work on the opposite and yet analogous system. With a keen eye for line, eager to detect its most subtle curves, they have no time to observe atmosphere and light, or more precisely their effects, indeed they deliberately try not to see them in order not to harm the principle of their school.

And so it is possible to be both a colourist and a draughtsman, but only in a certain sense. Just as a draughtsman can be a colourist by broad masses, so a colourist can be a draughtsman by a logical understanding of lines as total shape, but one of these two qualities will always absorb the detail of the other.

Colourists draw like nature; their figures are naturally outlined by the harmonious conflict of colour masses.

Pure draughtsmen are philosophers and distillers of quintessentials.

Colourists are epic poets. [...]

1 Except with its parent colours, yellow and blue; but I am speaking here only of pure tones. For this rule is not applicable to the supreme colourists, who are masters of the science of counterpoint.
2 [The American painter George Catlin (1796–1872). His portraiture of native Americans was included in the Paris Salon of 1846.]
3 [E.T.A. Hoffmann (1776–1822).]

Charles Baudelaire, extract from 'The Salon of 1846' (1846); reprinted in Baudelaire, *Selected Writings on Art and Artists*, trans. and ed. P.E. Charvet (Cambridge: Cambridge University Press, 1972) section III, 'Of Colour', 54–9; section VIII, Of Some Draughtsmen', 80; 106.

John Ruskin
The Elements of Drawing//1857

On First Practice
[...] Everything that you can see, in the world around you, presents itself to your eyes only as an arrangement of patches of different colours variously shaded.

[*footnote:*] The perception of solid Form is entirely a matter of experience.

We *see* nothing but flat colours; and it is only by a series of experiments that we find out that a stain of black or grey indicates the dark side of a solid substance, or that a faint hue indicates that the object in which it appears is far away. The whole technical power of painting depends on our recovery of what may be called the *innocence of the eye*; that is to say, of a sort of childish perception of these flat stains of colour, merely as such, without consciousness of what they signify, as a blind man would see them if suddenly gifted with sight.

For instance; when grass is lighted strongly by the sun in certain directions, it is turned from green into a peculiar and somewhat dusty-looking yellow. If we had been born blind, and were suddenly endowed with sight on a piece of grass thus lighted in some parts by the sun, it would appear to us that part of the grass was green, and part a dusty yellow (very nearly of the colour of primroses); and, if there were primroses near, we should think that the sunlighted grass was another mass of plants of the same sulphur-yellow colour. We should try to gather some of them, and then find that the colour went away from the grass when we stood between it and the sun, but not from the primroses; and by a series of experiments we should find out that the sun was really the cause of the colour in the one – not in the other. We go through such processes of experiment unconsciously in childhood; and having once come to conclusions touching the signification of certain colours, we always suppose that we see what we only know, and have hardly any consciousness of the real aspect of the signs we have learned to interpret. Very few people have any idea that sunlighted grass is yellow.

Now, a highly accomplished artist has always reduced himself as nearly as possible to this condition of infantine sight. He sees the colours of nature exactly as they are, and therefore perceives at once in the sunlighted grass the precise relation between the two colours that form its shade and light. To him it does not seem shade and light, but bluish green barred with gold.

Strive, therefore, first of all, to convince yourself of this great fact about sight. This, in your hand, which you know by experience and touch to be a book, is to your eye nothing but a patch of white, variously gradated and spotted; this other thing near you, which by experience you know to be a table, is to your eye only a patch of brown, variously darkened and veined; and so on; and the whole art of Painting consists merely in perceiving the shape and depth of these patches of colour, and putting patches of the same size, depth and shape on canvas. The only obstacle to the success of painting is that many of the real colours are brighter and paler than it is possible to put on canvas: we must put darker ones to represent them. [...]

On Colour and Composition

My dear Reader – If you have been obedient, and have hitherto done all that I have told you, I trust it has not been without much subdued remonstrance, and some serious vexation. For I should be sorry if, when you were led by the course of your study to observe closely such things as are beautiful in colour, you had not longed to paint them, and felt considerable difficulty in complying with your restriction to the use of black, or blue, or grey. You *ought* to love colour, and to think nothing quite beautiful or perfect without it; and if you really do love it, for its own sake, and are not merely desirous to colour because you think painting a finer thing than drawing, there is some chance you may colour well. Nevertheless, you need not hope ever to produce anything more than pleasant helps to memory, or useful and suggestive sketches in colour, unless you mean to be wholly an artist. You may, in the time which other vocations leave at your disposal, produce finished, beautiful and masterly drawings in light and shade. But to colour well requires your life. It cannot be done cheaper. The difficulty of doing right is increased – not twofold nor threefold, but a thousandfold, and more – by the addition of colour to your work. For the chances are more than a thousand to one against your being right both in form and colour with a given touch: it is difficult enough to be right in form, if you attend to that only; but when you have to attend, at the same moment, to a much more subtle thing than the form, the difficulty is strangely increased – and multiplied almost to infinity by this great fact, that, while form is absolute, so that you can say at the moment you draw any line that it is either right or wrong, colour is wholly *relative*. Every hue throughout your work is altered by every touch that you add in other places; so that what was warm, a minute ago, becomes cold when you have put a hotter colour in another place, and what was in harmony when you left it, becomes discordant as you set other colours beside it; so that every touch must be laid, not with a view to its effect at the time, but with a view to its effect in futurity, the result upon it of all that is afterwards to be done being previously considered. You may easily understand that, this being so, nothing but the devotion of life, and great genius besides, can make a colourist. [...]

John Ruskin, extracts from 'Letter I: On First Practice' and 'Letter III: On Colour and Composition', *The Elements of Drawing* (London: Smith, Elder & Co., 1857) 5–7; 194–6.

LISZT NUMBERS DELACROIX AMONGST THE MUSICIAN-POET'S MOST FREQUENT VISITORS, AND SAYS THAT HE LOVED TO FALL INTO DEEP REVERIE AT THE SOUND OF THAT DELICATE AND PASSIONATE MUSIC, WHICH EVOKES A BRIGHTLY COLOURED BIRD, HOVERING OVER THE HORRORS OF A BOTTOMLESS PIT.

Charles Baudelaire, 'The Painter of Modern Life', 1863

Charles Baudelaire
The Life and Work of Eugène Delacroix//1863

[...] I referred just now to the remarks of certain *masons*. For me, the word describes that class of gross materialistic minds (their number is legion) that take an appreciative interest in objects only by their contour or worse still on a three-dimensional basis: breadth, length and depth, just as savages or peasants do. I have often heard people of that sort draw up a hierarchy of qualities, which was totally unintelligible to me; they would maintain, for example, that the faculty that enables this man to create an exact contour or that man a contour of supernatural beauty is superior to the faculty that can assemble colours in an enchanting manner. According to these people colour has no power to dream, to think or speak. It would appear that when I contemplate the works of those men especially known as colourists, I am giving myself up to a pleasure that is not of a noble kind; for twopence they would stamp me as a materialist, reserving for themselves the aristocratic epithet of spiritualists.

These shallow minds do not reflect that the two faculties can never be entirely separated and that both are the result of an original seed carefully cultivated. External nature does no more than provide the artist with an ever-recurring chance of cultivating the seed; nature is no more than an uncoordinated mass of material that the artist is invited to assemble and put in order, an *incitamentum*, an alarm-clock for the slumbering faculties. To speak with precision, there is in nature neither line nor colour. It is man that creates line and colour. Both are abstractions drawing their equal dignity from the same origin.

As a child, a draughtsman-born will see in nature, whether still or moving, a number of sinuous shapes from which he gets some pleasure and which he enjoys recording by lines on paper, accentuating or reducing as the spirit moves him their inflections. In this way he learns how to produce curves, elegance and character in drawing. Now let us imagine the case of a child destined to perfect that part of art called colour: it is from the collision or happy union of two tones and the pleasure he gets from it that he will derive the inexhaustible knowledge of tone combinations. In both cases nature has acted exclusively as a stimulus.

Both line and colour arouse thought and induce reverie; the pleasures that flow from these are different in kind, but perfectly equal and absolutely independent of the subject of the picture. [...]

In his delightful monograph study on Chopin, Liszt numbers Delacroix amongst the musician-poet's most frequent visitors, and says that he loved to fall into

deep reverie at the sound of that delicate and passionate music, which evokes a brightly coloured bird, hovering over the horrors of a bottomless pit. [...]

Charles Baudelaire, extract from 'The Painter of Modern Life' (1863); reprinted in Baudelaire, *Selected Writings on Art and Artists*, trans. and ed. P.E. Charvet (Cambridge: Cambridge University Press, 1972) 369–70;379.

Charles Blanc
The Grammar of Painting and Engraving//1867

[...] Intelligent beings have a language represented by articulate sounds; organized beings, like animals and vegetables, express themselves by cries or forms, contour, carriage. Inorganic nature has only the language of colour. It is by colour alone that a certain stone tells us it is a sapphire or an emerald. If the painter can by means of some features give us a clear idea of animals and vegetables, make us recognize at once a lion, a horse, a poplar, a rose, it is absolutely impossible, without the aid of colour, to show us an emerald or a sapphire. Colour, then, is the peculiar characteristic of the lower forms of nature, while the drawing becomes the medium of expression, more and more dominant, the higher we rise in the scale of being. Therefore painting can sometimes dispense with colour, if, for example, the inorganic nature and the landscape are insignificant or useless in the scene represented. [...]

Colour being that which especially distinguishes painting from the other arts, it is indispensible to the painter to know its laws, so far as these are essential and absolute.

If there is affinity between chiaroscuro and sentiment, much more is there between sentiment and colour, since colour is only the different shades of chiaroscuro.

Supposing the painter had only ideas to express, he would perhaps need only drawing and the monochrome of chiaroscuro, for with them he can represent the only figure that thinks – the human figure, which is the *chef d'oeuvre* of a designer rather than the work of a colourist. With drawing and chiaroscuro he can also put in relief all that depends upon intelligent life, that is life in its relation to other lives, but there are features of organic, of interior and individual life that could not be manifested without colour. How for instance, without

colour, give, in the expression of a young girl, that shade of trouble or sadness so well expressed by the pallor of the brow, or the emotion of modesty that makes her blush? Here we recognize the power of colour, and that its role is to tell us what agitates the heart, while drawing shows us what passes in the mind, a new proof of what we affirmed at the beginning of this work, that drawing is the masculine side of art, colour the feminine.

As sentiment is multiple, while reason is one, so colour is a mobile, vague, intangible element, while form, on the contrary, is precise, limited, palpable and constant. But in the material creation there are substances of which drawing can give no idea; there are bodies whose distinctive characteristic is in colour, like precious stones. If the pencil can put a rose under the eye, it is powerless to make us recognize a turquoise or a ruby, the colour of the sky or the tint of a cloud. Colour is *par excellence* the means of expression, when we would paint the sensations given us by inorganic matter and the sentiments awakened in the mind thereby. We must, then, add to chiaroscuro, which is only the external effect of white light, the effect of colour, which is, as it were, the interior of this light.

We hear it repeated every day, and we read in books that colour is a gift of heaven; that it is an impenetrable arcanum to him who has not received its *secret influence*; that one learns to be a draughtsman but one is born a colourist – nothing is falser than these adages; for not only can colour, which is under fixed laws, be taught like music, but it is easier to learn than drawing, whose absolute principles cannot be taught. Thus we see that great designers are as rare, even rarer than great colourists. From time immemorial the Chinese have known and fixed the laws of colour, and the tradition of those laws, transmitted from generation to generation down to our own days, spread throughout Asia, and perpetuated itself so well that all oriental artists are infallible colourists, since we never find a false note in the web of their colours. But would this infallibility be possible if it were not engendered by certain and invariable principles?

What, then, is colour?

Before replying, let us take a look at creation. Beholding the infinite variety of human and animal forms, man conceives an ideal perfection of each form; he seeks to seize the primitive exemplar, or at least, to approach it nearer and nearer, but this conception is a sublime effort of his intelligence, and if, at times, the soul believes it has an obscure souvenir of original beauty, this fugitive memory passes like a dream, and the perfect form that issued from the hand of God is unknown to us; remains always veiled from our eyes. It is not so with colour, and it would seem as if the eternal colourist had been less jealous of his secret than the eternal designer, for he has shown us the ideal of colour in the rainbow, in which we see, in sympathetic gradation, but also in mysterious promiscuity, the mother-tints that engender the universal harmony of colours. […]

Thus colourists can charm us by means that science has discovered. But the taste for colour, when it predominates absolutely, costs many sacrifices; often it turns the mind from its course, changes the sentiment, swallows up the thought. The impassioned colourist invents his form for his colour, everything is subordinated to the brilliancy of his tints. Not only the drawing bends to it, but the composition is dominated, restrained, forced by the colour. To introduce a tint that shall heighten another, a perhaps useless accessory is introduced. In the *Massacre of Scio*, a sabre-tache has been put in the corner solely because in that place the painter needed a mass of orange. To reconcile contraries after having heightened them, to bring together similars after having lowered or broken them, he indulges in all sorts of licence, seeks pretexts for colour, introduces brilliant objects; furniture, bits of stuff, fragments of mosaic, arms, carpets, vases, flights of steps, walls, animals with rich furs, birds of gaudy plumage; thus, little by little, the lower strata of nature take the first place instead of human beings which alone ought to occupy the pinnacle of art, because they alone represent the loftiest expression of life, which is thought.

In passionately pursuing the triumph of colour, the painter runs the risk of sacrificing the action to the spectacle. Our colourists go to the Orient, to Egypt, Morocco, Spain, to bring back a whole arsenal of brilliant objects; cushions, slippers, narghilehs, turbans, burnous, caftans, mats, parasols. They make heroes of lions and tigers, exaggerate the importance of the landscape, double the interest of the costume, and of inert substances, and thus painting becomes descriptive; high art sensibly declines and threatens to disappear.

Let colour play its true role, which is to bring to us the côrtege of external nature, and to associate the splendours of the material creation with the action or the presence of man. Above all let the colourist choose in the harmonies of colour those that seem to *conform to his thought*. The predominance of colour at the expense of drawing is a usurpation of the relative over the absolute, of fleeting appearance over permanent form, of physical impression over the empire of the soul. As literature tends to its decadence, when images are elevated above ideas, so art grows material and inevitably declines when the mind that draws is conquered by the sensation that colours, when, in a word, the orchestra, instead of accompanying the song, becomes the whole poem. [...]

Charles Blanc, extracts from *Grammaire des arts du dessin* [*Grammar of the Arts of Drawing*] (Paris: Renouard, 1867) trans. Kate Newell Doggett, *The Grammar of Painting and Engraving* (New York: Hurd and Houghton, 1874) 5; 145–7; 168–9.

Vincent van Gogh
On Shades of Grey//1882

[...] Absolute black does not really occur. But like white, it is present in almost all colours and forms the endless variety of greys – distinguished in tone and intensity – so that in nature one really does not see anything but tones and intensities. There are only three basic colours – red, yellow, blue, 'composites' orange, green and purple. By adding black and some white one gets the endless variations of greys, red-grey, yellow-grey, blue-grey, green-grey, orange-grey, violet-grey. It is impossible to say, for instance, how many different green-greys there are, it varies endlessly. But the whole chemistry of colours is no more complicated than these few simple basics. And a good understanding of this is worth more than seventy different colours of paint, since one can make more than seventy tones and intensities with the three principal colours and white and black. He is a colourist, who, seeing a colour in nature, knows very well how to analyse it and to say, for instance, that green-grey is yellow with black and almost no blue, etc.; in short, he knows how to make the greys of nature on the palette. [...]

Vincent van Gogh, Letter to his brother Theo (The Hague, c. 1 August 1882); reprinted in *Art in Theory 1815–1900*, ed. Charles Harrison, Paul Wood (Oxford: Blackwell, 1998) 942–3.

Alphonse Allais
Titles of Monochrome Works//1883–84

First Communion of Anaemic Young Girls in the Snows.

Apoplectic Cardinals Harvesting Tomatoes on the Shore of the Red Sea (Study of Aurora Borealis).

Alphonse Allais, Titles of two monochrome works (1883–84) documented in *Post Impressionism* (London: Royal Academy of Arts, 1979) 26.

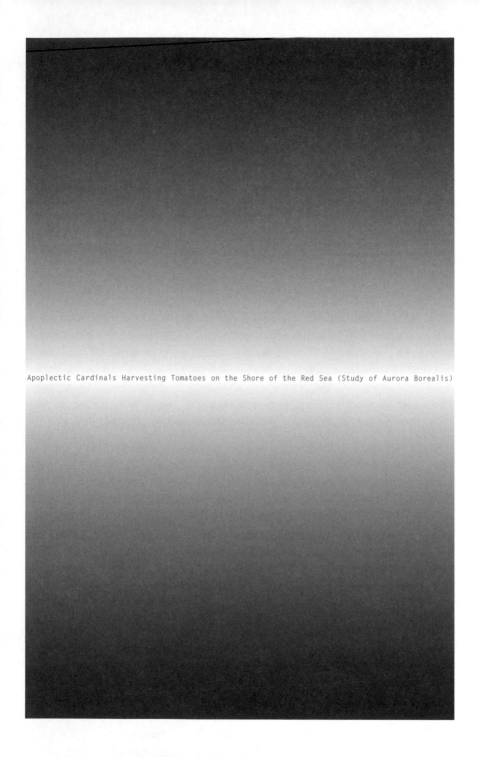

Apoplectic Cardinals Harvesting Tomatoes on the Shore of the Red Sea (Study of Aurora Borealis)

Alphone Allais, title of monochrome painting, 1883–84

Herman Melville
The Whiteness of the Whale//1851

What the white whale was to Ahab, has been hinted; what, at times, he was to me, as yet remains unsaid.

Aside from those more obvious considerations touching Moby Dick, which could not but occasionally awaken in any man's soul some alarm, there was another thought, or rather vague, nameless horror concerning him, which at times by its intensity completely overpowered all the rest; and yet so mystical and well nigh ineffable was it, that I almost despair of putting it in a comprehensible form. It was the whiteness of the whale that above all things appalled me. But how can I hope to explain myself here; and yet, in some dim, random way, explain myself I must, else all these chapters might be naught.

Though in many natural objects, whiteness refiningly enhances beauty, as if imparting some special virtue of its own, as in marbles, japonicas and pearls; and though various nations have in some way recognized a certain royal pre-eminence in this hue; even the barbaric, grand old kings of Pegu placing the title 'Lord of the White Elephants' above all their other magniloquent ascriptions of dominion; and the modern kings of Siam unfurling the same snow-white quadruped in the royal standard; and the Hanoverian flag bearing the one figure of a snow-white charger; and the great Austrian Empire, Caesarian heir to overlording Rome, having for the imperial colour the same imperial hue; and though this pre-eminence in it applies to the human race itself, giving the white man ideal mastership over every dusky tribe; and though, besides all this, whiteness has been even made significant of gladness, for among the Romans a white stone marked a joyful day; and though in other mortal sympathies and symbolizings, this same hue is made the emblem of many touching, noble things – the innocence of brides, the benignity of age; though among the Red Men of America the giving of the white belt of wampum was the deepest pledge of honour; though in many climes, whiteness typifies the majesty of Justice in the ermine of the Judge, and contributes to the daily state of kings and queens drawn by milk-white steeds; though even in the higher mysteries of the most august religions it has been made the symbol of the divine spotlessness and power; by the Persian fire worshippers, the white forked flame being held the holiest on the altar; and in the Greek mythologies, Great Jove himself being made incarnate in a snow-white bull; and though to the noble Iroquois, the midwinter sacrifice of the sacred White Dog was by far the holiest festival of their theology, that spotless, faithful creature being held the purest envoy they

could send to the Great Spirit with the annual tidings of their own fidelity; and though directly from the Latin word for white, all Christian priests derive the name of one part of their sacred vesture, the alb or tunic, worn beneath the cassock; and though among the holy pomps of the Romish faith, white is specially employed in the celebration of the Passion of our Lord; though in the Vision of St. John, white robes are given to the redeemed, and the four-and-twenty elders stand clothed in white before the great white throne, and the Holy One that sitteth there white like wool; yet for all these accumulated associations, with whatever is sweet, and honourable, and sublime, there yet lurks an elusive something in the innermost idea of this hue, which strikes more of panic to the soul than that redness which affrights in blood.

This elusive quality it is, which causes the thought of whiteness, when divorced from more kindly associations, and coupled with any object terrible in itself, to heighten that terror to the furthest bounds. Witness the white bear of the poles, and the white shark of the tropics; what but their smooth, flaky whiteness makes them the transcendent horrors they are? That ghastly whiteness it is which imparts such an abhorrent mildness, even more loathsome than terrific, to the dumb gloating of their aspect. So that not the fierce-fanged tiger in his heraldic coat can so stagger courage as the white-shrouded bear or shark. [...]

Is it that by its indefiniteness it shadows forth the heartless voids and immensities of the universe, and thus stabs us from behind with the thought of annihilation, when beholding the white depths of the milky way? Or is it, that as in essence whiteness is not so much a colour as the visible absence of colour, and at the same time the concrete of all colours; is it for these reasons that there is such a dumb blankness, full of meaning, in a wide landscape of snows – a colourless, all-colour of atheism from which we shrink? [...]

Herman Melville, extracts from 'The Whiteness of the Whale', *Moby-Dick, or The Whale* (New York: Harper and Brothers, 1851); reprinted edition (New York and London: Penguin, 1992) 204–6; 212.

Arthur Rimbaud
A Season in Hell//1873

[...] I invented the colour of the vowels!
A – black, E – white, I – red, O – blue, U – green.
I controlled the shape and movement of each consonant and with rhythms

born of instinct claimed to have invented a poetic language which one day would capture all the senses. Its translation I kept secret. [...]

Arthur Rimbaud, extract from *Une Saison en enfer* (Brussels: M.-J. Poot et Cie, 1873); trans. Patricia Roseberry, *A Season in Hell* (Harrogate: Broadwater House, 1995) 56.

Gustave Moreau
On Colour//1893

Note one thing well: you must think through colour, have imagination in it. If you don't have imagination, your colour will never be beautiful. Colour must be thought, dreamed, imagined ...

Gustave Moreau, untitled statement (1893) cited from Roger Benjamin, *Matisse's 'Notes of a Painter': Criticism, Theory and Context 1891–1908* (Ann Arbor: University of Michigan Press 1987) 29.

Joris-Karl Huysmans
Against Nature//1884

[...] This tortoise was the result of a fancy which had occurred to him shortly before leaving Paris. Looking one day at an Oriental carpet aglow with iridescent colours, and following with his eyes the silvery glints running across the weft of the wool, which was a combination of yellow and plum, he had thought what a good idea it would be to place on this carpet something that would move about and be dark enough to set off these gleaming tints.

Possessed by this idea, he had wandered at random through the streets as far as the Palais-Royal, where he glanced at Chevet's display and suddenly struck his forehead – for there in the window was a huge tortoise in a tank. He had bought the creature; and once it had been left to itself on the carpet, he had sat down and subjected it to a long scrutiny, screwing up his eyes in concentration.

Alas, there could be no doubt about it: the negro-brown tint, the raw Sienna hue of the shell, dimmed the sheen of the carpet instead of bringing out its

colours; the predominating gleams of silver had now lost nearly all their sparkle and matched the cold tones of scraped zinc along the edges of this hard, lustreless carapace.

He bit his nails, trying to discover a way of resolving the marital discord between these tints and preventing an absolute divorce. At last he came to the conclusion that his original idea of using a dark object moving to and fro to stir up the fires within the woollen pile was mistaken. The fact of the matter was that the carpet was still too bright, too garish, too new-looking; its colours had not yet been sufficiently toned down and subdued. The thing was to reverse his first plan and to deaden those colours, to dim them by the contrast of a brilliant object that would kill everything around it, drowning the gleams of silver in a golden radiance. Stated in these terms, the problem was easier to solve; and Des Esseintes accordingly decided to have his tortoise's buckler glazed with gold.

Back from the workshop where the gilder had given it board and lodging, the reptile blazed as brightly as any sun, throwing out its rays over the carpet, whose tints turned pale and weak, and looking like a Visigothic shield tegulated with shining scales by a barbaric artist.

At first, Des Esseintes was delighted with the effect he had achieved; but soon it struck him that this gigantic jewel was only half-finished and that it would not be really complete until it had been encrusted with precious stones.

From a collection of Japanese art he selected a drawing representing a huge bunch of flowers springing from a single slender stalk, took it to a jeweller's, sketched out a border to enclose this bouquet in an oval frame and informed the astonished lapidary that the leaves and petals of each and every flower were to be executed in precious stones and mounted on the actual shell of the tortoise.

Choosing the stones gave him pause. The diamond, he told himself, has become terribly vulgar now that every businessman wears one on his little finger; Oriental emeralds and rubies are not so degraded and they dart bright tongues of fire, but they are too reminiscent of the green and red eyes of certain Paris buses fitted with headlamps in the selfsame colours; as for topazes, whether pink or yellow, they are cheap stones, dear to people of the small shopkeeper class who long to have a few jewel-cases to lock up in their mirror wardrobes. Similarly, although the Church has helped the amethyst to retain something of a sacerdotal character, at once unctuous and solemn, this stone too has been debased by use in the red ears and on the tubulous fingers of butchers' wives whose ambition it is to deck themselves out at little cost with genuine, heavy jewels. Alone among these stones, the sapphire has kept its fires inviolate, unsullied by contact with commercial and financial stupidity. The glittering sparks playing over its cold, limpid water have as it were protected its discreet and haughty nobility against any defilement. But unfortunately in artificial light

its bright flames lose their brilliance; the blue water sinks low and seems to go to sleep, to wake and sparkle again only at daybreak.

It was clear that none of these stones satisfied Des Esseintes' requirements; besides, they were all too civilized, too familiar. Instead he turned his attention to more startling and unusual gems; and after letting them trickle through his fingers, he finally made a selection of real and artificial stones which in combination would result in a fascinating and disconcerting harmony.

He made up his bouquet in this way: the leaves were set with gems of a strong and definite green – asparagus-green chrysoberyls, leek-green peridots, olive-green olivines – and these sprang from twigs of almandine and uvarovite of a purplish red, which threw out flashes of harsh, brilliant light like the scales of tartar that glitter on the insides of wine-casks.

For the flowers which stood out from the stem a long way from the foot of the spray, he decided on a phosphate blue; but he absolutely refused to consider the Oriental turquoise which is used for brooches and rings, and which, together with the banal pearl and the odious coral, forms the delight of the common herd.

He chose only turquoises from the West – stones which, strictly speaking, are simply a fossil ivory impregnated with coppery substances and whose celadon blue looks thick, opaque and sulphurous, as if jaundiced with bile.

This done, he could now go on to encrust the petals of such flowers as were in full bloom in the middle of his spray, those closest to the stem, with translucent minerals that gleamed with a glassy, sickly light and glinted with fierce, sharp bursts of fire. For this purpose he used only Ceylon cat's-eyes, cymophanes and sapphirines – three stones which all sparkled with mysterious, deceptive flashes, painfully drawn from the icy depths of their turbid water: the cat's-eye of a greenish grey streaked with concentric veins which seem to shift and change position according to the way the light falls; the cymophane with blue waterings rippling across the floating, milky-coloured centre; the sapphirine which kindles bluish, phosphorescent fires against a dull, chocolate-brown background.

The lapidary took careful notes as it was explained to him exactly where each stone was to be let in.

'What about the edging of the shell?' he then asked Des Esseintes.

The latter had originally thought of a border of opals and hydrophanes. But these stones, interesting though they may be on account of their varying colour and vacillating fire, are too unstable and unreliable to be given serious consideration; the opal, in fact, has a positively rheumatic sensitivity, the play of its rays changing in accordance with changes in moisture or temperature, while the hydrophane will burn only in water and refuses to light up its grey fires unless it is wetted.

He finally decided on a series of stones with contrasting colours – the mahogany-red hyacinth of Compostella followed by the sea-green aquamarine, the vinegar-pink balas ruby by the pale slate-coloured Sudermania ruby. Their feeble lustre would be sufficient to set off the dark shell but not enough to detract from the bunch of jewelled flowers which they were to frame in a slender garland of subdued brilliance.

Now Des Esseintes sat gazing at the tortoise where it lay huddled in a corner of the dining-room, glittering brightly in the half-light. [...]

Joris-Karl Huysmans, extracts from *À Rebours* (Paris: Charpentier, 1884); trans. Robert Baldick, *Against Nature* (London: Penguin Books, 1956) 40–4.

Max Nordau
Degeneration//1892

[...] The curious style of certain recent painters – 'impressionists,' 'stipplers', or 'mosaists', 'papilloteurs' or 'quiverers', 'roaring' colourists, dyers in grey and faded tints – becomes at once intelligible to us if we keep in view the researches of the Charcot school into the visual derangements in degeneration and hysteria. The painters who assure us that they are sincere, and reproduce nature as they see it, speak the truth. The degenerate artist who suffers from *nystagmus*, or trembling of the eyeball, will, in fact, perceive the phenomena of nature trembling, restless, devoid of firm outline, and, if he is a conscientious painter, will give us pictures reminding us of the mode practised by the draughtsmen of the *Fliegende Blätter* when they represent a wet dog shaking himself vigorously. If his pictures fail to produce a comic effect, it is only because the attentive beholder reads in them the desperate effort to reproduce fully an impression incapable of reproduction by the expedients of the painter's art as devised by men of normal vision.

There is hardly a hysterical subject whose retina is not partly insensitive. As a rule the insensitive parts are connected, and include the outer half of the retina. In these cases the field of vision is more or less contracted, and appears to him not as it does to the normal man – as a circle – but as a picture bordered by whimsically zigzag lines. Often, however, the insensitive parts are not connected, but are scattered in isolated spots over the entire retina. Then the sufferer will have all sorts of gaps in his field of vision, producing strange effects,

and if he paints what he sees, he will be inclined to place in juxtaposition larger or smaller points or spots which are completely or partially dissociated. The insensitiveness need not be complete, and may exist only in the case of single colours, or of all. If the sensitiveness is completely lost ('achromatopsy') he then sees everything in a uniform grey, but perceives differences in the degree of lustre. Hence the picture of nature presents itself to him as a copper-plate or a pencil drawing, where the effect of the absent colours is replaced by differences in the intensity of light, by greater or less depth and power of the white and black portions. Painters who are insensitive to colour will naturally have a predilection for neutral-toned painting; and a public suffering from the same malady will find nothing objectionable in falsely-coloured pictures. But if, besides the whitewash of a Puvis de Chavannes, obliterating all colours equally, fanatics are found for the screaming yellow, blue and red of a Besnard, this also has a cause, revealed to us by clinical science. 'Yellow and blue', Gilles de la Tourette teaches us, 'are peripheral colours' (i.e., they are seen with the outermost parts of the retina); 'they are, therefore, the last to be perceived' (if the sensitiveness for the remaining colours is destroyed). 'These are ... the very two colours the sensations of which in hysterical amblyopia [dullness of vision] endure the longest. In many cases, however, it is the red, and not the blue, which vanishes last.'

Red has also another peculiarity, explanatory of the predilection shown for it by the hysterical. The experiments of Binet have established that the impressions conveyed to the brain by the sensory nerves exercise an important influence on the species and strength of the excitation distributed by the brain to the motor nerves. Many sense-impressions operate enervatingly and inhibitively on the movements; others, on the contrary, make these more powerful, rapid and active; they are 'dynamogenous', or 'force-producing'. As a feeling of pleasure is always connected with dynamogeny, or the production of force, every living thing, therefore, instinctively seeks for dynamogenous sense-impressions, and avoids enervating and inhibitive ones. [...]

Hence it is intelligible that hysterical painters revel in red, and that hysterical beholders take special pleasure in pictures operating dynamogenously, and producing feelings of pleasure.

If red is dynamogenous, violet is conversely enervating and inhibitive. It was not by accident that violet was chosen by many nations as the exclusive colour for mourning, and by us also for half-mourning. The sight of this colour has a depressing effect, and the unpleasant feeling awakened by it induces dejection in a sorrowfully-disposed mind. This suggests that painters suffering from hysteria and neurasthenia will be inclined to cover their pictures uniformly with the colour most in accordance with their condition of lassitude and exhaustion. Thus

originate the violet pictures of Manet and his school, which spring from no actually observable aspect of nature, but from a subjective view due to the condition of the nerves. When the entire surface of walls in salons and art exhibitions of the day appears veiled in uniform half-mourning, this predilection for violet is simply an expression of the nervous debility of the painter. [...]

Max Nordau, extract from *Entartung* (Berlin: Carl Duncker, 1892); trans. George L. Mosse,, *Degeneration* (Lincoln, Nebraska: University of Nebraska Press, 1993); reprinted in *Art in Theory 1815–1900*, ed. Charles Harrison, Paul Wood (Oxford: Blackwell, 1998) 802–3.

Paul Gauguin
Notes on Colour//1896–98

[...] The century is coming to an end and the masses press anxiously about the scientist's door; they whisper, they frown, faces brighten. 'Is it all over?' 'Yes.' A few minutes later: 'No, not yet.' 'What is happening?' 'Is a virgin giving birth?' 'Is a pope becoming truly Christian?' 'Is a hanged man being resuscitated?' Not at all; quite simply it's the question of colour photography, the absorbing problem whose solution is going to make so many unsavory characters fall down with their behinds right in their ... At last we will know who is right, Cabanel, Claude Monet, Seurat, Chevreul, Rood, Charles Henry; the painters, the chemists.

Rood and Charles Henry broke colour down, decomposed it, or composed it, if you like. Delacroix naïvely left aside his worries as poet-painter to run after ladies' purple-shaded yellow hats.

Zola himself, who had so little of the painter in him, and had such a pronounced taste for an asphalt-coloured world [of streetwalkers] (to put it in polite terms), is busy, in Mouret's store, the Bonheur des Dames, fashioning white bouquets combining an infinite number of shades. As you can see, everybody is concerned with colour. I was about to forget Brunetière, such an educated man. At the Puvis de Chavannes banquet, we all listened, somewhat dazed, as he congratulated that great painter ... on having made such beautiful paintings with pale tones. In your splendid garden only wisteria blooms; no deep-red roses, no scarlet geraniums, no deep-purple pansies, above all no sunflowers, no poppies; cornflowers perhaps! Like the Impressionist gardens. Then too, everyone has a preference for some specific colour. Paul does not like blue, Henri hates green (spinach!), Eugène is afraid of red, Jacques feels sick

when he sees yellow. Confronted with these four critics a painter doe'
how to account for himself; timidly he tries to say a few w
observation of colours in nature, calling upon Chevreul, Rood, Charles ᴴᵉ.
support of his views, but in vain; the critics howl and then are silent.

And as easily as you let out a fart in order to get rid of someone who's a pain
in the neck, Cézanne says, with his accent from the Midi: 'A kilo of green is
greener than half a kilo.' Everyone laughs: he's crazy! The craziest person is not
the one you think. His words have a meaning other than their literal meaning,
and why should he explain their rational meaning to people who laugh? That
would be casting pearls before swine.

The photography of colours will tell us the truth. What truth? the real colour
of a sky, of a tree, of all of materialized nature. What then is the real colour of a
centaur, or a minotaur, or a chimera, of Venus or Jupiter? [...]

Truth is in front of our eyes, nature vouches for it. Would nature be deceiving
you, by any chance? Is truth really naked, or disguised? Though your eyes cannot
reason, have they the necessary perfection to discover truth?

Let's look and see, as the skeptical worker would say. The sky is blue, the sea
is blue, the trees are green, their trunks are grey, the ground on which they grow
is slightly indefinable. All of this, as everybody knows, is called local colour, but
the light comes and changes the look of every colour at will. And the sea that we
know to be blue, which is the pure truth, becomes yellow and somehow seems to
take on a fabulous hue that you can find only at the clothes-dyers'. The shadows
on the ground become purple or other colours that are complementary to the
tones closest to them. And everyone peers through his opera glasses at the right
colour and dexterously applies to the canvas, in squares prepared in advance, the
true colour, the genuine colour which for a few seconds is there before his eyes.

All of this toned down a little – it is better to err on the side of less than more,
exaggeration is a crime (as everybody knows). But who can guarantee that his
colours are true at this very hour, this minute which no one has witnessed, not
even the painter who has forgotten the previous minute? Men apply their tones
delicately, with utmost care, for fear of being called coarse; the women apply
theirs with vigorous, bold strokes, so as to be considered masculine and jaunty,
and hot-blooded (without any other adjective; in studio terms the word 'hot-
blooded' is enough). But where is this source of luminous strength? Indeed I see
shadows that indicate that the sun must have distorted the local colour, indeed
I have heard the servant usher in the king, but I do not see the sun, the king.

This whole heap of accurate colours is lifeless, frozen; stupidly, with
effrontery, it tells lies. Where is the sun that provides warmth, what has become
of that huge Oriental rug?

When we see that little canvas, with its pretentious claim to imitate nature,

: are tempted to say: 'Oh man, how small you are.' And also that a kilogram of green is greener than half a kilo.

I have observed that the play of shadows and zones of light did not in any way form a coloured equivalent of any light. A lamp, or the moon, or the sun can produce as much, that is, an effect; but what makes all these types of light distinct from one another? Colour. The pictorial rendering of these zones of light with the contrasting shadows becomes negative, and the values they embody become negative; it would be merely a literary translation (a signpost to indicate that here is where light, a form of light, resides). And also, since all these zones of light are indicated in the landscape in uniform fashion, mathematically, monotonously, governed by the law of radiance, and since they take over all the colours and they in turn are overtaken by that law, it follows that the wealth of harmonies and effects disappears and is imprisoned in a uniform mold. What then would be the equivalent? Pure colour! and everything must be sacrificed to it. A local-colour, bluish-grey tree trunk becomes pure blue, and so on for all colours. The intensity of colour will indicate the nature of each colour: for example, the blue sea will be of a blue more intense than the grey tree trunk which has become a pure blue, but less intense. And since a kilo of green is greener than half a kilo, then in order to achieve the equivalent (your canvas being smaller than nature) you have to use a green that is greener than the one nature uses. That is the truthfulness of falsehood. In this way your painting, illuminated by a subterfuge, a falsehood, will be true because it will give you the impression of something true (light, power and grandeur), with harmonies as varied as you could wish. Cabaner, the musician, used to say that in order to give the impression of silence in music, he would use a brass instrument sounding one single high-pitched note rapidly and very loudly. This then would be a musical equivalent, rendering a truth by a lie. Let's not carry the subject any further; as I told you, this is merely a sketch. It can be important only to people concerned with physics. So now I'll leave that aside and talk about colour solely from the standpoint of art. About colour alone as the language of the listening eye, about its suggestive quality (says A. Delaroche) suited to help our imaginations soar, decorating our dream, opening a new door onto mystery and the infinite. Cimabue would have shown posterity the way into this Eden, but posterity answered, Watch out! What the Orientals, Persians and others did, first of all, was to print a complete dictionary, so to speak, of this language of the listening eye; they made their rugs marvelously eloquent. Ah you painters who demand a technique for colour! study those rugs; in them you will find all that science can teach you, but who knows, perhaps the book is sealed and you cannot read it. And the recollection of bad traditions obstructs your understanding. For you, the result of seeing colour thus determined by its own

charm, yet indeterminate when it comes to designating objects perceived in nature, is a disturbing 'What on earth is that all about?' which defeats your powers of analysis. So what!

Photograph a colour, or several colours; that is, transpose them into black and white, and all you have left is an absurdity, the charm has disappeared. That is why a photograph of a Delacroix, a Puvis de Chavannes, etc., gives us a very rough idea of those paintings; and this proves that their qualities do not lie in their colour. Delacroix, it has been said over and over again, was a great colourist but a poor draftsman. Yet you can see that the opposite is true because the charm that pervades his works has not disappeared in the photographs of them.

As best we could, we have just pointed out and then explained colour as living matter; like the body of a living being. Now we must talk about its soul, that elusive fluid which by means of intelligence and the heart has created so much and stirred so much – about colour that helps our imagination to soar, opening a new door onto mystery and the infinite. We cannot explain it, but perhaps indirectly, by using a comparison, we can suggest its language.

Colour being enigmatic in itself, as to the sensations it gives us, then to be logical we cannot use it any other way than enigmatically every time we use it, not to draw with but rather to give the musical sensations that flow from it, from its own nature, from its internal, mysterious, enigmatic power. By means of skilfull harmonies we create symbols. Colour which, like music, is a matter of vibrations, reaches what is most general and therefore most undefinable in nature: its inner power … Outlined so briefly, suggested so enigmatically, this problem of colour remains to be solved, you will say. But who has claimed that it could be solved by a mathematical equation or explained by literary means? It can be solved only by a pictorial work – even if that pictorial work is of an inferior quality. It is enough that the being be created, that it have an embryonic soul; whereupon the progression up to its perfected state ensures the triumph of doctrine.

The battle for painting through colour, thus explained, must be joined without delay. It is all the more appealing for being difficult, for offering a limitless and virgin terrain. […]

Paul Gauguin, extract from 'Notes on Colour' (Tahiti, 1896–98) in Gauguin, *Écrits d'un sauvage*, ed. Daniel Guérin (Paris: Gallimard, 1974); trans. Eleanor Levieux, *The Writings of a Savage* (New York: Viking Press, 1978) 138–46.

Paul Signac
The Education of the Eye//1899

[...] Why then has *divisionism*, which can claim for itself advantages that the other techniques cannot offer, encountered so much hostility? The reason is that in France people revolt against any new thing in art and are not merely insensitive, but hostile, to colour. (Consider the fact that our national guide book, the *Joanne*, does not simply provide information, but finds it necessary to provoke laughter and incomprehension in the tourist who views the colours of Turner's admirable canvases in the South Kensington Museum.)

The complaint against Neo-Impressionist art was twofold: it was innovative, and the paintings executed in accordance with its technique shone with an unwonted brilliance.

There is no need to list here all the innovative painters who have been reviled in this century, and have subsequently imposed their particular vision on the public. Injustice, struggle and triumphs: that is the history of art. [...]

A single generation does not twice make the effort which is required to assimilate a new way of seeing things. The detractors of Delacroix had to yield to his supporters. But the supporters did not understand the colourists who came after him, the Impressionists. These too have triumphed, and today the fanciers of the work of Monet, Pissarro, Renoir and Guillaumin misuse the reputation for good taste which they have gained by their choice and condemn Neo-Impressionism. [...]

It is particularly when innovation tends towards light or colour that it meets a churlish reception. Changes in the subjects of painting, corresponding to changes in literary fashion, are easily accepted by the same people who become alarmed at the slightest new touch of brilliance. The distortions of the Rose-Croix movement certainly did not provoke as much hilarity as did Monsieur Monet's blue locomotives or the violet trees of Monsieur Cross. Rarely does a drawing, a statue, arouse the wrath of an uncomprehending public: but a bold use of colour always does.

All pure, bold colour is shocking; people only admire paintings that are flat, smooth, muted and dull. If, on the pretext of shading, half a figure is covered with bitumen or brown, the public willingly accepts it, but not the use of blue or violet. But shadows are always tinged with this blue or violet which repels the viewers, not with the excremental hues which have their approval. Optical physics would say the same thing. [...]

These laws of colour can be learned in a few hours. They are summed up in two pages of [Michel-Eugène] Chevreul and [Ogden] Rood. The eye guided by them need only train itself to see still better. But, since the time of Charles Blanc, the situation has scarcely changed. Nothing has been done to propagate this special education. Chevreul's discs, which, used as a form of entertainment, could prove to so many eyes that they do not see and could teach them to see, are not yet adopted by our elementary schools, despite all the efforts of the great scientist in this direction.

It is this simple science of contrast which forms the solid basis of Neo-Impressionism. Without it, there will be no lovely lines or perfect colours. While we see every day what services it can render to the artist, by directing and fortifying his inspiration, we have yet to discover what harm it can do him. [...]

The art of the colourist is, indeed, not a matter of placing reds, greens and yellows side by side, without regard for rule or measure. The painter must know how to arrange these diverse elements, sacrificing some so as to give weight to others. Noise and music are not synonymous. Juxtaposition of colours, however intense, with no concern for contrast, is merely daubing, and not colouring.

One of the serious reproaches addressed to the Neo-Impressionists is that they are too scientific to be artists: They are, it is said, so buried in their experiments that they cannot freely express their sensations.

To this we reply that the lowliest Oriental weaver knows as much about this as they do. These notions which are held against them are not very complicated. The Neo-Impressionists are not unduly scientific. But ignorance of the laws of contrast and harmony is too great an ignorance.

Why then would their mastery of these rules of beauty blot out their sensations? Is a musician, because he knows that the 3/2 proportion is harmonic, or a painter, because he is aware that orange together with green and violet forms a ternary combination, any less of an artist, less able to feel and to impart emotion? Théophile Silvestre has said: 'This almost mathematical knowledge, far from chilling works of art, increases their exactness and their solidity.'

The Neo-Impressionists are not slaves to science. They apply it as their inspiration directs: They make their knowledge serve their intention. Can we reproach young painters for refusing to neglect this essential component of their art when we see a genius like Delacroix forcing himself to study the laws of colour and profiting from this inquiry? [...]

Paul Signac, extracts from 'L'education de l'oeil' (1899), in *D'Eugène Delacroix au Néo-Impressionisme*, third ed. (Paris: H. Floury, 1921); trans. Willa Silverman, in *Paul Signac and Colour in Neo-Impressionism*, ed. Floyd Ratliff (New York: The Rockefeller University Press, 1992) 276–86.

Maurice Denis
Cézanne//1907

[…] 'I wished to copy nature', said Cézanne. 'I could not. Yet I was satisfied when I discovered that the sun, for instance, could not be reproduced but must be represented by something else … by colour.' […]

'There is no such thing as line,' he said, 'no such thing as modelling, there are only contrasts. When colour attains its richness form attains its plenitude.'

Thus, in his essentially concrete perception of objects, form is not separated from colour; they condition one another, they are indissolubly united. And in consequence in his execution he wishes to realize them as he sees them, by a single brush-stroke. […]

All his faculty for abstraction – and we see how far the painter dominates the theorist – all his faculty for abstraction permits him to distinguish only among notable forms 'the sphere, the cone and the cylinder'. All forms are referred to those which he is alone capable of thinking. The multiplicity of his colour schemes varies them infinitely. But still he never reaches the conception of the circle, the triangle, the parallelogram; those are abstractions which his eye and brain refuse to admit. Forms are for him volumes.

Hence all objects were bound to tell for him according to their relief, and to be situated according to planes at different distances from the spectator within the supposed depth of the picture. A new antinomy, this, which threatens to render highly accidental 'that plane surface covered with colours arranged in a determined order'. Colourist before everything, as he was, Cézanne resolves this antinomy by chromatism – the transposition, that is, of values of black and white into values of colour.

'I want,' he told me, following the passage from light to shade on his closed fist – 'I want to do with colour what they do in black and white with the stump.' He replaces light by colour. This shadow is a colour, this light, this half-tone are colours. The white of this table-cloth is a blue, a green, a rose; they mingle in the shadows with the surrounding local tints; but the crudity in the light may be harmoniously translated by dissonant blue, green and rose. He substitutes, that is, contrasts of tint for contrasts of tone. He disentangles thus what he used to call 'the confusion of sensations'. In all this conversation, of which I here report scraps, he never once mentioned the word values. His system assuredly excludes relations of values in the sense accepted in the schools.

Volume finds, then, its expression in Cézanne in a gamut of tints, a series of touches; these touches follow one another by contrast or analogy according as

the form is interrupted or continuous. This was what he was fond of calling *modulating* instead of modelling. We know the result of this system, at once shimmering and forcible; I will not attempt to describe the richness of harmony and the gaiety of illumination of his pictures. [...]

Maurice Denis, extract from 'Cézanne', *L'Occident* (Paris, 1907); trans. Roger Fry, *Burlington Magazine*, xvi (London, January–February 1910); reprinted in *Art in Theory 1900–2000*, ed. Charles Harrison and Paul Wood (Oxford: Blackwell, 2003) 44; 45.

Rainer Maria Rilke
Letter on Cézanne//1907

[...] the Salon is closing today. And already, as I'm leaving it, on the way home for the last time, I want to go back to look up a violet, a green, or certain blue tones which I believe I should have seen better, more unforgettably. Already, even after standing with such unrelenting attention in front of the great colour scheme of the woman in the red armchair,[1] it is becoming as unretrievable in my memory as a figure with very many digits. And yet I memorized it, number by number. In my feeling, the consciousness of their presence has become a heightening which I can feel even in my sleep; my blood describes it within me, but the naming of it passes by somewhere outside and is not called in. Did I write about it? – A red, upholstered low armchair has been placed in front of an earthy-green wall in which a cobalt-blue pattern (a cross with the centre left out) is very sparingly repeated; the round bulging back curves and slopes forward and down to the arm rests (which are sewn up like the sleeve-stump of an armless man). The left arm rest and the tassel that hangs from it full of vermilion no longer have the wall behind them but instead, near the lower edge, a broad stripe of greenish blue, against which they clash in loud contradiction. Seated in this red armchair, which is a personality in its own right, is a woman, her hands in the lap of a dress with broad vertical stripes that are very lightly indicated by small, loosely distributed flecks of green yellows and yellow greens, up to the edge of the blue-grey jacket, which is held together in front by a blue, greenly scintillating silk bow. In the brightness of the face, the proximity of all these colours has been exploited for a simple modelling of form and features: even the brown of the hair roundly pinned up above the temples and the smooth brown in the eyes has to express itself against its surroundings. *It's as if every*

place were aware of all the other places – it participates that much; that much adjustment and rejection is happening in it, that's how each daub plays its part in maintaining equilibrium and in producing it: just as the whole picture finally keeps reality in equilibrium. For if one says, this is a red armchair (and it is the first and ultimate red armchair ever painted): it's true only because it contains latently within itself an experienced sum of colour which, whatever it may be, reinforces and confirms this red. To reach the peak of its expression, it is very strongly painted around the light human figure, so that a kind of waxy surface develops; and yet the colour does not preponderate over the object, which seems so perfectly translated into its painterly equivalents that, while it is fully achieved and given as an object, its bourgeois reality is at the same time relinquishing all its heaviness to a final and definitive picture-existence. Everything, as I already wrote, has become an affair that's settled among the colours themselves: a colour will come into its own in response to another, or assert itself, or recollect itself. Just as in the mouth of a dog various secretions will gather in anticipation at the approach of various things – consenting ones for drawing out nutrients, and correcting ones to neutralize poisons: in the same way, various intensifications and dilutions take place in the core of every colour, helping it to survive contact with others. In addition to this glandular activity within the intensity of colours, reflections (whose presence in nature always surprised me so: to discover the evening glow of the water as a permanent colouration in the rough green of the Nenuphar's covering-leaves –) play the greatest role: weaker local colours abandon themselves completely, contenting themselves with reflecting the dominant one. In this hither and back of mutual and manifold influence, the interior of the picture vibrates, rises and falls back into itself, and does not have a single unmoving part. Just this for today ... You see how difficult it becomes when one tries to get very close to the facts ...

1 [*Madame Cézanne in a Red Armchair, c.* 1877; now in collection of Museum of Fine Arts, Boston.]

Rainer Maria Rilke, Letter, Paris VIe, 29, rue Cassette, 22 October 1907; Rilke, *Briefe über Cézanne*, ed. Clara Rilke (Frankfurt am Main: Insel Verlag, 1952); trans. Joel Agee, *Letters on Cézanne* (London: Jonathan Cape, 1988) 79–82. Reprinted by permission of the Random House Group Ltd.

Henri Matisse
Notes of a Painter//1908

[...] The chief function of colour should be to serve expression as well as possible. I put down my tones without a preconceived plan. If at first, and perhaps without my having been conscious of it, one tone has particularly seduced or caught me, more often than not once the picture is finished I will notice that I have respected this tone while I progressively altered and transformed all the others. The expressive aspect of colours imposes itself on me in a purely instinctive way. To paint an autumn landscape I will not try to remember what colours suit this season, I will be inspired only by the sensation that the season arouses in me: the icy purity of the sour blue sky will express the season just as well as the nuances of foliage. My sensation itself may vary, the autumn may be soft and warm like a continuation of summer, or quite cool with a cold sky and lemon-yellow trees that give a chilly impression and already announce winter.

My choice of colours does not rest on any scientific theory; it is based on observation, on sensitivity, on felt experiences. Inspired by certain pages of Delacroix, an artist like Signac is preoccupied with complementary colours, and the theoretical knowledge of them will lead him to use a certain tone in a certain place. But I simply try to put down colours which render my sensation. There is an impelling proportion of tones that may lead me to change the shape of a figure or to transform my composition. Until I have achieved this proportion in all the parts of the composition I strive towards it and keep on working. Then a moment comes when all the parts have found their definite relationships, and from then on it would be impossible for me to add a stroke to my picture without having to repaint it entirely.

In reality, I think that the very theory of complementary colours is not absolute. In studying the paintings of artists whose knowledge of colours depends upon instinct and feeling, and on a constant analogy with their sensations, one could define certain laws of colour and so broaden the limits of colour theory as it now defined. [...]

Henri Matisse, extract from 'Notes of a Painter' (1908) in *Matisse on Art*, ed. Jack D. Flam (London: Phaidon Press, 1975); reprinted ed. (Berkeley and Los Angeles: University of California Press, 1994) 38.

Roger Fry
An Essay in Aesthetics//1909

[...] Let us now see how the artist passes from the stage of merely gratifying our demand for sensuous order and variety to that where he arouses our emotions. I will call the various methods by which this is effected, the emotional elements of design.

The first element is that of the rhythm of the line with which the forms are delineated.

The drawn line is the record of a gesture, and that gesture is modified by the artist's feeling which is thus communicated to us directly.

The second element is mass. When an object is so represented that we recognize it as having inertia we feel its power of resisting movement, or communicating its own movement to other bodies, and our imaginative reaction to such an image is governed by our experience of mass in actual life.

The third element is space. The same sized square on two pieces of paper can be made by very simple means to appear to represent either a cube two or three inches high, or a cube of hundreds of feet, and our reaction to it is proportionately changed.

The fourth element is that of light and shade. Our feelings towards the same object become totally different according as we see it strongly illuminated against a black background or dark against light.

A fifth element is that of colour. That this has a direct emotional effect is evident from such words as gay, dull, melancholy in relation to colour.

I would suggest the possibility of another element, though perhaps it is only a compound of mass and space : it is that of the inclination to the eye of a plane, whether it is impending over or leaning away from us.

Now it will be noticed that nearly all these emotional elements of design are connected with essential conditions of our physical existence: rhythm appeals to all the sensations which accompany muscular activity, mass to all the infinite adaptations to the force of gravity which we are forced to make, the spatial judgment is equally profound and universal in its application to life, our feeling about inclined planes is connected with our necessary judgments about the conformation of the earth itself, light, again, is so necessary a condition of our existence that we become intensely sensitive to changes in its intensity. Colour is the only one of our elements which is not of critical or universal importance to life, and its emotional effect is neither so deep nor so clearly determined as the others. It will be seen, then, that the graphic arts arouse emotions in us by

playing upon what one may call the overtones of some of our primary physical needs. They have, indeed, this great advantage over poetry, that they can appeal more directly and immediately to the emotional accompaniments of our bare physical existence. […]

Roger Fry, extract from 'An Essay in Aesthetics', *The New Quarterly*, vol. II, no. 6 (London, 1909); reprinted in Fry, *Vision and Design* (London: Chatto & Windus, 1920) 22–3.

Umberto Boccioni, Carlo Carrà, Luigi Russolo, Giacomo Balla, Gino Severini
Futurist Painting: Technical Manifesto//1910

On the 18th of March, 1910, in the limelight of the Chiarella Theatre of Turin, we launched our first manifesto to a public of three thousand people – artists, men of letters, students and others; it was a violent and cynical cry which displayed our sense of rebellion, our deep-rooted disgust, our haughty contempt for vulgarity, for academic and pedantic mediocrity, for the fanatical worship of all that is old and worm-eaten. […]

And now during a temporary pause in this formidable struggle we come out of the crowd in order to expound with technical precision our programme for the renovation of painting, of which our Futurist Salon at Milan was a dazzling manifestation.

Our growing need of truth is no longer satisfied with Form and Colour as they have been understood hitherto.

The gesture which we would reproduce on canvas shall no longer be a fixed *moment* in universal dynamism – It shall simply be the dynamic *sensation* itself. […]

Space no longer exists: the street pavement, soaked by rain beneath the glare of electric lamps, becomes immensely deep and gapes to the very centre of the earth. Thousands of miles divide us from the sun; yet the house in front of us fits into the solar disk.

Who can still believe in the opacity of bodies, since our sharpened and multiplied sensitiveness has already penetrated the obscure manifestations of the medium? Why should we forget in our creations the doubled power of our sight, capable of giving results analogous to those of the X-rays? […]

We would at any price re-enter into life. Victorious science has nowadays

disowned its past in order the better to serve the material needs of our time; we would that art, disowning its past, were able to serve at last the intellectual needs which are within us.

Our renovated consciousness does not permit us to look upon man as the centre of universal life. The suffering of man is of the same interest to us as the suffering of an electric lamp, which, with spasmodic starts, shrieks out the most heart-rending expressions of colour. The harmony of the lines and folds of modern dress works upon our sensitiveness with the same emotional and symbolical power as did the nude upon the sensitiveness of the old masters.

In order to conceive and understand the novel beauties of a Futurist picture, the soul must be purified; the eye must be freed from its veil of atavism and culture, so that it may at last look upon Nature and not upon the museum as the one and only standard.

As soon as ever this result has been obtained, it will be readily admitted that brown tints have never coursed beneath our skin; it will be discovered that yellow shines forth in our flesh, that red blazes, and that green, blue and violet dance upon it with untold charms, voluptuous and caressing.

How is it possible still to see the human face pink, now that our life, redoubled by noctambulism, has multiplied our perceptions as colourists ? The human face is yellow, red, green, blue, violet. The pallor of a woman gazing in a jeweller's window is more intensely iridescent than the prismatic fires of the jewels that fascinate her like a lark.

The time has passed for our sensations in painting to be whispered. We wish them in future to sing and re-echo upon our canvases in deafening and triumphant flourishes.

Your eyes, accustomed to semi-darkness, will soon open to more radiant visions of light. The shadows which we shall paint shall be more luminous than the highlights of our predecessors, and our pictures, next to those of the museums, will shine like blinding daylight compared with deepest night. [...]

Umberto Boccioni, Carlo Carrà, Luigi Russolo, Giacomo Balla, Gino Severini, extracts from 'Futurist Painting: Technical Manifesto', first published as a leaflet by *Poesia* (Milan, 11 April 1910); translated in *Exhibition of Works by the Italian Futurist Painters* (London: Sackville Gallery, March 1912); reprinted in *Futurist Manifestos*, ed. Umbro Apollonio (London: Thames & Hudson, 1973) 27; 28; 29.

Wassily Kandinsky
Concerning the Spiritual in Art//1911

The Psychological Working of Colour

[...] Whether the psychic effect of colour is a direct one [...] or whether it is the outcome of association, is perhaps open to question. The soul being one with the body, the former may well experience a psychic shock, caused by association acting on the latter. For example, red may cause a sensation analogous to that caused by flame, because red is the colour of flame. A warm red will prove exciting, another shade of red will cause pain or disgust through association with running blood. In these cases colour awakens a corresponding physical sensation, which undoubtedly works upon the soul.

If this were always the case, it would be easy to define by association the effects of colour upon other senses than that of sight. One might say that keen yellow looks sour, because it recalls the taste of a lemon.

But such definitions are not universally possible. There are many examples of colour working which refuse to be so classified. A Dresden doctor relates of one of his patients, whom he designates as an 'exceptionally sensitive person', that he could not eat a certain sauce without tasting 'blue', i.e., without experiencing a feeling of seeing a blue colour. It would be possible to suggest, by way of explanation of this, that in highly sensitive people, the way to the soul is so direct and the soul itself so impressionable, that any impression of taste communicates itself immediately to the soul, and thence to the other organs of sense (in this case, the eyes). This would imply an echo or reverberation, such as occurs sometimes in musical instruments which, without being touched, sound in harmony with some other instrument struck at the moment.

But not only with taste has sight been known to work in harmony. Many colours have been described as rough or sticky, others as smooth and uniform, so that one feels inclined to stroke them (e.g., dark ultramarine, chromic oxide green and rose madder). Equally the distinction between warm and cold colours belongs to this connection. Some colours appear soft (rose madder), others hard (cobalt green, blue-green oxide), so that even fresh from the tube they seem to be dry.

The expression 'scented colours' is frequently met with. And finally the sound of colours is so definite that it would be hard to find anyone who would try to express bright yellow in the bass notes, or dark lake in the treble. The explanation by association will not suffice us in many, and the most important cases. Those who have heard of chromotherapy will know that coloured light can exercise very definite influences on the whole body. Attempts have been

made with different colours in the treatment of various nervous ailments. They have shown that red light stimulates and excites the heart, while blue light can cause temporary paralysis. But when the experiments come to be tried on animals and even plants, the association theory falls to the ground. So one is bound to admit that the question is at present unexplored, but that colour can exercise enormous influence over the body as a physical organism.

No more sufficient, in the psychic sphere, is the theory of association. Generally speaking, colour is a power which directly influences the soul. Colour is the keyboard, the eyes are the hammers, the soul is the piano with many strings. The artist is the hand which plays, touching one key or another, to cause vibrations in the soul. *It is evident therefore that colour harmony must rest only on a corresponding vibration in the human soul; and this is one of the guiding principles of the inner need.*

The Language of Form and Colour

'Musical sound acts directly on the soul and finds an echo there because, though to varying extents, music is innate in man.' [E. Jacques-Dalcroze, *The Eurhythmics of Jacques-Dalcroze.*]

'Everyone knows that yellow, orange and red suggest ideas of joy and plenty.' (Delacroix).

These two quotations show the deep relationship between the arts, and especially between music and painting. Goethe said that painting must count this relationship her main foundation, and by this prophetic remark he seems to foretell the position in which painting is today. She stands, in fact, at the first stage of the road by which she will, according to her own possibilities, make art an abstraction of thought and arrive finally at purely artistic composition.

Painting has two weapons at her disposal:

1. Colour
2. Form

Form can stand alone as representing an object (either real or otherwise) or as a purely abstract limit to a space or a surface.

Colour cannot stand alone; it cannot dispense with boundaries of some kind. A never-ending extent of red can only be seen in the mind; when the word red is heard, the colour is evoked without definite boundaries. If such are necessary they have deliberately to be imagined. But such red as is seen by the mind and not by the eye exercises at once a definite and an indefinite impression on the soul, and produces spiritual harmony. I say 'indefinite', because in itself it has no suggestion of warmth or cold, such attributes having to be imagined for it afterwards, as modifications of the original 'redness'. I say 'definite', because the spiritual harmony exists without any need for such subsequent attributes of

warmth or cold. An analogous case is the sound of a trumpet which one hears when the word 'trumpet' is pronounced. This sound is audible to the soul, without the distinctive character of a trumpet heard in the open air or in a room, played alone or with other instruments, in the hands of a postilion, a huntsman, a soldier or a professional musician.

But when red is presented in a material form (as in painting) it must possess (1) some definite shade of the many shades of red that exist and (2) a limited surface, divided off from the other colours, which are undoubtedly there. The first of these conditions (the subjective) is affected by the second (the objective), for the neighbouring colours affect the shade of red.

This essential connection between colour and form brings us to the question of the influences of form on colour. Form alone, even though totally abstract and geometrical, has a power of inner suggestion. A triangle (without the accessory consideration of its being acute- or obtuse-angled or equilateral) has a spiritual value of its own. In connection with other forms, this value may be somewhat modified, but remains in quality the same. The case is similar with a circle, a square, or any conceivable geometrical figure. As above, with the red, we have here a subjective substance in an objective shell.

The mutual influence of form and colour now becomes clear. A yellow triangle, a blue circle, a green square, or a green triangle, a yellow circle, a blue square – all these are different and have different spiritual values.

It is evident that many colours are hampered and even nullified in effect by many forms. On the whole, keen colours are well suited by sharp forms (e.g., a yellow triangle), and soft, deep colours by round forms (e.g., a blue circle). But it must be remembered that an unsuitable combination of form and colour is not necessarily discordant, but may, with manipulation, show the way to fresh possibilities of harmony.

Since colours and forms are well-nigh innumerable, their combination and their influences are likewise unending. The material is inexhaustible. […]

The starting point is the study of colour and its effects on men.

There is no need to engage in the finer shades of complicated colour, but rather at first to consider only the direct use of simple colours.

To begin, let us test the working on ourselves of individual colours, and so make a simple chart, which will facilitate the consideration of the whole question.

Two great divisions of colour occur to the mind at the outset: into warm and cold, and into light and dark. To each colour there are therefore four shades of appeal – warm and light or warm and dark, or cold and light or cold and dark.

Generally speaking, warmth or cold in a colour means an approach respectively to yellow or to blue. This distinction is, so to speak, on one basis, the

colour having a constant fundamental appeal, but assuming either a more material or more non-material quality. The movement is a horizontal one, the warm colours approaching the spectator, the cold ones retreating from him.

The colours, which cause in another colour this horizontal movement, while they are themselves affected by it, have another movement of their own, which acts with a violent separative force. This is, therefore, the first antithesis in the inner appeal, and the inclination of the colour to yellow or to blue, is of tremendous importance.

The second antithesis is between white and black; i.e., the inclination to light or dark caused by the pair of colours just mentioned. These colours have once more their peculiar movement to and from the spectator, but in a more rigid form.

Yellow and blue have another movement which affects the first antithesis – an ex- and concentric movement. If two circles are drawn and painted respectively yellow and blue, brief concentration will reveal in the yellow a spreading movement out from the centre, and a noticeable approach to the spectator. The blue, on the other hand, moves in upon itself, like a snail retreating into its shell, and draws away from the spectator.

In the case of light and dark colours the movement is emphasized. That of the yellow increases with an admixture of white, ie., as it becomes lighter. That of the blue increases with an admixture of black, i.e., as it becomes darker. This means that there can never be a dark-coloured yellow. The relationship between white and yellow is as close as between black and blue, for blue can be so dark as to border on black. Besides this physical relationship, is also a spiritual one (between yellow and white on one side, between blue and black on the other) which marks a strong separation between the two pairs.

An attempt to make yellow colder produces a green tint and checks both the horizontal and excentric movement. The colour becomes sickly and unreal. The blue by its contrary movement acts as a brake on the yellow, and is hindered in its own movement, till the two together become stationary, and the result is green. Similarly a mixture of black and white produces grey, which is motionless and spiritually very similar to green.

But while green, yellow and blue are potentially active, though temporarily paralysed, in grey there is no possibility of movement, because grey consists of two colours that have no active force, for they stand the one in motionless discord, the other in a motionless negation, even of discord, like an endless wall or a bottomless pit.

Because the component colours of green are active and have a movement of their own, it is possible, based on this movement, to reckon their spiritual appeal.

The first movement of yellow, that of approach to the spectator (which can be increased by an intensification of the yellow), and also the second movement, that

of over-spreading the boundaries, have a material parallel in the human energy which assails every obstacle blindly, and bursts forth aimlessly in every direction.

Yellow, if steadily gazed at in any geometrical form, has a disturbing influence, and reveals in the colour an insistent, aggressive character. The intensification of the yellow increases the painful shrillness of its note.

Yellow is the typically earthly colour. It can never have profound meaning. An intermixture of blue makes it a sickly colour. It may be paralleled in human nature, with madness, not with melancholy or hypochondriacal mania, but rather with violent raving lunacy.

The power of profound meaning is found in blue, and first in its physical movements (1) of retreat from the spectator, (2) of turning in upon its own centre. The inclination of blue to depth is so strong that its inner appeal is stronger when its shade is deeper.

Blue is the typical heavenly colour. The ultimate feeling it creates is one of rest. When it sinks almost to black, it echoes a grief that is hardly human. When it rises towards white, a movement little suited to it, its appeal to men grows weaker and more distant. In music a light blue is like a flute, a darker blue a cello; a still darker a thunderous double bass; and the darkest blue of all – an organ.

A well-balanced mixture of blue and yellow produces green. The horizontal movement ceases; likewise that from and towards the centre. The effect on the soul through the eye is therefore motionless. This is a fact recognized not only by opticians but by the world. Green is the most restful colour that exists. On exhausted men this restfulness has a beneficial effect, but after a time it becomes wearisome. Pictures painted in shades of green are passive and tend to be wearisome; this contrasts with the active warmth of yellow or the active coolness of blue. In the hierarchy of colours green is the 'bourgeoisie' – self-satisfied, immovable, narrow. It is the colour of summer, the period when nature is resting from the storms of winter and the productive energy of spring.

Any preponderance in green of yellow or blue introduces a corresponding activity and changes the inner appeal. The green keeps its characteristic equanimity and restfulness, the former increasing with the inclination to lightness, the latter with the inclination to depth. In music the absolute green is represented by the placid, middle notes of a violin.

Black and white have already been discussed in general terms. More particularly speaking, white, although often considered as no colour (a theory largely due to the Impressionists, who saw no white in nature), is a symbol of a world from which all colour as a definite attribute has disappeared. This world is too far above us for its harmony to touch our souls. A great silence, like an impenetrable wall, shrouds its life from our understanding. White, therefore, has this harmony of silence, which works upon us negatively, like many pauses in

music that break temporarily the melody. It is not a dead silence, but one pregnant with possibilities. White has the appeal of the nothingness that is before birth, of the world in the ice age.

A totally dead silence, on the other hand, a silence with no possibilities, has the inner harmony of black. In music it is represented by one of those profound and final pauses, after which any continuation of the melody seems the dawn of another world. Black is something burnt out, like the ashes of a funeral pyre, something motionless like a corpse. The silence of black is the silence of death. Outwardly black is the colour with least harmony of all, a kind of neutral background against which the minutest shades of other colours stand clearly forward. It differs from white in this also, for with white nearly every colour is in discord, or even mute altogether. [...]

Wassily Kandinsky, extracts from *Über das Geistige in der Kunst* (1911, first published Munich: Piper verlag, 1912); trans. M.T.H. Sadler, *The Art of Spiritual Harmony* (London: Constable & Co., 1914); reprinted edition, *Concerning the Spiritual in Art* (New York: Dover Publications Inc., 1977) 23–6; 36–9; 39; 40–1 [footnotes not included].

Oswald Spengler
The Decline of the West//1918

[...] Blue and green are transcendent, spiritual, non-sensuous colours. They are missing in the strict Attic fresco and *therefore dominant* in oil-painting. Yellow and red, the Classical colours, are the colours of the material, the near, the full-blooded. Red is the characteristic colour of sexuality – hence it is the only colour that works upon the beasts. It matches best the Phallus-symbol – and therefore the statue and the Doric column – but it is pure blue that etherealizes the Madonna's mantle. This relation of the colours has established itself in every great school as a deep-felt necessity. Violet, a red succumbing to blue, is the colour of women no longer fruitful and of priests living in celibacy.

Yellow and red are the *popular* colours, the colours of the crowd, of children, of women, and of savages. Amongst the Venetians and the Spaniards high personages affected a splendid black or blue, with an unconscious sense of the aloofness inherent in these colours. For red and yellow, the *Apollinian*, *Euclidean-polytheistic* colours, belong to the foreground even in respect of social life; they are meet for the noisy hearty market-days and holidays, the

naïve immediateness of a life subject to the blind chances of the Classical *Fatum*, the point-existence. But blue and green – the Faustian, monotheistic colours – are those of loneliness, of care, of a present that is related to a past and a future, of destiny as the dispensation governing the universe from within. [...]

Oswald Spengler, extract from *Der Untergang des Abendlandes* [Twilight of the evening-lands], vol. 1 (Vienna: Braumüller, 1918); trans. Charles Francis Atkinson, *The Decline of the West: Form and Actuality* (London: George Allen and Unwin Ltd., 1926) 246.

Walter Benjamin
A Child's View of Colour//1914–15

Colour is something spiritual, something whose clarity is spiritual, so that when colours are mixed they produce nuances of colour, not a blur. The rainbow is a pure childlike image. In it colour is wholly contour; for the person who sees with a child's eyes, it marks boundaries, is not a layer of something superimposed on matter, as it is for adults. The latter abstract from colour, regarding it as a deceptive cloak for individual objects existing in time and space. Where colour provides the contours, objects are not reduced to things but are constituted by an order consisting of an infinite range of nuances. Colour is single, not as a lifeless thing and a rigid individuality but as a winged creature that flits from one form to the next. Children make soap bubbles. Similarly, games with painted sticks, sewing kits, decals, parlour games, even pull-out picture books, and, to a lesser extent, making objects by folding paper – all involve this view of colour.

Children like the way colours shimmer in subtle, shifting nuances (as in soap bubbles), or else make definite and explicit changes in intensity, as in oleographs, paintings, and the pictures produced by decals and magic lanterns. For them colour is fluid, the medium of all changes, and not a symptom. Their eyes are not concerned with three-dimensionality; this they perceive through their sense of touch. The range of distinctions within each of the senses (sight, hearing, and so on) is presumably larger in children than in adults, whose ability to correlate the different senses is more developed. The child's view of colour represents the highest artistic development of the sense of sight; it is sight at its purest, because it is isolated. But children also elevate it to the spiritual level because they perceive objects according to their colour content and hence do not isolate them, instead using them as a basis from which to create the interrelated

totality of the world of the imagination. The imagination can be developed only by contemplating colours and dealing with them in this fashion; only in this way can it be both satisfied and kept within bounds. Wherever it applies itself to the plastic arts, it becomes overly lush; the same applies to history, and in music it is sterile. For the fact is that the imagination never engages with form, which is the concern of the law, but can only contemplate the living world from a human point of view creatively in feeling. This takes place through colour, which for that reason cannot be single and pure, for then it remains dull. Instead, wherever it is not confined to illustrating objects, it must be full of light and shade, full of movement, arbitrary and always beautiful. In this respect, colouring-in has a purer pedagogical function than painting, so long as it makes transparent and fresh surfaces, rather than rendering the blotchy skin of things. Productive adults derive no support from colour; for them colour can subsist only within law-given circumstances. Their task is to provide a world order, not to grasp innermost reasons and essences but to develop them. In a child's life, colour is the pure expression of the child's pure receptivity, in so far as it is directed at the world. It contains an implicit instruction to a life of the spirit which is no more dependent on accidental circumstances for its creativity than colour, for all its receptivity, is capable of communicating about the existence of dead, causal reality.

Children's drawings take colourfulness as their point of departure. Their goal is colour in its greatest possible transparency, and there is no reference to form, area, or concentration into a single space. For a pure vision is concerned not with space and objects but with colour, which must indeed be concerned with objects but not with spatially organized objects. As an art, painting starts from nature and moves cumulatively towards form. The concern of colour with objects is not based on their form; without even touching on them empirically, it goes right to the spiritual heart of the object by isolating the sense of sight. It cancels out the intellectual cross-references of the soul and creates a pure mood, without thereby sacrificing the world. Colourfulness does not stimulate the animal senses because the child's uncorrupted imaginative activity springs from the soul. But because children see with pure eyes, without allowing themselves to be emotionally disconcerted, it is something spiritual: the rainbow refers not to a chaste abstraction but to a life in art. The order of art is paradisiacal because there is no thought of the dissolution of boundaries – from excitement – in the object of experience. Instead the world is full of colour in a state of identity, innocence and harmony. Children are not ashamed, since they do not reflect but only see.

Walter Benjamin, 'A Child's View of Colour' (1914–15, formerly unpublished), trans. Rodney Livingstone, in Benjamin, *Selected Writings, vol. 1: 1913–1926*, ed. Marcus Bullock and Michael W. Jennings (Cambridge, Massachusetts: The Belknap Press of Harvard University Press, 1996) 50–1.

Walter Benjamin
Aphorisms on Imagination and Colour//1914–15

[...] Relation of the artistic canon to the imagination beyond colour? All the arts are ultimately related to the imagination.

Colour is beautiful, but there is no sense in producing beautiful colours, because colour follows in the wake of beauty as an attribute, not as a phenomenon in its own right.

Colour absorbs into itself, by imparting colour and surrendering itself.

Colour must be seen.

It is not possible to establish a theory of harmony for colours, because in such a theory number is merely the expression of an infinite range of possibilities that are just systematically assembled. For each basic colour there is an octave through to a ninth, and so forth on an ever more diversified scale. The harmony of colour is a single thing within a particular medium; it lacks multiplicity, because it is undefined and exists only in perception. A theory of harmony is possible only in the transition from light to shade – that is to say, with reference to space.

On painterly colour: it arises as a simple phenomenon in the imagination, but its purity is distorted by its existence in space and this is the origin of light and shade. These form a third thing between pure imagination and creation, and in them painterly colours have their existence.

Colour does not relate to optics the way line relates to geometry.

In sculpture, colour is an attribute. Coloured statues, in contrast to painting.

Walter Benjamin, 'Aphorisms on Imagination and Colour' (1914–15, unpublished in Benjamin's lifetime); trans. Rodney Livingstone, in Benjamin, *Selected Writings, vol. 1: 1913–1926*, ed. Marcus Bullock and Michael W. Jennings (Cambridge, Massachusetts: The Belknap Press of Harvard University Press, 1996) 48–9. Translations © 1996 the President and Fellows of Harvard College.

Clive Bell
The Aesthetic Hypothesis//1914

[...] 'Are you forgetting about colour?' someone enquires. Certainly not; my term 'significant form' included combinations of lines and of colours. In fact it is impossible, philosophically, to separate form and colour. You cannot conceive a colourless line or a colourless space; neither can you conceive a formless relation of colours. It will be found, I think, that in practice colour becomes significant only when it is used as an attribute of form; that the function of colour is to emphasize and heighten the value of forms. But that is a rather technical question, and this is not the place to deal with it. For the present I need only explain that, when I speak of significant form, I mean a combination of lines, or of lines and colours, that moves me aesthetically. [...]

Clive Bell, extract from 'The Aesthetic Hypothesis', in *Art* (London: Chatto & Windus, 1914) 11–12.

Albert Gleizes and Jean Metzinger
Cubism//1912

[...] The art of the Impressionists involves an absurdity: by diversity of colour it tries to create life, yet its drawing is feeble and worthless. A dress shimmers, marvellous; forms disappear, atrophied. Here [...] the retina predominates over the brain; they were aware of this and, to justify themselves, gave credit to the incompatability of the intellectual faculties and artistic feeling. [...]

After the Impressionists had burned up the last Romantic bitumens, some believed in a renaissance, or at least the advent of a new art: of colour. Some were delirious. They would have given the Louvre and all the museums of the world for a scrap of cardboard spotted with hazy pink and apple-green. We are not jesting. To these excesses we owe the experience of a bold and necessary experiment.

Seurat and Signac thought of schematizing the palette and, boldly breaking with an age-long habit of the eye, established optical admixture.

Noble works of art, by Seurat as well as by Signac, [Henri-Edmond] Cross and others, testify to the fertility of the Neo-Impressionist method; but it appears contestable as soon as we cease to regard it on the plane of superficial realism.

Endeavouring to assimilate the colours of the palette with those of the prism, it is based on the exclusive use of pure elements. Now the colours of the prism are homogeneous, while those of the palette, being heterogeneous, can furnish pure elements only in so far as we accept the idea of a *relative purity*.

Suppose this were possible. A thousand little touches of pure colour break down white light, and the resultant synthesis should take place in the eye of the spectator. They are so disposed that they are not reciprocally annihilated by the optical fusion of the complementaries; for, outside the prism, whether we form an optical mixture or a mixture on the palette, the result of the sum of complementaries is a troubled grey, not a luminous white. This contradiction stops us. On the one hand, we use a special procedure to reconstitute light; on the other hand, it is implicitly admitted that this reconstitution is impossible.

The Neo-Impressionists will not claim that it is not light they have divided, but colour; they know too well that colour in art is a quality of light, and that one cannot divide a quality. It is still light that they divide. For their theory to be perfect, they ought to be able to produce the sensation of white with the seven fundamentals. Then, when they juxtapose a red and a blue, the violet obtained should be equivalent to the red plus the blue. It is nothing of the sort. Whether the mixture is effected on the palette or on the retina, the result always is less luminous and less intense than the components. However, let us not hasten to condemn the optical mixture; it causes a certain stimulation of the visual sense, and we cannot deny that herein lies a possible advantage. But in this latter case it is sufficient to juxtapose elements of the same hue, yet of unequal intensity, to give that colour a highly seductive animation; it is sufficient to *graduate* them. On this point the Neo-Impressionists can readily convince us.

The most disturbing point of their theory is an obvious tendency to eliminate those elements called *neutral* which, on canvas or elsewhere, form the indefinite, and whose presence is betrayed by Fraunhofer rays [a form of X-ray] even in the spectrum itself. Have we the right thus to suppress the innumerable combinations which separate a cadmium yellow from a cobalt violet? Is it permissible thus to reduce the limits imposed by the colour-makers? Neither Seurat, Signac, nor Cross, fundamentally painters, went so far as this; but others, desirous of absolute equivalence, the negation of living beauty, renounced all mixtures, misunderstood the gradation of colours, and confided the task of lighting their paintings to the pre-selected chromatics [*précellences chromatiques*] exactly determined by industry.

The law of contrast, old as the human eye and on which Seurat judiciously insisted, was promulgated with much clamour. Among those who flattered themselves most on being sensitive to it, none was sufficiently so to perceive that to apply the law of complementaries without tact is to deny it, since it is

only of value by the fact of automatic application, and only demands a delicate handling of values.

It was then that the Cubists taught a new way of imagining light.

According to them, to illuminate is to reveal; to colour is to specify the mode of revelation. They call luminous that which strikes the mind, and dark that which the mind has to penetrate.

We do not automatically associate the sensation of white with the idea of light, any more than black with the idea of darkness. We admit that a black jewel, even if of a matt black, may be more luminous than the white or pink satin of its case. Loving light, we refuse to measure it, and we avoid the geometric ideas of focus and ray, which imply the repetition – contrary to the principle of variety which guides us – of light planes and dark intervals in a given direction. Loving colour, we refuse to limit it, and sober or dazzling, fresh or muddy, we accept all the possibilities contained between the two extreme points of the spectrum, between the cold and the warm tone.

Here are a thousand tints which escape from the prism, and hasten to range themselves in the lucid region forbidden to those who are blinded by the immediate. [...]

Albert Gleizes and Jean Metzinger, 'Cubism' (1912); reprinted in *Modern Artists on Art*, ed. R.L. Herbert (New Jersey: Prentice Hall, 1964) 2–3; 9–11.

Robert Delaunay
To Maximovitch Minsky//1912–18

[...] Real French art, completely clear and absolute representation, constructed according to the laws of light, or rather, of colour, that is to say, purely visual,, with a new craft, as was great Italian painting with its old craft; in reaction against all the *cerebral* incoherences of the cubists, the futurists, centrists, rayonists, integrists, cerebrists, abstractionists, expressionists, dynamists, patheticism (to the exclusion of some directions in the research of colour: fauvism, orphists, synchronists). [...]

In your article of 1913, you noted this effort directed towards the new construction of colour at once mysterious and profound. These efforts date from 1909 and even earlier. It is one long series of *studies of form expressed in light or lights (prism) of the sun, moon, gas, electricity, etc., by means of simultaneous*

contrasts of colour. The point of departure for these painters is the of study of colour, of the laws that govern colours – as in music there are .__ sounds. Each creator, each discoverer carries in him the innovations that come to augment the universal patrimony of Art.

These investigations were begun by the observation of the action of light on objects which led to the discovery that the line, according to the old laws of painting, no longer existed, but was deformed, broken by luminous rays (Robert Delaunay: *La Ville*, 1909, *Saint-Severin*, 1909–10, *La Tour*, 1910–11).

There followed an exact study of colour in itself: *simultaneous contrast, creation of profundity by means of complementary and dissonant colours,* which give volume direction. A more objective vision, but one still insufficiently representative, with poetic inspiration derived from the play of pure colour. Depth of colour replaces the linear perspective of the old craft. This discovery was the object of elaborate studies, various articles appearing in Germany, Russia, and in Paris. [...]

Robert Delaunay, extracts from draft of a letter to Nicholas Maximovitch Minsky (1912– c. 1918); trans. David Shapiro and Arthur A. Cohen in *The New Art of Colour: The Writings of Robert and Sonia Delaunay*, ed. Arthur Cohen (New York: The Viking Press, 1978) 62–4 [footnotes not included].

Piet Mondrian
The New Plastic in Painting//1917

[...] Abstract-real painting can create in an aesthetic-mathematic way because it possesses an *exact mathematical means of expression: colour brought to determination.*

To determine colour involves, first, *the reduction of naturalistic colour to primary colour;* second, *the reduction of colour to plane;* third, *the delimitation of colour – so that it appears as a unity of rectangular planes.*

Reduction to primary colour leads to the visual internalization of the material, to a purer manifestation of light. *The material, the corporeal* (through its *surfaces*) causes us to see colourless sunlight as natural colour. Colour then arises from *light* as well as from the *surface,* the *material.* Thus natural colour is *inwardness* (light) in its most outward manifestation. Reducing natural colour to primary colour changes the most outward manifestation of colour back to the most inward. If, of the three primary colours, yellow and blue are the most

inward, if red (the union of blue and yellow – see Dr H. Schoenmaekers, *Het nieuwe wereldbeeld*) is more outward, then a painting in yellow and blue alone would be more inward than a plastic in the three primary colours.

But if the near future is still far from this realization of the inward, and if today the time of natural colour is not yet over, the abstract-real painting must rely upon the three primary colours, supplemented by white, black and grey.

In abstract-real painting *primary colour* only signifies *colour appearing in its most basic aspect*. Primary colour thus appears very relative – the principal thing is that *colour be free of individuality and individual sensations, and that it express only the serene emotion of the universal.*

The primary colours in abstract-real painting *represent* primary colours in such a way that they *no longer depict the natural, but nevertheless remain real.*

Colour is thus *transformed* not arbitrarily but in complete harmony with all principles of art. Colour in painting owes its appearance not only to visible reality but also to the vision of the artist: the artist inwardly changes and interiorizes the outwardness of colour. If colour expression results from a reciprocal action of the subjective and the objective, and if the subjective is growing towards the universal, colour will increasingly express the universal – and will be manifested more and more *abstractly*.

If it is difficult to understand that expression through line can be abstract – plastic, then it is even more difficult to perceive this in intensified colour-as-colour (as distinguished from colour as black and white – dark and light).

The new plastic's abstract colour is *meaningless* to subjective vision: abstract colour omits individual expression of emotion – it still expresses emotion, but an emotion dominated by the spirit.

The new plastic succeeds in *universalizing* colour for it not only seeks the universal *in each colour-as-colour*, but *unifies all through equilibrated relationships*. In this way the particularities of each colour are destroyed: colour is *governed* by relationship.

In nature, as in art, colour is always *to some degree* dependent upon relationships but not always governed by them. In naturalistic expression, colour always leaves room for subjectivization of the universal. Although colour becomes *tone* through relationship (tonal or value relations), colour remains dominant.

Only through the exact expression of equilibrated colour relationships can colour be governed, and can the universal appear determinately.

If the emotion aroused by *colours themselves* is connected with feeling, and *conscious recognition of relationships* is connected with the spiritual, then spiritual feeling – of the future – will make relationships increasingly dominant over colour.

As an exact plastic expression of intensified colour as well as relationships, the

new plastic can express *complete* humanity, that is, equilibrium of spirit and feeling. Equilibrium in plastic art, however, demands a most exact technique. Although the new plastic *appears* to have given up all technique, its technique has actually become so important that the *colours must be painted in the precise place where the work is to be seen.* Only then can the effect of the colours and relationships be precise, for they are interdependent with the entire architecture; and the architecture in turn must harmonize completely with the work.

In so far as the time is not yet ripe for the complete unification of architecture, the new plastic must continue to be manifested as painting, and this will influence the abstract-real plastic of the present. Each artist must seek his own colour-expression, adapting himself to time and place. If he does not reckon with today's environment, his work will be *disharmonious* whenever it is not *seen simply in and for itself.* But perhaps this *disharmony* will open people's eyes to the present environment – as it mostly is – in all its traditionalism and arbitrariness.

Natural colour in the new plastic is intensified not only because it is reduced to primary colour but also because it appears as *plane*. [...]

In general, then, painting creates *plastically* by accentuating angularity. The plastic is necessary in painting because it creates *space*. Because painting expresses space *on a flat surface*, it *requires a plastic other than naturalistic plastic* (which is *not* perceived on one plane).

Painting has found this *new* plastic by *reducing the corporeality of objects to a composition of planes that give the illusion of lying on one plane.*

These planes, by both their dimensions (line) and their values (colour), can express space without the use of visual perspective. Space can be expressed in an equilibrated way because the dimensions and values create *pure* relationship: height and breadth oppose each other without foreshortening, and depth is manifested through the different colours of the planes.

The new plastic expresses the essential of space through the relationship of one colour plane to another; perspective illusion is completely abolished, and pictorial devices (such as the rendering of atmosphere, etc.) are excluded.

Because colour appears as pure, planar and separate, the new plastic *directly expresses expansion*, that is, directly expresses the basis of spatial appearance. Expansion – the exteriorization of active primal force – creates corporeal form by growth, addition, construction, etc. Form results when expansion is limited. If expansion is fundamental (as action arises from it), it must also be fundamental to plastic expression. If it is to be recognized consciously as fundamental, it must be represented clearly and directly. If the time is ripe for this, then the *limitations of particularity must be abolished* within the plastic expression of expansion, since only then can expansion be expressed in all its purity.

If, in the morphoplastic, the boundaries of form are established by *closed line* (contour), then they must be tensed to *straight line.*

Then the most outward (the appearance of form) comes into equilibrated relationship with the *exact plastic expression of expansion,* which also becomes perceptible to the senses as *straight line.* Thus by *expansion* and *limitation* (the extreme opposites), an *equilibrated relationship of position* is created – the perpendicular relationship. Thus, expansion is realized *without particular limitation,* purely through differences in the colour of the planes and the perpendicular relationships of lines or colour planes.

Perpendicularity delimits colour *without closing it.* Thus, in the *rectangular* plane, colour is for a third time, finally and completely, determined.

Just like the expression of colour as *plane colour,* rectangular delimitation of colour grew out of the *attempt to express the planarity of visual reality,* as found in art of the past.

The new plastic has *realized* the age-old idea of art: *the determination of colour.* […]

Piet Mondrian, extracts from 'De Nieuwe Beelding in de schilderkunst' (1917), first published in instalments in *De Stijl* (1917–18); trans. Harry N. Holtzman and Martin S. James in *The New Art – The New Life: The Collected Writings of Piet Mondrian,* eds. Holtzman and James (Boston: G.K. Hall & Co., 1986/London: Thames & Hudson, 1987) 35–9 [footnotes not included].

C.E. Jeanneret (Le Corbusier) and Amédée Ozenfant Purism//1920

[…] When one says painting, inevitably he says colour. But colour has properties of shock (sensory order) which strike the eye before form (which is a creation already cerebral in part).

Now painting is a question of architecture, and therefore volume is its means.

In the expression of volume, colour is a perilous agent; often it destroys or disorganizes volume because the intrinsic properties of colour are very different, some being radiant and pushing forward, others receding, still others being massive and staying in the real plane of the canvas, etc.; citron yellow, ultramarine blue, earths and vermilions all act very differently, so differently that one can admit without error a certain classification by family.

One can by hierarchy determine the *major scale,* formed of ochre yellows,

reds, earths, white, black, ultramarine blue, and, of course, certain of their derivatives; this scale is a strong, stable scale giving unity and holding the plane of the picture since these colours keep one another in balance. They are thus essentially constructive colours; it is these that all the great periods employed; it is these that whoever wishes to paint in volume should use.

Second scale. – The *dynamic scale*, including citron yellow, the oranges (chrome and cadmium), vermilions, Veronese green, light cobalt blues. An essentially animated, agitated scale, giving the sensation of a perpetual change of plane; these colours do not keep to one plane; sometimes they seem in front of the surface plane, sometimes behind. They are the disturbing elements.

Finally there is the *transitional scale*, the madders, emerald green, all the lakes which have properties of tinting, not of construction.

This analysis leads to a formal conclusion; on the use of one or another of these categories, or their intermixing, rest the three great methods of plastic realization which have shared the favour of artists, who pursued different goals according as their aesthetic was more or less architectural.

There are in effect two strong, and totally different manners of pictorial expression, either using the exclusive aid of light and shade and uniting all objects by the unique factor of luminous intensity, or else accepting objects in their qualifying colour and painting them in this local qualifying hue (local tone). A painting cannot be made without colour. Neither Cubism – cameo period of Picasso among others – nor the Last Judgment in the Sistine Chapel were able to do without it. The painters resolved this formidable fatality of colour in both cases by harmonizing it with the first great need of a plastic work, unity. Artists of the first manner mentioned above, Michelangelo, Rembrandt, El Greco, Delacroix, found harmony by judiciously arranging tinted light; the others, Raphael, Ingres, Fouquet, accepted local qualifiers and attempted to maintain the expression of volume, despite the disaggregating force of colour. Thus, with El Greco, the same yellow lightens the edge of an angel's wing, the knee of a figure, the lines of a face, and the convexities of a cloud; the same madder red colours clothing, ground or buildings; the same thing in Renoir's case. With Ingres, as with Raphael, a figure is in flesh tone, a drapery is blue or red, a pavement is black, brown or white, a sky is blue or grey. As for Cézanne, who practised the obstinate and maniacal search for volume with all the confusion and trouble which animated his being, his work became monochromatic; all his beautiful, vivid greens, all the precious vermilions, all the chrome yellows and azure blues of his palette were in the end broken to such a degree that his painting is one of the most monochromatic of any period: the paradoxical activity of an orchestra leader (this latter a really contemporary figure) who tries to make violin music with an English horn, and bassoon sounds with a violin.

Finally there are painters of recent times who have mixed the two manners and who, not possessed of an architectural aesthetic, use indifferently all the families of colours, happy that they produce a vibrato adjudged pleasant but which in the long run brings their work back to the aesthetic of printed cloth (virtue of dyes).

In summary, in a true and durable plastic work, it is *form* which comes first and everything else should be subordinated to it. Everything should help establish the architectural achievement. Cézanne's imitators were quite right to see the error of their master, who accepted without examination the attractive offer of the colour-vendor, in a period marked by a fad for colour-chemistry, a science with no possible effect on great painting.

Let us leave to the clothes-dyers the sensory jubilations of the paint tube.

As for us, we find that the *major scale* alone furnishes unlimited richnesses, and that an impression of vermilion can be given not just sufficiently, but yet more powerfully, by the use of burnt ochre. In accepting this discipline, we have the certitude of confining colour to its hierarchical place; even then, with this carefully picked scale, what discernment it takes to mat the colours!

To conclude the problem of colour, it is well to specify certain purely rational investigations which add reassuring certitudes based upon our visual functions, our experience, and our habits. Our mind reacts to colours as it reacts to basic forms. There are brutal colours and suave colours, each appropriate to its object. Moreover, given the play of memory, acquired in looking at nature, logical and organic habits are created in us which confer on each object a qualifying, and hence constructive colour; thus blue cannot be used to create a volume that should 'come forward', because our eye, accustomed to seeing blue in depths (sky, sea), in backgrounds and in distant objects (horizons), does not permit with impunity the reversing of these conditions. Hence a plane that comes forwards can never be blue; it could be green (grass), brown (earth); in summary, colours should be disciplined while taking account of these two incontestable standards:

1. The primary sensory standard, immediate excitation of the senses (red and the bull, black and sadness).

2. The secondary standard of memory, recall of visual experience and of our harmonization of the world (soil is not blue, the sky is not brown, and if sometimes they may seem so, it would only be an accident to be disregarded by an art of invariables). [...]

C.E. Jeanneret (Le Corbusier) and Amédée Ozenfant, extracts from 'Le Purisme', *L'Esprit nouveau*, 4 (Paris, 1920); reprinted in Robert L. Herbert, trans. and ed., *Modern Artists on Art* (New Jersey: Prentice Hall, 1964) 70–2.

Kazimir Malevich
Non-Objective Art and Suprematism//1919

The plane which formed a square was the progenitor of Suprematism, the new colour realism, as non-objective art.

Suprematism arose in Moscow in 1913; the first works which appeared at an exhibition of painting in Petrograd aroused indignation among 'papers that were then in good standing' and critics as well as professionals – the leading painters.

In referring to non-objectivity, I merely wished to make it plain that Suprematism is not concerned with things, objects, etc., and more: non-objectivity in general has nothing to do with it. Suprematism is a definite system in accordance with which colour has developed throughout the long course of its culture. *colour not objectiveness – subject.*

Painting arose from the mixing of colours and – at moments when aesthetic warmth brought about a flowering – turned colour into a chaotic mix, so that it was objects as such which served as the pictorial framework for the great painters. I found that the closer one came to the culture of painting, the more the frameworks (i.e., objects) lost their systematic nature and broke up, thus establishing a different order governed by painting.

It became clear to me that new frameworks of pure colour must be created, based on what colour demanded and also that colour, in its turn, must pass out of the pictorial mix into an independent unity, a structure in which it would be at once individual in a collective environment and individually independent.

The system is constructed in time and space, independently of any aesthetic considerations of beauty, experience or mood, but rather as a philosophical colour system, the realization of new trends in my thinking – as a matter of knowledge.

At the present moment man's path lies across space. Suprematism is the semaphore of light in its infinite abyss.

The blue colour of the sky has been overcome by the Suprematist system; it has been broken through, and entered into white, the true actual representation of infinity, and thus been freed from the colour background of the sky.

A hard, cold system, unsmilingly set in motion by philosophical thought. Indeed, its real power may already be in motion within this system.

All the daubings produced by utilitarian intentions are insignificant and limited in scope. Their point is merely a matter of application and the past, and it arises from recognition and deduction by philosophical thought at the level at which we see cosy nooks that cater for commonplace taste, or create a new one.

In one of its phases, Suprematism has a purely philosophical impetus,

cognitive by means of colour: in another, it is a form capable of application by making available a new style of Suprematist decoration.

But it may manifest itself in objects as a transformation or embodiment of space within them, thereby removing their singularity from the mind.

It has become clear as a result of Suprematist philosophical colour thinking that the will is able to develop an artistic system when the object has been annulled in the artist's mind as a pictorial framework and a vehicle, and that, as long as objects remain a framework and a vehicle, his will must go on gyrating within a compositional circle and among objective forms.

Everything that we see arose from the colour mass transformed into plane and volume. Every machine, house, person and table, all are pictorial volume systems intended for particular purposes.

The artist too must transform the colour masses and create an artistic system, but he must not paint little pictures of fragrant roses, since all this would be dead representation pointing back to life.

And even if his construction is non-objective, but is based on the interrelation of colours, his will cannot but be confined between the walls of aesthetic planes, instead of achieving philosophical penetration.

I am only free when my will, basing itself critically and philosophically on that which exists, is able to formulate a basis for new phenomena.

I have ripped through the blue lampshade of the constraints of colour. I have come out into the white. Follow me, comrade aviators!

Swim into the abyss. I have set up the semaphores of Suprematism.

I have overcome the lining of the coloured sky, torn it down and, into the bag thus formed, put colour, tying it up with a knot. Swim! the white free abyss, infinity is before you.

Kazimir Malevich, 'Non–Objective Art and Suprematism', catalogue of the 10th State Exhibition, Moscow (1919); trans. Alexander Lieven, in Larissa Zhadova, *Malevich: Suprematism and Revolution in Russian Art 1910–1930* (London: Thames and Hudson, 1982) 282–3.

Naum Gabo and Anton Pevsner
The Realistic Manifesto//1920

[...] The realization of our perceptions of the world in the forms of space and time is the only aim of our pictorial and plastic art.

In them we do not measure our works with the yardstick of beauty, we do not weigh them with pounds of tenderness and sentiments.

The plumb-line in our hand, eyes as precise as a ruler, in a spirit as taut as a compass ... we construct our work as the universe constructs its own, as the engineer constructs his bridges, as the mathematician his formula of the orbits.

We know that everything has its own essential image; chair, table, lamp, telephone, book, house, man ... they are all entire worlds with their own rhythms, their own orbits.

That is why we, in creating things, take away from them the labels of their owners ... all accidental and local, leaving only the reality of the constant rhythm of the forces in them.

1. Thence in painting *we renounce* colour as a pictorial element; colour is the idealized optical surface of objects, an exterior and superficial impression of them; colour is accidental and it has nothing in common with the innermost essence of a thing.

We affirm that the tone of a substance, i.e., its light-absorbing material body, is its only pictorial reality. [...]

Naum Gabo and Anton Pevsner, extract from *The Realistic Manifesto* [published in Russian] (Moscow, 1920); trans. Christina Lodder in *Gabo on Gabo: Texts and interviews*, ed. Martin Hammer and Christina Lodder (Forest Row, East Sussex: Artists . Bookworks, 2000) 27.

Aleksandr Rodchenko
Line//1921

[...] Compared to form, colour in painting scarcely evolved. It advanced from grey to brown, from brown to pure, vivid colour and back again; and this interchange was a terribly uniform, monotonous rotation. Pure colour (the spectrum) did exist in paints, but painters killed it by mixing it to get different

tones. The tone appeared in painting exclusively because of objectivity, because of the aspiration to transmit nature. Until recent times it existed in painting as a special accomplishment of painterly culture and attained a kind of browny-orange mess, downright ugly.

The Impressionists turned to the spectrum, but again adapted it so as to transmit an impression, the air, light, etc. The Expressionists alighted on colour as a game of coloured spots, as ornamentation.

Non-objective painting cultivated colour as such: it occupied itself with its total exposure, with its processing and conditioning and gave it depth, intensity, density, weight, etc. The ultimate stage in this process was the attainment of monochrome intensity within the confines of a single colour and intensity (no decreasing or increasing). (Works shown at the 1918 exhibition Non-objective Creation and Suprematism, Moscow), can serve as examples of this – works by RODCHENKO (black on black) and MALEVICH (white on white) were exhibited simultaneously).

Lately I have been working exclusively on the construction of forms and the systems of their construction and I have started to introduce LINE into plane as a new element of construction (RODCHENKO's works of 1917–18).

At last the meaning of LINE has been elucidated in full: on the one hand its facetal and lateral relationship, and on the other as a factor of principal construction in any organism in life as a whole – so to say, the skeleton or the basis, the framework or system. Both in painting and in any construction in general, line is the first and last thing. Line is the path of advancement, it is movement, collision, it is facetation, conjunction, combination, section.

Thus, line has conquered everything and has destroyed the last citadels of painting – colour, tone, facture and plane. Line has bid a red farewell to painting (XIX State Exhibition, Moscow, 1920. Works by RODCHENKO – lines proclaimed in painting for the first time).

In putting line in the forefront – line as an element by whose exclusive means we can construct and create – we thereby reject all aesthetics of colour, facture and style: because everything that obstructs construction is style (e.g. , Malevich's square).

Line has revealed a new world-view – to construct essence, and not to depict, to objectivize or to non-objectivize; to build new, expedient, constructive structures in life, and not from life or outside life.

A construction is a system by which an object is realized from the expedient utilization of material together with predetermined purpose.

Aleksandr Rodchenko, extract from notes for a lecture given at Inkhuk (Institute of Artistic Culture (Moscow, 1921); translated in *Rodchenko* (Oxford: Museum of Modern Art, 1979) 128.

Paul Klee
On Modern Art//1924

The creation of a work of art – the growth of the crown of the tree – must of necessity, as a result of entering into the specific dimensions of pictorial art, be accompanied by distortion of the natural form. For therein is nature reborn.

What, then, are these specific dimensions?

First, there are the more or less limited, formal factors, such as line, tone value and colour.

Of these, line is the most limited, being solely a matter of simple Measure. Its properties are length (long or short), angles (obtuse or acute), length of radius and focal distance. All are quantities subject to measurement. Measure is the characteristic of this element. Where the possibility of measurement is in doubt, line cannot have been handled with absolute purity.

Of a quite different nature is tone value, or, as it is also called, chiaroscuro – the many degrees of shading between black and white. This second element can be characterized by Weight. One stage may be more or less rich in white energy, another more or less weighted towards the black. The various stages can be weighed against one another. Further, the blacks can be related to a white norm (on a white background) and the whites to a black norm (on a blackboard). Or both together can be referred to a medium grey norm.

Thirdly, colour, which clearly has quite different characteristics. For it can be neither weighed nor measured. Neither with scales nor with ruler can any difference be detected between two surfaces, one a pure yellow and the other a pure red, of similar area and similar brilliance. And yet, an essential difference remains, which we, in words, label yellow and red.

In the same way, salt and sugar can be compared, in their saltiness and sweetness.

Hence, colour may be defined as Quality. We now have three formal means at our disposal – Measure, Weight and Quality, which in spite of fundamental differences, have a definite interrelationship.

The form of this relationship will be shown by the following short analysis.

Colour is primarily Quality. Secondly, it is also Weight, for it has not only colour value but also brilliance. Thirdly, it is Measure, for besides Quality and Weight, it has its limits, its area and its extent, all of which may be measured.

Tone value is primarily Weight, but in its extent and its boundaries, it is also Measure.

Line, however, is solely Measure.

Thus, we have found three quantities which all intersect in the region of pure colour, two only in the region of pure contrast, and only one extends to the region of pure line.

These three quantities impart character, each according to its individual contribution – three interlocked compartments. The largest compartment contains three quantities, the medium two, and the smallest only one.

(Seen from this angle the saying of Liebermann may perhaps be best understood 'The art of drawing is the art of omission.')

This shows a remarkable intermixture of our quantities and it is only logical that the same high order should be shown in the clarity with which they are used. It is possible to produce quite enough combinations as it is. Vagueness in one's work is therefore only permissible when there is a real inner need. A need which could explain the use of coloured or very pale lines, or the application of further vagueness such the shades of grey ranging from yellow to blue.

The symbol of pure line is the linear scale with its wide variation of length. The symbol of pure contrast is the weight scale with its different degrees between white and black.

What symbol is now suitable for pure colour? In what unit can its properties best be expressed?

In the completed colour circle, which is the form best suited for expressing the data necessary to define the relationship between the colours.

Its clear centre, the divisibility of its circumference into six arcs, the picture of the three diameters drawn through these six intersections; in this way the outstanding points are shown in their place against the general backcloth of colour-relationships.

These relationships are firstly diametrical and, just as there are three diameters, so are there three diametrical relations worthy of mention, namely Red/Green, Yellow/Purple and Blue/Orange (i.e., the principal complementary colour-pairs).

Along the circumference the main or primary colours alternate with the most important mixed or secondary colours in such a manner that the mixed colours (three in number) lie between their primary components, i.e., green between yellow and blue, purple between red and blue, and orange between yellow and red.

The complementary colour pairs connected by the diameters mutually destroy each other since their mixture along the diameter results in grey. That this is true for all three is shown by the fact that all three diameters possess a common point of intersection and of bisection, the grey centre of the colour circle.

Further, a triangle can be drawn through the points of the three primary colours, yellow, red and blue. The corners of this triangle are the primary colours

themselves and the sides between each represent the mixture of the two primary colours lying at their extremes. Thus the green side lies opposite the red corner, the purple side opposite the yellow corner, and the orange side opposite the blue corner. There are now three primary and three main secondary colours or six main adjacent colours, or three colour pairs. [...]

And what tremendous possibilities for the variation of meaning are offered by the combination of colours.

Colour as tone value: e.g., red in red, i.e., the entire range from a deficiency to an excess of red, either widely extended, or limited in range. Then the same in yellow (something quite different). The same in blue – what contrasts!

Or colours diametrically opposed – i.e. changes from red to green, from yellow to purple, from blue to orange.

Tremendous fragments of meaning. [...]

What subtleties of shading compared with the former contrasts.

Or: colour changes in the direction of arcs of the circle, from yellow through orange to red or from red through violet to blue, or far flung over the whole circumference.

What tremendous variations from the smallest shading to the glowing symphony of colour. What perspectives in the dimension of meaning!

Or finally, journeys through the whole field of colour, including the grey centre, and even touching the scale from black to white. [...]

I have tried pure drawing, I have tried painting in pure tone values. In colour, I have tried all partial methods to which I have been led by my sense of direction in the colour circle. As a result, I have worked out methods of painting in coloured tone values, in complementary colours, in multicolours and methods of total colour painting. [...]

Paul Klee, extracts from lecture to the Jena Kunstverein, 1924, first published as *Paul Klee: Über die moderne Kunst* (Bern: Benteli verlag, 1945); trans. Paul Findlay, *Paul Klee: On Modern Art*, ed. Herbert Read (London: Faber & Faber, 1948); reprinted in *Modern Artists on Art*, ed. R.L. Herbert (New Jersey: Prentice Hall, 1964) 79–81; 85–6; 90.

Le Corbusier
A Coat of Whitewash: The Law of Ripolin//1925

If some Solon imposed these two laws on our enthusiasm:

THE LAW OF RIPOLIN[1]

A COAT OF WHITEWASH

we would perform a moral act: *to love purity*!

we would improve our condition: *to have the power of judgement*!

An act which leads to the joy of life: the pursuit of perfection.

Imagine the results of the Law of Ripolin. Every citizen is required to replace his hangings, his damasks, his wallpapers, his stencils, with a plain coat of white ripolin. *His home* is made clean. There are no more dirty, dark corners. Everything is shown as it is. Then comes *inner* cleanness, for the course adopted leads to refusal to allow anything at all which is not correct, authorized, intended, desired, thought-out: no action before thought. When you are surrounded with shadows and dark corners you are at home only as far as the hazy edges of the darkness your eyes cannot penetrate. You are not master in your own house. Once you have put Ripolin on your walls you will be *master of yourself*. And you will want to be precise, to be accurate, to think clearly. You will rearrange your house, which your work has disturbed. After your work you will set out what has been produced: you will clear away what cannot be used. You will draw up a new balance sheet, a new sum to be carried forward.

With Ripolin you will throw away what has served its purpose and is now scrap. An important act in life; productive morality. You will set on one side what is useful. When we eat, nature knows well how to rid us of what has served its purpose. Without the Law of Ripolin we accumulate, we make our houses into museums or temples filled with votive offerings, turning our mind into a concierge or *custodian*. Moreover we flatter the miser in us and we are gripped and bound by the instinct for material possessions, like Harpagon [the miser in Molière's *L'Avare*]. We are led to lying, since we try to camouflage both this ugly accumulation, and our cowardice in not facing a separation. *We set up the cult of the souvenir*. And we lie every day to ourselves. We lie to others. We are false to our destiny, for instead of leaving our mind free to explore the vast continent before us, we confine it in manacles, in the traps, dungeons and ditches of memory. On white Ripolin walls these accretions of dead things from the past would be intolerable: they would leave a mark. Whereas the marks do not show on the medley of our damasks and patterned wall-papers. [...]

Whitewash exists wherever peoples have preserved intact the balanced structure of a harmonious culture.

Once an extraneous element opposed to the harmony of the system has been introduced, whitewash disappears. Hence the collapse of regional arts – the death of folk culture. Peoples are then obliged to climb by conscious knowledge the long road leading to a new equilibrium.

In the course of my travels I found whitewash wherever the twentieth century had not yet arrived. But all these countries were in the course of acquiring, one after the other, the culture of cities, and the whitewash, which was still traditional, was sure to be driven out in a few years by wallpaper, gilt porcelain, tin 'brassware', cast-iron decoration – driven out by Pathé-Ciné and Pathé-Phono, brutally driven out by industry, which brought complete confusion to their calm souls. [...]

Whitewash has been associated with human habitation since the birth of mankind. Stones are burnt, crushed and thinned with water – and the walls take on the purest white, an extraordinarily beautiful white.

If the house is all white, the outline of things stands out from it without any possibility of mistake; their volume shows clearly; their colour is distinct. The white of whitewash is absolute, everything stands out from it and is recorded absolutely, black on white; it is honest and dependable.

Put on it anything dishonest or in bad taste – it hits you in the eye. It is rather like an X-ray of beauty. It is a court of assize in permanent session. It is the eye of truth.

Whitewash is extremely moral. Suppose there were a decree requiring that all the rooms in Paris be given a coat of whitewash. I maintain that this would be a police task of real stature and a manifestation of high morality, the sign of a great people.

Whitewash is the wealth of the poor and of the rich – of everybody, just as bread, milk and water are the wealth of the slave and of the king.

Law of Ripolin, Coat of Whitewash: elimination of the equivocal. Concentration of intention on its proper object. Attention concentrated on the object. An object is held to be made only out of necessity, for a specific purpose, and to be made with perfection. The perfect object is a living organism, animated by the sense of truth. We have in us an unfailing imperative which is the sense of truth and which recognizes in the smoothness of Ripolin and the white of whitewash an object of truth. The object of truth radiates power. Between one object of truth and another, astonishing relationships develop. We have the soul of a demiurge, which bases its acts on these objects of truth made by the human genius. The supreme joy, the true joy, is to create: to create objects or hypotheses, but always

to respond to this profound primordial function which animates even the lowest cell of organic life: to create.

The machine has inaugurated the age of the demi-gods. Everything has still to be made. Our confident hearts and thrilled eyes are bent unanimously on this future, which is advancing rapidly, bearing us with it. [...]

The Stadium, like the Bank, demands precision and clarity, speed and correctness. Stadium and bank both provide conditions appropriate for action, conditions of clarity like that in a head that has to think. There may be people who think against a background of black. But the tasks of our age – so strenuous, so full of danger, so violent, so victorious – seem to demand of us that we think against a background of white.

1 The French household paint brand Ripolin.

Le Corbusier, extract from *L'Art décoratif d'aujourd'hui* (1925) trans. James I. Dunnett, in *Essential Le Corbusier: L'Esprit Nouveau Articles* (Oxford: Architectural Press, 1998) 135; 188–92.

Theo van Doesburg
Space-Time and Colour//1928

The plastic expression of space is inconceivable without light. Light and space complete one another. In architecture light represents an element of plastic expression – in fact, the most important one. An organic relationship between *space* and *material* is possible only with the aid of light. The highest achievements in architecture can be accomplished only if light also is treated as plastic form. Plastic expression in architecture is inconceivable without colour. Colour and light complete one another. Without colour, architecture is expressionless, blind.

This truth has been expressed in every period in a different manner and according to different needs. If the Functionalists wish to suppress colour completely, then this merely proves that they never understood the importance of colour as an *architectural element*, as a means of plastic expression, no matter whether used with iron, glass or concrete. It does not make any fundamental difference whether one is concerned here with paint that has been applied to something or with the colour inherent in the materials used. Naturally, architecture does not become art merely through the use of colour, and it is

therefore understandable that revolutionary and Constructivist architects wish to restrict themselves to the use of strictly architectural means. Colour was misused in architecture because it was applied decoratively. However, colour is as indispensable to man as is light. The plane in modern architecture demands intensified realization, which is to say plastic expression in terms of spatial, pure colour. The correct use of modern materials remains subject to the same laws as those governing colour in space and time, even if applied paint is completely abandoned. Just as the various colours (for example, red, blue and yellow) each have an energy of their own, the modern materials (for example, concrete, iron, glass) each possess an energy of their own. Blue and yellow, for instance, produce two entirely opposed energies. I call this opposition a *tension*.

A similar tension is produced by the two materials iron and glass. The application of this tension in space and time is as aesthetically and architecturally relevant as the application of two colours on a plane or in space. In order to orient ourselves correctly to the use of colour in space (while not as yet touching upon the notion of 'time'), we must agree upon the various manners of relating painting to architecture.

We shall list the following:

1. the decorative, ornamental manner;
2. the Rationalist or Constructivist manner;
3. the creative manner or plastic expression.

In the *decorative use of colour* one is concerned with a tasteful effect of colour in space. Space is decorated with colour (the ornament) without achieving any organic relationship to the construction. Colour merely serves to hide construction. (The Dutch architect, Berlarge, in his theories, has even indicated where ornament must be applied in architecture.) Construction and painting are never truly related. They co-exist, rather than penetrate one another, and, therefore, they do not evoke a 'synoptical' result. The principle of decoration and ornamentation is based fundamentally upon repetition of the pattern, a repetition established by the element of 'time'. THE SOLUTION OF THE PROBLEM OF COLOUR IN ARCHITECTURE IS IDENTICAL TO THE SOLUTION OF THE PROBLEM OF TIME IN PAINTING!

Only today in the twentieth century, have we understood that the practice of repeating an ornament is the result of spiritual poverty. Oriental tapestries and wallpaper which is derived from them are subject to the same weakness of repetition. All painting in the past implied continuation into space and therefore, being subject to the continuation of time, possessed the character of repetition. This applies to painting and architecture, music and poetry. The problem remains; only the means and the styles of expression have changed. They have

become *realistic* instead of illusionistic. The repetition of a musical theme is as decorative as the regular repetition of certain architectural parts. Similarly, the element of symmetry retained today by some modern architects (Le Corbusier, Loos, Oud, and others) has its roots in decorative and ornamental habits.

About fifteen years ago, when there was a reaction against decorativism, a demand was made: 'Return to rational construction. Down with ornament.' Ornament was considered criminal and colour was banished completely from architecture. Only the creation of 'grey in grey' remained. When construction ended, the world of colour ceased to exist. Architecture was rendered naked, consisting of skeleton and skin.

Some time ago (about 1918), I described this architecture which dealt only with naked structure as 'anatomical' architecture. Indeed, in Germany, one spoke of a 'skeleton and skin' architecture and was not prepared to discuss aesthetic speculation or problems of plastic form. One healthy phenomenon in this movement was the suppression of predetermined form in architecture. The new definition of architecture could be summarized as organization of materials according to function. Form was considered secondary and independent of function. There was no room for colour. Painting was 'finished'. The Russians were the first to return to 'painting' and even to 'art for art's sake'.

Subsequently (or, rather, in practice), one admitted that this elementary, grey architecture was expressionless and blind. Through the fanatic glorification of 'pure utility' and the 'purely functional', one was restricted to practical or factual considerations and prone to neglect the 'optical, tactile and spiritual' factors. In modern man the desire for colour is as indispensable as that for light. Movement (the dance) and even mere noise have become essential elements in the life of modern man, in the modern 'nerve-system'. Any attempt at renovation that stresses only one factor and, consequently, leaves out all other factors, is weak and bound to perish.

Thus, Functionalism would have perished, too, if it had not acknowledged human spiritual needs. However, the functional romantic was willing to accept colour only as functional colour. A second manner of using colour thus came into existence, the rationalist or Constructivist method. I must stress here that this debasement of colour into functional colour occurred at a time when the very existence of the artist as such was in danger. A virtue was made of the necessity by declaring that the poster, the emblem and the advertisement were the consequence of a new 'abstract' art in painting. However, only results possess meaning within the field of creative activity.

The basis for painting does not lie in its purpose. Nor can the suppression of colour in architecture be considered the basis for modern architecture. On the contrary, since painting and architecture developed increasingly a common

denominator, a more coherent relationship between colour and space was manifested. It was at this moment that the problem of the creative use or the plastic expression of colour in space was born.

During my collaboration with the young architect C. van Eesteren (1923), I myself sought to employ colour as *an element which stressed* the architectural expression of space. In this attempt any artistic or compositional approaches were barred. The planes which determined space were painted in a certain colour according to their positions in space. Height, depth and width were emphasized by red, blue and yellow, whereas volume was conceived in grey, black and white. In this fashion the dimensions of space became quite expressive and architecture was reinforced instead of destroyed.

What is it, in the end, that we believe the plastic use of colour in space to represent? Since the founding of the so-called De Stijl movement, we have attempted to solve this problem in both practice and theory. The solution has presented itself as the logical result of the consequences of two-dimensional painting. After illusion had been eliminated from painting and the picture had ceased to limit itself to the representation of the individual expression of personal experiences, painting achieved a relationship to space and, more important still, to MAN. The relationship of colour to space, and of man to colour, sprang to life. Through this relationship of 'dynamic man' to space, a new notion was established in architecture, the notion of time.

The movements of man in space (left to right; in front of to behind; above to below) gained an importance fundamental for painting's role in architecture. Whereas man had remained fixed in a certain position in reference to static painting, and although decorative or 'monumental wall-painting' had already made him susceptible to a kinetic, 'linear' termination of the picturesque in space, the plastic expression of SPACE-TIME PAINTING would enable him to experience the full CONTENT of space in a pictorial (Optical-aesthetic) manner. This experience was just as novel as the first flight by aeroplane.

This manner of painting did not propose to direct men along the coloured planes of the walls with the purpose of allowing them to perceive the pictorial development of space from wall to wall, but rather to evoke a *synoptical effect* between painting and architecture. In order that this could be achieved, the coloured planes had to be related in both an architectural and a pictorial manner. The whole had to represent the plastic expression of a *tangible object.*

Construction and composition, space and time, and statics and dynamics were welded into a unified organism. Fundamentally architectural space must represent nothing but expressionless and inarticulate *emptiness* so long as colour has not transformed it into the true expression of plastic space.

The plastic expression of space-time painting in the twentieth century

the artist to realize his grand vision of placing man *within* painting of in front of it. *In the final analysis it is only the exterior surface which defines architecture*, since man does not live within a construction but within an *atmosphere* which has been established by the exterior surface.

Theo van Doesburg, 'Space–Time and Colour', first published in Dutch in *De Stijl*, Aubette Issue, series xv, 87–9 (1928); translated in Joost Baljeu, *van Doesburg* (New York: Macmillan, 1974) 175–80.

Theo van Doesburg
Towards White Painting//1929

'Brown', 'Blue' and 'White' correctly express the three phases of the development of humanity and of all of its activities: science, art, religion, technology and architecture.

WHITE This is the spiritual colour of our times, the clearness which directs all our actions. It is neither grey nor ivory white, but pure white.

WHITE This is the colour of modern times, the colour which dissipates a whole era; our era is one of perfection, purity and certitude.

WHITE It includes everything.

We have superseded both the 'brown' of decadence and classicism and the 'blue' of divisionism, the cult of the blue sky, the gods with green beards and the spectrum.

White pure white.

Looking around us, we see only manure, and it is in manure that filth and microbes live.

Let them amuse themselves, down there in the depths; we want more, we want to mount the heights of truth where the air is pure and can be withstood only by metallic lungs. [...]

Theo van Doesburg, 'Towards White Painting' (1929), first published in *Art Concret* (Paris, April 1930); translated in Joost Baljeu, *van Doesburg* (New York: Macmillan, 1974) 183.

Robert Delaunay
Note on Orphism//c. 1928–30

[...] *Colour* specifically and not considered as *colouring* is still to be acknowledged, to be discovered, but it is on the way. This new art of perception is opposed to all retrogression, to symbolism, to traditions. It is endowed with movement, with life, and not with the stasis of a *crystal*, or known archaisms. We see a wave of *simultaneous fashion* mounting that corresponds to a real wish. Fabrics, advertisements, furniture are undeniably moving towards living colour. We will be present at a totally visual transformation in the appearance of dress, architecture and cities in general, in fact, *every dimension of the visual order*, through a pure and new creation that will be truly expressive of our desire to live.

Robert Delaunay, extract from second of two notes on Orphism (c. 1928–30)); trans. David Shapiro and Arthur A. Cohen in *The New Art of Colour: The Writings of Robert and Sonia Delaunay*, ed. Arthur Cohen (New York: The Viking Press, 1978) 110.

Osip Brik
Photography versus Painting//1926

Photography pushes painting aside. Painting resists and is determined not to capitulate. This is how the battle must be interpreted which started a hundred years ago when the camera was invented and which will only end when photography has finally pushed painting out of the place it held in daily life. The photographers' motto was: precision, speed, cheapness. These were their advantages. Here they could compete with painters. Particularly in the case of portraits. Even the most gifted painter cannot achieve the degree of faithful reproduction of which the camera is capable. Even the quickest painter cannot supply a portrait within minutes. The cheapest painting is more expensive than the most expensive photograph. After portraits landscapes were tackled, reproductions, genre pictures. And all had the same advertisement: precision, speed, cheapness. The painters recognized the danger. The success of photography was enormous. Immediate steps had to be taken. A stronger counter-attack mounted.

I KNEW FROM EXPERIENCE THAT

COLOURS

SEEM TO ATTRACT THE

CONSCIOUS

Carl Jung, *Archetypes and the Collective Unconscious*, 1934

Cheapness and speed could hardly be fought. The camera works mo
and quickly. Precision can be disputed. So this was where the attack w

Photography is not coloured. Painting is. This means tha
reproduces an object more faithfully and is without rival in this respect.

This is how the painters argue. And the consumer had to be convinced of
this. But the painters were wrong and many are still wrong today.

It is true that in life we do see objects in colour. And a painting reproduces
these objects by means of colours. But these are different from nature, not
identical with her. Painting cannot transpose real colours, it can only copy –
more or less approximately – a tint we see in nature. And the problem is not how
talented a painter is, but is basic to the very nature of his or her work. The colour
media with which a painter works (oil, watercolour, size) have a different effect
on our eyes than the rays of light which give diverse colours to objects. However
much the painter tries he or she cannot go beyond the narrow limits of the
palette. He or she cannot give a picture those colours – either in quality or in
quantity – which objects possess in reality.

Photography does not yet reproduce exact colouring, but at least it does not
falsify an object by giving it the wrong colours. And this is an advantage not to
be underestimated.

The most sensitive and progressive painters have long since grasped that
precision of colour reproduction is not at all easy and that the principles of
painterly colouring are not identical with those of reality. So they declared:
'Precision is not the ultimate aim.'

Osip Brik, extract from 'Photography versus Painting', first published in Russian in *Sovetskoe Foto*, no.
2 (Moscow, 1926); trans. in *Rodchenko*, ed. David Elliott (Oxford: Museum of Modern Art, 1979) 90.

Carl Jung
Archetypes and the Collective Unconscious//1934

… I knew from experience that vivid colours seem to attract the unconscious …

Carl Jung, from 'Über die Archetypen des kollektiven Unbewußten,' *Eranos-Jahrbuch* (Zurich, 1934);
trans. R.F.C. Hull, *Archetypes and the Collective Unconscious* (New Jersey: Princeton University Press,
1969) 294.

Adrian Stokes
Colour and Form//1937

Let our first thought about colour be as follows: when we shut our eyes we see a film of colour that scientists call the visual grey. Now, they distinguish so-called film colour from what they call surface colour on which there is always a perceptible texture or microstructure. Film colours are indefinite in location, spongy in character; since the eye seems to go into them looking for the resistant surface more usually associated with colour. Hering described film colour as 'a smooth or space-filling *quale*'.[1] It is this kind of colour that has associative connections with the orchestra where at one moment there seems to be a transparent surface created by the strings, at the next a luminous hole through which the woodwind draws us, a hole blasted into a yawning void by the brass. Katz says of film colours: 'They are, in a sense, "homeless" colours, adapting themselves to any kind of situation which provides proper spatial support.'[2] The colours observed in a spectrum are of such character. My immediate point is this: the only other pure film colour seen in ordinary life besides the visual grey that we perceive when our eyes are closed, is the colour of the sky. In the light of these initial remarks, it appears appropriate that the only parallel under ordinary circumstances for what we see inside, as it were, ourselves, is what we see when we look into the furthest distance. We have here the perfect parable of all over-reaching rationalizations.

The visual world exists between the film colours of our closed eyes and those of an unclouded sky: as harmonious surfaces in this outer world the artist externalizes and orders the extortionate divisions of the ego. [...]

Colour is a glorified form of tone, but one so glorified, bringing with its two further dimensions, hue and intensity, such a host of relationships foreign to the purely linear progression of tone from lightness to darkness, that no misapprehension about the meaning of colours to the fantasy could be further from the mark than to conceive of colour as a bright yet convenient fancy-dress facilitating the perception of tonal difference. [...]

1 Ewald Hering (1834–1918).
2 David Katz, *The World of Colour* (1911).

Adrian Stokes, extract from *Colour and Form* (London: Faber & Faber, 1937) 22–3; 62.

Mark Rothko
Objective Impressionism//c. 1940–41

The Impressionism which is connected, in the vernacular, with art such as that of Monet, Sisley and Pissarro, is really the continuation of the integrity of the light factor in a picture, and from that point of view is no departure from the interests of painting since the end of the myth. These artists, like their predecessors, continued to use light as the chief sensual coordinator – the common denominator which bound all the elements of the picture – and maintained the use of the resultant mood as the emotional source of the picture. Their chief contribution was the discovery of the possibility of achieving these effects without reliance on tone, and they showed the possibilities of reducing the extended spectrum palette into the domain of impressionism.

Now the use of colour for its own sensual ends as well as for its structural end had greatly deteriorated since the time of Giotto. Perspective displaced the use of the organic quality of colours, which had previously, in and of themselves, produced the tactile effect of recession and advancement. Painters who wished to push distance farther and farther into the canvas, away from the frontal plane, and who were interested in the illustration of the illusion of space, had found perspective a more suitable demonstration of these desires. Also, the development of atmospheric perspective had emphasized the tonal values of colour as they appeared at various distances from the frontal plane, and abstracted colour from its sensual effects to the functional ends it served. A painter was not interested in giving the sensation of colourfulness but rather the sensation of the recession of colour, that is, in its various intervals of grey as it receded. Also, instead of affecting the emotions sensually by the interaction of colours the artist affected mood through the pervasion of the entire surface by a single colour mood in much the same way we described the use of colour mood in the modern theatre.

For these reasons, the colourfulness of painting since the Renaissance had been greatly reduced. Colours might have been used with a certain amount of brilliance to portray a specific local material, but they always had to participate in the general greyness of tonality. We know, in contrast, that as the last step in painting a canvas some of the old masters would sometimes cover the entire canvas with a glaze of a single colour in order to achieve the one colour tonality. To achieve a similar effect, the Venetians worked on coloured backgrounds wherein the basic colour was allowed to function everywhere through the other colours superimposed upon it. And we of course are all familiar with the general

brownness and greyness of the Dutch and English and French pictures. Even Delacroix, who had a passion for the sensual qualities of colour, never really understood the problem. He succeeded simply in producing more sensual and more dramatic tonality. That is, instead of browns he used red tonalities, which gave his pictures more dramatic moods than those of his immediate predecessors and contemporaries. The use of fatty oils and varnishes also gave the pictures a more unified tonality, for the reflection of the shiny surfaces made them all participate in the mysterious depths which these materials created.

Now French Impressionism did not alter the objectives of the painters in relation to this tonality, but set out rather to render this tonality, this ultimate greyness, by means of a greatly extended palette. In other words, while this technique made it possible for the artist actually to have a greater number of pure or brighter colours on his canvas, the quality of greyness as the ultimate effect could still be preserved. This approach was sparked by the discovery that the optical apparatus actually synthesized. That is, the fundamental or basic materials received by the eye were really different bits of colour, which the eye proceeded to combine into the various tonal relationships characteristic of the laws of colour perspective. [...]

Mark Rothko, extract from 'Objective Impressionism', in previously unpublished manuscript, *The Artist's Reality*, c. 1940–41, first published as Rothko, *The Artist's Reality: Philosophies of Art*, ed. Christopher Rothko (New Haven and London: Yale University Press, 2004) 38–41.

Fernand Léger
On Monumentality and Colour//1943

Coloured space.

The craving for colour is a natural necessity just as for water and fire. Colour is a raw material indispensable to life. At every era of his existence and of his history, the human being has associated colour with his joys, his actions and his pleasures.

The flowers come into the home: the most usual objects cover themselves with colour. Dresses, hats, make-up – all these things call for decorative attention the whole day long. It is colour which remains the chief interest. Its action is multiple. Inside and outside, colour imposes itself victoriously everywhere.

Modern publicity has taken possession of colour and roads are framed with violent-coloured posters, which are destroying the landscape. A decorative life is

born out of this main preoccupation, it has imposed itself upon the whole world.

So colour and its dynamic or static function, its decorative or destructive possibilities in architecture, is the reason for this study. Possibilities for a new orientation in mural painting exist; they should be utilized.

A bare wall is a 'dead, anonymous surface'. It will come alive only with the help of objects and colour. They can give life to the wall or destroy it. A stained, coloured wall becomes a living element.

The transformation of the wall by colour will be one of the most thrilling problems of modern architecture of this present or the coming time.

For the undertaking of this modern mural transformation, colour has been set free. How has colour been set free?

Until the pictorial realization by the painters of the last fifty years, colour or tone were fast bound to an object, to a representative form. A dress, a human being, a flower, a landscape, had the task of wearing colour.

In order that architecture should be able to make use of it without any reservations, the wall had first to be freed to become an experimental field. Then colour had to be got out, extricated, and isolated from the objects in which it had been kept prisoner.

It was about 1910, with Delaunay, that I personally began to liberate pure colour in space.

Delaunay developed an experience of his own, keeping the relations of pure complementary colours (it was really the continuation on a larger and more abstract scale of the New Impressionists). I was seeking out a path of my own in an absolutely opposite sense, trying to avoid so much as possible complementary relations and to develop the strength of pure local colours.

In 1912, I got some pure blue and pure red rectangles into the picture (*Femme en bleu*, 1912).

In 1919, with *La Ville*, pure colour, written in a geometrical drawing, found itself realized at its maximum. It could be static or dynamic; but the most important thing was to have isolated a colour so that it had a plastic activity of its own, a plastic activity without being bound to any object.

It was modern publicity which at first understood the importance of this new value: the pure tone ran away out from the paintings, took possession of the roads, and transformed the landscape!

Mysterious abstract signals made of yellow triangles, blue curves, red rectangles spread around the motorist to guide him on his way.

Colour was the new object, colour set free. Colour had become a new reality. The colour-object had been discovered.

It was about this time that architecture in turn understood how it would be possible to utilize this free colour (colour set free), its possibilities inside and

outside the building. Decorative papers began to disappear from the walls. The white naked wall appeared all of a sudden. One obstacle: its limitations.

Experience will be able to lead towards the coloured space. The space, that I shall call the 'habitable rectangle' is going to be transformed. The feeling of a jail, of a bounded, limited space, is going to change into a boundless 'coloured space'.

The 'habitable rectangle' becomes an 'elastic rectangle'. A light blue wall draws back. A black wall advances, a yellow wall disappears. Three selected colours laid out in dynamic contrasts can destroy the wall. [...]

Why not undertake the polychrome organization of a street and of a city?

During the First World War, I spent my furloughs in Montparnasse; there I had met Trotsky and we often spoke about the thrilling problem of a coloured city! He wanted me to go to Moscow because of the prospect of a blue street and a yellow street had raised some enthusiasm in him.

I think that it is in the urbanism of middle-class housing, the habitations where the workers are dwelling, that the need for polychromy is most evident. An artificially increased space needs to be given to the people in these areas.

No serious attempt has been made as yet in this direction. The poor man, or the poor family, cannot find a space of liberation through the help of a masterpiece upon his wall, but he can become interested in the realization of a coloured space. Because this coloured space is bound up with his inner needs for light and colour. These are vital needs: necessities.

Colour set free is indispensable to urban centres.

The urban centre.

Polychrome problem, interior and exterior: a shaded view of static façades leading, for instance, to an attractive central place. At this place I conceive a spectacular, mobile, bright monument with some possibilities of change (attractive, powerful means), giving it the same importance as the form of the church that Catholicism has so well succeeded in imposing upon every village.

Liberated colour will play its part in blending new modern materials and light will be employed to make an orchestration of everything.

The psychological influences, conscious or unconscious, of these factors, light and colour, are very important. The example of a modern factory in Rotterdam is conclusive. The old factory was dark and sad. The new one was bright and coloured: transparent. Then something happened. Without any remark to the personnel, the clothes of the workers became neat and tidy. More neat and tidy. They felt that an important event had just happened around them, within them. Colour and light had succeeded in creating this new evolution. Its action is not only external. It is possible, while leaving it to grow rationally, wholly to change a society.

The moral emancipation of a man becoming conscious of three dimensions, of exact volume of weight! This man is no more a shadow, working mechanically behind a machine. He is a new human being before a transformed daily job. This is tomorrow's problem.

Paris Exhibition, 1937. The organizers summoned a number of artists to try to find an attractive sensational effect; a spectacular effect, which in their minds would bribe the visitors to keep the fête in memory when they went back home. I proposed: Paris all white! I asked for 300,000 unemployed persons to clean and scrape all the façades.

To create a white, bright city! In the evening, the Eiffel Tower, as an orchestral conductor, with the most powerful projectors in the world, would diffuse along these streets, upon those white and receptive houses, bright many-coloured lights (some aeroplanes would have been able to cooperate in this new fairy scene). Loudspeakers would have diffused a melodious music in connection with this new coloured world ... My project was thrown back.

The cult of the old patinas, of the sentimental ruins: the taste for ramshackle houses, dark and dirty, but so picturesque, are they not? The secular dust which covers the historic, stirring remembrance, did not permit my project the opportunity of realization.

The polychrome clinic, the colour cure, was a new unknown domain beginning to thrill young doctors: some green and blue wards for nervous and sick people, some others painted yellow and red, stimulating and nutritious for depressed and anaemic people.

Colour in social life has indeed a great role to fill. Colour tries to cover over humdrum daily routines. It dresses them up. The humblest objects use it as a concealment of their real purpose. A bird on a handkerchief, a flower on a coffee cup. A decorative life.

Colour keeps within itself its eternal magic which, like music, allows truth to be wrapped around. The men who like truth, who like to think of living with it raw, without any retouching, are scarce. Creators in all domains know how difficult it is to use truth, how it becomes dangerous to be too 'true'. Expressive strength resides in a balanced verity. The work of art is a perfect balance between a real fact and an imaginary fact. [...]

Fernand Léger, 'On Monumentality and Colour' (1943); reprinted in Siegfried Giedion, *Architecture You and Me: The Diary of a Development* (Cambridge, Massachusetts: The Belknap Press of Harvard University Press, 1958) 40–1; 41–2; 43–5. © 1958 the President and Fellows of Harvard College.

Henri Matisse
The Role and Modalities of Colour//1945

To say that colour has once again become expressive is to write its history. For a long time colour was only the complement of drawing. Raphael, Mantegna or Dürer, like all Renaissance painters, constructed with drawing first and then added colour.

On the other hand, the Italian primitives and especially the Orientals, had made colour a means of expression. It was with some reason that Ingres was called an 'unknown Chinese in Paris', since he was the first to use bold colours, limiting them without distorting them.

From Delacroix to van Gogh and especially Gauguin, through the Impressionists, who cleared the way, and Cézanne, who gives a definitive impulse and introduces coloured volumes, one can follow this rehabilitation of the role of colour, and the restitution of its emotive power.

Colours have a beauty of their own which must be preserved, as one strives to preserve tonal quality in music. It is a question of organization and construction which is sensitive to maintaining this beautiful freshness of colour.

There was no lack of examples. We had not only painters, but also popular art and Japanese *crépons* which could be bought at the time. Thus, Fauvism for me was proof of the means of expression: to place side by side, assembled in an expressive and structural way, a blue, a red, a green. It was the result of a necessity within me, not a voluntary attitude arrived at by deduction or reasoning; it was something that only painting can do.

What counts most with colours are relationships. Thanks to them and them alone a drawing can be intensely coloured without there being any need for actual colour.

No doubt there are a thousand different ways of working with colour. But when one composes with it, like a musician with harmonies, it is simply a question of emphasizing the differences.

Certainly music and colour have nothing in common, but they follow parallel paths. Seven notes, with slight modifications are all that is needed to write any score. Why wouldn't it be the same for plastic art?

Colour is never a question of quantity, but of choice.

At the beginning, the Russian Ballet, particularly *Scheherazade* by Bakst, overflowed with colour. Profusion without moderation. One might have said that it was splashed about from a bucket. The result was gay because of the material itself, not as the result of any organization. However the ballets

facilitated the employment of new means of expression through which they themselves greatly benefited.

An avalanche of colour has no force. Colour attains its full expression only when it is organized, when it corresponds to the emotional intensity of the artist.

With a drawing, even if it is done with only one line, an infinite number of nuances can be given to each part that the line encloses. Proportion plays a fundamental role.

It is not possible to separate drawing and colour. Since colour is never applied haphazardly, from the moment there are limits, and especially proportions, there is a division. It is here that the creativity and personality of the artist intervene.

Drawing also counts a great deal. It is the expression of one who possesses objects. When you understand an object thoroughly, you are able to encompass it with a contour that defines it entirely. Ingres said that the drawing is like a basket: you cannot remove a cane without making a hole.

Everything, even colour, can only be a creation. I first of all describe my feelings before arriving at the object. It is necessary then to recreate everything, the object as well as the colour.

When the means employed by painters are taken up by fashion and by big department stores, they immediately lose their significance. They no longer command any power over the mind. Their influence only modifies the appearance of things; only the nuances are changed.

Colour helps to express light, not the physical phenomenon, but the only light that really exists, that in the artist's brain.

Each age brings with it its own light, its particular feeling for space, as a definite need. Our civilization, even for those who have never been up in an aeroplane, has led to a new understanding of the sky, of the expanse of space. Today there is a demand for the total possession of this space.

Awakened and supported by the divine, all elements will find themselves in nature. Isn't the Creator himself nature?

Called forth and nourished by matter, recreated by the mind, colour can translate the essence of each thing and at the same time respond to the intensity of emotional shock. But drawing and colour are only a suggestion. By illusion, they must provoke a feeling of the property of things in the spectator, in so far as the artist can intuit this feeling, suggest it in his work and get it across to the viewer. An old Chinese proverb says: 'When you draw a tree, you must feel yourself gradually growing with it.'

Colour, above all, and perhaps even more than drawing, is a means of liberation.

Liberation is the freeing of conventions, old methods being pushed aside by

the contributions of the new generation. As drawing and colour are means of expression, they are modified.

Hence the strangeness of new means of expression, because they refer to other matters than those which interested preceding generations.

Colour, then, is magnificence and eye-catching. Isn't it precisely the privilege of the artist to render precious, to ennoble the most humble subject?

Henri Matisse, 'The Role and Modalities of Colour' (1945) in *Matisse on Art*, ed. Jack D. Flam (London: Phaidon Press, 1975); reprinted edition (Berkeley and Los Angeles: University of California Press, 1994) 99–100.

Henri Matisse
Black is a Colour//1946

Before, when I didn't know what colour to put down, I put down black. Black is a force: I depend on black to simplify the construction. Now I've given up blacks.

The use of black as a colour in the same way as the other colours – yellow, red or blue – is not a new thing.

The Orientals made use of black as a colour, notably the Japanese in their prints. Closer to us, I recall a painting by Manet in which the velvet jacket of a young man with a straw hat is painted in a blunt and lucid black.

In the portrait of Zacharie Astruc by Manet, a new velvet jacket is also expressed by a blunt, luminous black. Doesn't my painting of the *Marocains* use a grand black which is as luminous as the other colours in the painting?

Like all evolution, that of black in painting has been made in jumps. But since the Impressionists it seems to have made continuous progress, taking a more and more important part in colour orchestration, comparable to that of the double-bass as a solo instrument.

Henri Matisse, 'Black is a Colour' (from transcript of a talk the artist gave at Galerie Maeght, Paris, December 1946), in *Matisse on Art*, ed. Jack D. Flam (London: Phaidon Press, 1975); reprinted edition (Berkeley and Los Angeles: University of California Press, 1994) 106–7.

Sergei Eisenstein
On Colour//1947

[...] It is worth noting that Disney's astounding sensitivity to melody in his graphic line is, I think, developed in him to such a supra-normal degree that it makes him sound-blind where colour is concerned: colour in his works is an amorphous, extraneous element that plays no part in his amazing synchronous dance of lines and shapes, melody and rhythm.

Thus the problem of true synchronicity of sound and image – in other words the most basic problem of sound-film montage – can only be resolved by colour.

Having now defined this fundamental principle of audiovisual montage, we must immediately and firmly refute an erroneous view that is current among Western theorists: namely the idea that correspondence between sound and colour is absolute; that a timbre or a musical note corresponds absolutely to a particular shade of colour.

Even if this were to be physically established and proved (which it doubtless could be), it would be meaningless where art is concerned. Even a direct conjunction of this sort does not and never can exist in the arts, still less a rigid, absolute and once-for-all rule. For convergence between sound and colour can only take place through the visual image, i.e., through something psychologically specific but essentially changeable, subject as it is to the mutations imposed by its content and by the overall conceptual system. What is unique in an image and what can blend essentially with it are absolute only in the conditions of a given context, of a given iconography, of a given construct.

How can anyone look for absolute correspondence with a colour, when you are not dealing with a total abstraction but with the actual, objective reality, to say nothing of the emotional and intellectual reality, of an image! One only has to descend for a moment from the abstract to objective phenomena and one will see that there, too, colour assumes an endless multitude of forms and is bound up with a most complex set of phenomena.

Red! The colour of the revolutionary flag. And the colour of the ears of a liar caught red-handed. The colour of a boiled crayfish – and the colour of a 'crimson' sunset. The colour of cranberry juice – and the colour of warm human blood.

And some eccentrics claim to find a musical note that is the sole, absolute equivalent to a single colour which possesses such a multitude of objective links and subjective associations!

A meadow is green. The sea is green. And it is not the colour but the content of the one or the other that determines the theme music, not some mystical

unity between the sound of the colour and the musical tone[1] of the colour green or a 'green' note!

Dealing as we are with an art form, we should not forget that not only the green of the sea or of a meadow, but the meadow itself and the ocean itself, as distinct from, say, a birch grove or a piece of snot (also green in colour),[2] are chosen by the author, by the author's emotions, with the sole aim of thereby creating that absolutely precise visual image which encapsulates his perception of and emotional response to his subject-matter (naturally within the bounds imposed on him by the necessary demands of objective depiction).

In one instance the gamut of colour needed to create an image may be shot through with the yellow of sheaves of rye, the glinting curve of a scythe blade and the dazzling orb of the sun. In another it may be the man yellow of a Chinaman's face; a row of old-gold bracelets; or the yellow marks on the back of a salamander. Can this multiplicity of shades of yellow really correspond to a single musical note or to a single chord? As much or as little, I would say, as does each of these two lists of examples, chosen entirely at random! [...]

This lack (or elusiveness?) of absolute correspondence of colour and sound in art is not a limitation. On the one hand, in a system that requires ever new images it is a perpetual stimulus to seek new forms of that fusion of sounds and colours; on the other hand, a fixed and once-for-all, absolute correspondence, i.e., a fixed and once-for-all scheme of mutually linked associations, would be profoundly inimical to the very nature of art. For one of the aims of art is to blaze new trails in our awareness of reality, to create new chains of association on the basis of utilizing those which already exist. (In phases of greater 'rigour' in my thinking about the mechanism of such phenomena, I formulated this as 'the aim of creating new conditioned reflexes on the basis of existing unconditioned reflexes'; that was in 1923–24.) It is only a dull, sterile, feeble, parasitic artform that lives by exploiting the existing stock of associations and reflexes, without using them to create chains of new images which form themselves into new concepts.

Nomina sunt odiosa, but the plays performed in our theatres have included not a few examples of precisely this sort, and only since the spring of 1937 have they been conducting a determined fight against this 'parasitic' tendency in their own ranks.

Thus, even allowing that beyond the confines of subjective synaesthesia there can be absolute correspondence between colour and musical sound; and assuming that it is present as a subconscious subtext behind all attempts to find correspondence between colour and sound; let us not forget that in its absolute form it can only be achieved, in lifeless abstraction, inside a physics laboratory, and not in the living organism of a work of art.

Let us also remember that this genuine, inner synchronicity is like the truth,

of which Lenin wrote: 'The truth is a process. From a subjective idea man proceeds towards objective truth *through* "practice" (and technique)'.

We should therefore remember that in the progression of ever more perfect fusions of colour and sound, in the ever more perfect images that reflect the reality of our time, we shall also draw nearer to an ever fuller representation of the absolute truth of our unique, socialist way of life.

On the question of colour, the aims of my article are very modest: I felt it important to establish the place of colour on an equal footing with the other elements of montage within filmmaking. We have identified it as the necessary and uniquely all-embracing precondition for achieving total and genuine synchronicity between the sonic and the visual image, between sound and depiction as separate functions. [...]

1 Here I am not using the word 'mystical' in the hackneyed and outworn sense found in the set of clichés in the vocabulary of polemical argument. I have in mind those schools of aesthetics that are connected with certain genuinely mystical views and doctrines (e.g., 'the note *la* is "green"; so too is the noise of a mob') Mysticism of this kind is, of course, nothing but the elevation into a system and a philosophy of the practices of the most primitive stage of human development, when a total factual and physical synaesthesia held sway. Even in these terms mystical teachings are profoundly regressive, and their doctrines cause our modern stage of development to revert to zero; they are profoundly reactionary in their very method.

2 I apologize to the oceans and to my readers for making such a juxtaposition in a single breath, but anyone who has read Chapter Two of Joyce's *Ulysses* will inevitably have found a similar image linked to the word 'ocean'.

Sergei Eisenstein, extract from essay on colour, trans. Jay Leyda, in Eisenstein, *The Film Sense* (New York: Harcourt Brace, 1942); trans. © 1969 Jay Leyda; reprinted in *Colour: The Film Reader*, ed. Angela Dalle Vacche and Brian Price (New York and London: Routledge, 2006) 106–7; 110–11.

Ludwig Wittgenstein
Philosophical Investigations//1945–49

55. 'What the names in language signify must be indestructible; for it must be possible to describe the state of affairs in which everything destructible is destroyed. And this description will contain words; and what corresponds to these cannot then be destroyed, for otherwise the words would have no

meaning.' I must not saw off the branch on which I am sitting.

One might, of course, object at once that this description would have to except itself from the destruction. – But what corresponds to the separate words of the description and so cannot be destroyed if it is true, is what gives the words their meaning – is that without which they would have no meaning. – In a sense, however, this man is surely what corresponds to his name. But he is destructible, and his name does not lose its meaning when the bearer is destroyed. – An example of something corresponding to the name, and without which it would have no meaning, is a paradigm that is used in connection with the name in the language-game.

56. But what if no such sample is part of the language, and we *bear in mind* the colour (for instance) that a word stands for? – 'And if we bear it in mind then it comes before our mind's eye when we utter the word. So, if it is always supposed to be possible for us to remember it, it must be in itself indestructible.' – But what do we regard as the criterion for remembering it right? – When we work with a sample instead of our memory there are circumstances in which we say that the sample has changed colour and we judge of this by memory. But can we not sometimes speak of a darkening (for example) of our memory-image? Aren't we as much at the mercy of memory as of a sample? (For someone might feel like saying: 'If we had no memory we should be at the mercy of a sample.') – Or perhaps of some chemical reaction. Imagine that you were supposed to paint a particular colour 'C', which was the colour that appeared when the chemical substances X and Y combined. – Suppose that the colour struck you as brighter on one day than on another; would you not sometimes say: 'I must be wrong, the colour is certainly the same as yesterday'? This shows that we do not always resort to what memory tells us as the verdict of the highest court of appeal.

57. 'Something red can be destroyed, but red cannot be destroyed, and that is why the meaning of the word 'red' is independent of the existence of a red thing.' – Certainly it makes no sense to say that the colour red is torn up or pounded to bits. But don't we say 'The red is vanishing'? And don't clutch at the idea of our always being able to bring red before our mind's eye even when there is nothing red any more. That is just as if you chose to say that there would still always be a chemical reaction producing a red flame. – For suppose you cannot remember the colour any more? – When we forget which colour this is the name of, it loses its meaning for us; that is, we are no longer able to play a particular language-game with it. And the situation then is comparable with that in which we have lost a paradigm which was an instrument of our language. [...]

272. The essential thing about private experience is really not that each person possesses his own exemplar, but that nobody knows whether other people also have *this* or something else. The assumption would thus be possible – though unverifiable – that one section of mankind had one sensation of red and another section another.

273. What am I to say about the word 'red'? – that it means something 'confronting us all' and that everyone should really have another word, besides this one, to mean his own sensation of red? Or is it like this: the word 'red' means something known to everyone; and in addition, for each person, it means something known only to him? (Or perhaps rather: it *refers* to something known only to him.)

274. Of course, saying that the word 'red' 'refers to' instead of 'means' something private does not help us in the least to grasp its function; but it is the more psychologically apt expression for a particular experience in doing philosophy. It is as if when I uttered the word I cast a sidelong glance at the private sensation, as it were in order to say to myself: I know all right what I mean by it.

275. Look at the blue of the sky and say to yourself 'How blue the sky is!' – When you do it spontaneously – without philosophical intentions – the idea never crosses your mind that this impression of colour belongs only to *you*. And you have no hesitation in exclaiming that to someone else. And if you point at anything as you say the words you point at the sky. I am saying: you have not the feeling of pointing-into-yourself, which often accompanies 'naming the sensation' when one is thinking about 'private language'. Nor do you think that really you ought not to point to the colour with your hand, but with your attention. (Consider what it means 'to point to something with the attention'.)

276. But don't we at least *mean* something quite definite when we look at a colour and name our colour-impression? It is as if we detached the colour-*impression* from the object, like a membrane. (This ought to arouse our suspicions.)

277. But how is it even possible for us to be tempted to think that we use a word to *mean* at one time the colour known to everyone – and at another the 'visual impression' which I am getting *now*? How can there be so much as a temptation here? – I don't turn the same kind of attention on the colour in the two cases. When I mean the colour impression that (as I should like to say) belongs to me alone I immerse myself in the colour – rather like when I 'cannot get my fill of a

colour'. Hence it is easier to produce this experience when one is looking at a bright colour, or at an impressive colour-scheme.

278. 'I know how the colour green looks to *me*' – surely that makes sense! – Certainly: what use of the proposition are you thinking of?

279. Imagine someone saying: 'But I know how tall I am!' and laying his hand on top of his head to prove it. [...]

Ludwig Wittgenstein, extracts from *Philosophical Investigations* (1945–49); trans. Gillian Anscombe (Oxford: Basil Blackwell, 1953); third edition (1978) 25; 27–8; 95–6.

Ludwig Wittgenstein
Remarks on Colour//1950

22. We do not want to establish a theory of colour (neither a physiological one nor a psychological one), but rather the logic of colour concepts. And this accomplishes what people have often unjustly expected of a theory. [...]

26. Something that may make us suspicious is that some people have thought they recognized three primary colours, some four. Some have thought green to be an intermediary colour between blue and yellow, which strikes me, for example, as wrong, even apart from any *experience*.

Blue and yellow, as well as red and green, seem to me to be opposites – but perhaps that is simply because I am used to seeing them at opposite points on the colour circle.

Indeed, what (so to speak psychological) *importance* does the question as to the number of Pure Colours have for me ?

27. I seem to see one thing that is of logical importance: if you call green an intermediary colour between blue and yellow, then you must also be able to say, for example, what a slightly bluish yellow is, or an only somewhat yellowish blue. And to me these expressions don't mean anything at all. But mightn't they mean something to someone else?

So if someone described the colour of a wall to me by saying: 'It was a somewhat reddish yellow', I could understand him in such a way that I could

choose approximately the right colour from among a number of samples. But if someone described the colour in *this* way: 'It was a somewhat bluish yellow', I could not show him such a sample. – Here we usually say that in the one case we can imagine the colour, and in the other we can't – but this way of speaking is misleading, for there is no need whatsoever to think of an image that appears before the inner eye. [...]

63. I see in a photograph (not a colour photograph) a man with dark hair and a boy with slicked-back blond hair standing in front of a kind of lathe, which is made in part of castings painted black, and in part of smooth axles, gears, etc., and next to it a grating made of light galvanized wire. I see the finished iron surfaces as iron-coloured, the boy's hair as blond, the grating as zinc-coloured, despite the fact that everything is depicted in lighter and darker tones of the photographic paper.

64. But do I really see the hair blond in the photograph? And what can be said in favour of this? What reaction of the viewer is supposed to show that he *sees* the hair blond, and doesn't just conclude from the shades of the photograph that he is blond? – If I were asked to describe the photograph I would do so in the most direct manner with these words. If this way of describing it won't do, then I would have to start looking for another. [...]

156. Runge: 'Black dirties'. That means it takes the *brightness* out of a colour, but what does that mean? Black takes away the luminosity of a colour. But is that something logical or something psychological? There is such a thing as a luminous red, a luminous blue, etc., but no luminous black. Black is the darkest of the colours. We say 'deep black' but not 'deep white'.

But a 'luminous red' does not mean a *light* red. A dark red can be luminous too. But a colour is luminous as a result of its context, in its context.

Grey, however, is not luminous.

But black seems to make a colour cloudy, but darkness doesn't. A ruby could thus keep getting darker without ever becoming cloudy; but if it became blackish red, it would become cloudy. Now black is a surface colour. Darkness is not called a colour. In paintings darkness can also be depicted as black.

The difference between black and, say, a dark violet is similar to the difference between the sound of a bass drum and the sound of a kettle-drum. We say of the former that it is a noise not a tone. It is matt and absolutely black. [...]

216. Why can't we imagine a grey-hot?

Why can't we think of it as a lesser degree of white-hot? [...]

271. Do I actually see the boy's hair blond in the photograph?! – Do I see it grey?

Do I only *infer* that whatever looks *this way* in the picture must in reality be blond?

In one sense I see it as blond, in another I see it lighter or darker grey. [...]

Ludwig Wittgenstein, extracts from *Remarks on Colour* (1950); trans. Linda L. McAlister and Margaret Schättle, ed. Gillian Anscombe (Oxford: Basil Blackwell, 1977) 7; 10–11; 19–20; 27; 29; 46; 36–7; 38; 52.

Bernard Berenson
Colour//1948

[...] I have now enumerated various elements, besides tactile values and movement, that go to make up the complete work of art, but I have as yet made no mention of what may seem of the first importance, the element of colour.

According to the method of thinking that has been roughly sketched here, where the work of art is envisaged as existing in a realm of ideated sensations and not of sensations like those experienced in the workaday world, colour is a difficult subject to treat. For colour belongs to the world of immediately present and not merely imagined sensations, and is only less material than tasting, smelling or touching, because it is perceived by one of the two signalling, reporting, informing senses, and not by the three more cannibal ones. Coloured artefacts have much in common with pastries or cocktails. Like these, they can be delicate or delicious and the product of high skill on the part of the cook or the barman. Only in textiles produced by un-Westernized nomads does colour play the sovereign role, design consisting merely in the contrasted surfaces of a geometrical pattern. The princes of Ormuz and of Ind who pass their fingers through sackfuls of precious stones, not only for the pride of power which great possessions give, but also for the touch, and perhaps chiefly for the gaiety and sparkle of colour, will scarcely be credited with enjoying them as works of art.

One may well ask how much art, as distinct from mere craft, there is in our best twelfth- and thirteenth-century stained-glass windows. Their pattern is not easy to decipher, so much is it melted into the colour; and when deciphered how inferior it is in appeal! I have seen windows, not mere fragments, but entire windows, from St. Denis removed from the interior they were intended to transfigure, and I confess that one's enjoyment of them thus isolated was not so

different from the Rajah's gloating over handfuls of emeralds, rubies and other precious stones. The Turks, guided by their creed, understood this and made no attempt at figures in the jewelled windows of their mosques, in the Suleimanieh at Constantinople for example.

In precious and hard stones, and their imitations in paste and glass, as well as in ceramics and textiles, the sensuous enjoyment of colour so outweighs any ideation evoked by design, that they can be classed as works of art in a limited sense only. As already hinted when speaking of materials, they play a subordinate part in epochs of great creation, and take a commanding position in times of decadence. Probably Greek colonnades were painted with ultramarine and vermilion. Many if perhaps not all marble sculptures of the Greek centuries before Christ were tinted. Plato speaks as if in his day all statuary was coated with pigments (*Republic*, 420 c.). It was only under the Romans that Greek architecture and sculpture took to using first multicoloured marbles, then hard and semi-precious stones, basalts, granites, porphyry, and finally glass mosaic. This last, by the way, may have been suggested by the coating of gold applied to the inside walls of temples, as was done by Antiochus IV at Antioch. It would seem as if form and colour could not exist together, and that as the first declined the other waxed and flourished. It appears, moreover, as if form was the expression of a society where vitality and energy were severely controlled by mind, and as if colour was indulged in by communities where brain was subordinated to muscle. If these suppositions are true, we may cherish the hope that a marvellous outburst of colour is ahead of us.

In all the varieties of visual representation and reproduction of objects that are assumed to be outside ourselves, and of images flitting through our minds, colour must necessarily be the servant, first of shape and pattern, and then of tactile values and movement. Colour cannot range free but must serve rapid recognition and identification, facilitate the interpretation of shapes and the articulation of masses, and accelerate the perception of form, or tactile values, and movement. In the figure arts you cannot sacrifice any of these in order to attain the unadulterated enjoyment of colour that is offered by textiles, jewels, precious stones and glass, as well as by certain metals and enamels.

Colour then must be subordinated, in painting at least, where our sense of veracity and of what is 'true to nature' is most easily offended; and colour can play the part only of tinted light and shade, of a polychrome chiaroscuro. 'The most beautiful colours laid on confusedly', says Aristotle, 'will not give as much pleasure as the chalk outline of a portrait' (*Poetics*, VI, 15). Pink and green horses may be tolerated in an *incunabulous* experimenter like Paolo Uccello, but I remember wincing at the sight of Impressionist portraits with faces and bosoms and hands blotched with vivid vegetable green reflected from the surrounding

orange and scarlet from the sunshades held by the subjects. If the clearly ..pressed intention of Uccello, or Besnard, or Rolle or Zorn had been to study the effect of reflections on horses' hides or women's skins, we should have adjusted ourselves accordingly. That was not the case. The portraits referred to will scarcely find now the admirers they had when their mere newness excited and, for an instant, fascinated the spectator.

So as they grew to be the complete masters of their art, the aged Titian, the aged Hals, the aged Rembrandt, and Tintoretto and Veronese in their maturity, tended to paint in a sort of monochrome, of a low tone in the case of the first three, and of a high one in that of the others; but in all of them far removed from the childish display of gold, scarlet, ultramarine and other dazzling pigments: and this accounts for the response the Trecento or the Catalan and German Quattrocento find in all of us, who have not outgrown the hankering for fairyland, or the longing for a new Jerusalem visualized as a Christmas card.

The problem of colour in the figure arts as well as in the other arts of visual representation is complicated. Far be it from me to fancy that the preceding paragraphs offer as much as a synopsis of the questions to be discussed. All I wish here to suggest is that colour is subordinated to form and movement; as for instance hair on the head, so ornamental and transfiguring, is subordinated to the skull and face. The justice of the comparison is strengthened by the fact that, like human hair, colour may continue for a while a sepulchral animation of its own, after spiritual and physical life has deserted the body. Colour may survive most other features of a decaying art. […]

Bernard Berenson, extract from section on colour in the essay 'Value', in *Aesthetics and History in the Visual Arts* (New York: Pantheon Books, 1948) 74–7.

Carlos Cruz-Diez
Reflections on Colour//1981

Why a Reflection on Colour?
For a long time, the general public and even artistic circles have institutionalized a single interpretation of colour, that ends with Impressionism, Matisse, Delaunay and Albers. Many say that:
Colour only serves to paint forms …
Colour only serves to make beautiful or ugly combinations …

Colour is trivial …

Colour is a chapter that is over …

These opinions increased my enthusiasm, for living in a 'hyper-baroque polychrome' society, it seemed strange that no one troubled to question established notions about colour. Thus, my work is an attempt to reveal the nature of colour and its effect on man, without the barriers of cultural convention, because I realized that our relationship with the world of colour is deeply affective.

Our chromatic decisions are not fully rational.

Why can't I stand that red and that yellow together?... I like that blue … I don't like that one …

There is no logical argument for my decision, unless it is a technical matter of respecting certain reading and signalling codes. Some think I have what is called 'good taste' in combining colours, whereas others think the opposite.

What does it mean to have good taste? Within a certain cultural context this is totally subjective, and in the case of colour, specifically affective.

In principle, all colours and their possible combinations already exist in nature and they act on our affectiveness, whether we accept them or reject them. Their apprehension is a phenomenological fact that, like all elementary perceptions, undergoes the cultural process of myths, prejudices, conveniences, references, etc.

Our contact with colour produces feelings of rejection or affection, just like the perception of sound, touch, smell and taste. Furthermore, we don't have a visual memory for colour. The only thing we memorize is 'generic blue', 'generic red', but never a particular shade, because the chromatic experience is the product of 'random events' like light, intensity, opaqueness, distance, matter, etc. It is like the person who returns home and realizes that the shade of colour he chose is not the same he thought he had seen at the store.

Cultural conditioning based on the 'worship' of form and of image prevents us from apprehending the subtle events that occur in space and time. The volume of visual and auditory information in modern society has made us visually deaf and auditorily blind.

A Concept That Hasn't Changed for Centuries

Throughout the centuries, colour has been understood and used in the same way: first *form*; then *colour*. The 'something' that fills the form.

For many, colour has been and remains *anecdotal to form*.

In general terms, this concept hasn't changed and it has created the binary:

form – colour

e.g., *the red apple … the white table …*

However, from Aristotle's definitions, passing through the theories of Goethe, Newton, Young and Chevreul's treaty, to Albers' research, *the unstable nature of colour* has been proven. And yet, with some exceptions, it has been used in art as an instrument of permanence and stability.

Perhaps this is because traditionally colour has been thought of as an 'accident' (due to its changing nature), when what the individual usually wants is stability.

This is why there have been attempts to subordinate colour to the stability of the individual, represented in painting by drawing (form). Many examples attest to this traditional view of colour; Ingres' work and the writings of Kant and Descartes are obvious examples.

My Reflection

I propose ...

Autonomous Colour

With no anecdotes or symbology, like an evolutionary event that affects us. Due to my chromatic experience, I try to present colour as *an ephemeral and autonomous situation.*

Colour in constant mutation creating *autonomous realities.*

Autonomous – because they don't depend on the anecdotes the spectator is used to finding in painting.

Realities – because these events happen in time and space.

Thus a different dialectic is created between the spectator and the work, as well as a different relationship of knowledge. [...]

Carlos Cruz-Diez, extracts from text written in 1981 derived from ideas first formulated in the 1950s, collected in Cruz-Diez, *Reflexion sobre el color/Reflections on Colour* (Caracas: Fabriart, 1989).

Victor Vasarely
Notes for a Manifesto//1955

Here are the determining facts of the past which tie us together and which, among others, interest us: 'plastic' triumphs over anecdote (Manet) – the first geometrization of the exterior world (Cézanne) – the conquest of pure colour (Matisse) – the explosion of representation (Picasso) – exterior vision changes into interior vision (Kandinsky) – a branch of painting dissolves into

architecture, becoming polychromatic (Mondrian) – departure from the large plastic synthetics (Le Corbusier) – new plastic alphabets (Arp, Taüber, Magnelli, Herbin) – abandoning volume for *SPACE* (Calder) ... The desire for a new conception was affirmed in the recent past by the invention of *PURE COMPOSITION* and by the choice of *UNITY*, which we will discuss later. Parallel to the decline of painting's ancestral technique, followed experimentation with *new materials* (chemical applications) and adoption of new took (discovery of physics) ... *Presently, we are headed towards the complete abandonment of routine, towards the integration of sculpture and the conquest of the plane's SUPERIOR DIMENSIONS.*

From the beginning, abstraction examined and enlarged its compositional elements. Soon, *form-colour* invaded the entire two-dimensional surface, this metamorphosis led the painting-object, by way of architecture, to a spatial universe of polychromy. • However, an extra-architectural solution was already proposed and we broke deliberately broke with the neo-plastic law. • *PURE COMPOSITION* is still a plastic plane where rigorous abstract elements, hardly numerous and expressed in few colours (matt or glossy) possess, on the whole surface the same complete plastic quality: *POSITIVE-NEGATIVE.* But, by the effect of opposed perspectives, these elements give birth to and make vanish in turn a 'spatial feeling' and thus, the illusion of *motion and duration.* • *FORM AND COLOUR ARE ONE.* Form can only exist when indicated by a coloured quality. Colour is only quality when unlimited in form. The line (drawing, contour) is a fiction which belongs not to one, but to two form-colours at the same time. It does not engender form-colours, it results from their meeting. • *Two necessarily contrasted form-colours constitute PLASTIC UNITY, thus the UNITY of the creation: eternal duality of all things, recognized finally as inseparable.* It is the coupling of affirmation and negation. Measurable and immeasurable, unity is both physical and metaphysical. It is the conception of the material, the mathematical structure of the Universe, as its spiritual superstructure. *Unity* is the absence of *BEAUTY*, the first form of sensitivity. Conceived with art, it constitutes *the work,* poetic equivalent of the World that it signifies. The simplest example of plastic unity is the square (or rectangle) with its complement *'contrast' or the two-dimensional plane with its complement 'surrounding space'.*

After these succinct explanations, we propose the following definition: *upon the straight line – horizontal and vertical – depends all creative speculation.* Two parallels forming the frame define the plane, or cut out part of the space. *FRAMING IS CREATING FROM NEW AND RECREATING ALL ART FROM THE PAST.* • In the considerably expanded technique of the plastic artist, the plane remains the place of first conception. The *small format* in pure composition constitutes

the departure from a recreation of multiple two-dimensional functions (large format, fresco, tapestry, engraving). But we are already discovering new orientation. • The *SLIDE* will be to painting what the record is to music: manageable, faithful, complex, in other words a document, a work tool, a work. It will constitute a new transitional function between the fixed image and the future moving image. • *THE SCREEN IS PLANE BUT, ALLOWING MOTION, IT IS ALSO SPACE. It does not have two, but four dimensions.* Thanks to unity, the illusive 'motion-duration' of pure composition, in the new dimension offered by the screen, becomes real motion. The *Lozenge*, another expression of 'square-plane unity', equals square + space + motion = duration. The *Ellipsis*, another expression of 'circle-plane unity', equals circle + space + motion + duration. • Other innumerable multiform and multicoloured unities result in the infinite range of formal expression. 'Depth' gives us the relative scale. The 'distant' condenses, the 'near' dilates, reacting thus on the *COLOUR-LIGHT* quality. *We possess therefore, both the tool and the technique, and finally the science for attempting the plastic-cinétique adventure.* Geometry (square, circle, triangle, etc.), chemistry (cadmium, chrome, cobalt, etc.) and physics (coordinates, spectrum, colourimeter, etc.) represent some *constants*. We consider them as quantities; our measure, our sensitivity, our art, will make qualities from them. (It is not a question here of 'Euclidian' or 'Einsteinian', but the artist's own geometry which functions marvellously without precise calculations.) • The animation of the Plastic develops nowadays in three distinct manners: 1) Motion in an architectural synthesis, where a spatial and monumental plastic work is conceived such that metamorphoses operate there through the displacement of the spectator's point of view. – 2) Automatic plastic objects which – while possessing an intrinsic quality – serve primarily as a means of animation at the moment of filming. – Finally, 3) *The methodological investment of the CINEMATOGRAPHIC DOMAIN by abstract discipline. We are at the dawn of a great age. THE ERA OF PLASTIC PROJECTIONS ON FLAT AND DEEP SCREENS, IN DAYLIGHT OR DARKNESS, BEGINS.* [...]

Victor Vasarely, extract from 'Notes for a Manifesto', *Mouvement II* (Paris: Galerie Denise René, 1955); reprinted in *Theories and Documents of Contemporary Art*, ed. Kristine Stiles and Peter Selz (Berkeley: University of California Press, 1996) 109–11.

Aldous Huxley
The Doors of Perception//1954

[...] Half an hour after swallowing the drug I became aware of a slow dance of golden lights. A little later there were sumptuous red surfaces swelling and expanding from bright nodes of energy that vibrated with a continuously changing, patterned life. [...]

I took my pill at eleven. An hour and a half later I was sitting in my study, looking intensely at a small glass vase. The vase contained only three flowers – a full-blown Belle of Portugal rose, shell pink with a hint at every petal's base of a hotter, flamier hue; a large magenta and cream-coloured carnation; and, pale purple at the end of its broken stalk, the bold heraldic blossom of an iris. Fortuitous and provisional, the little nosegay broke all the rules of traditional good taste. At breakfast that morning I had been struck by the lively dissonance of its colours. But that was no longer the point. I was not looking now at an unusual flower arrangement. I was seeing what Adam had seen on the morning of his creation – the miracle, moment by moment, of naked existence. [...]

At the same time, and no less obviously, it was these flowers, it was anything that I – or rather the blessed Not-I released for a moment from my throttling embrace – cared to look at. The books, for example, with which my study walls were lined. Like the flowers, they glowed, when I looked at them, with brighter colours, a brighter significance. Red books, like rubies; emerald books; books bound in white jade; books of agate, of aquamarine, of yellow topaz; lapis lazuli books whose colour was so intense, so intrinsically meaningful, that they seemed to be on the point of leaving the shelves to thrust themselves more insistently on my attention. [...]

Reflecting on my experience, I find myself agreeing with the eminent Cambridge philosopher, Dr C.D. Broad, 'that we should do well to consider much more seriously than we have hitherto been inclined to do the type of theory which Bergson put forward in connection with memory and sense perception. The suggestion is that the function of the brain and nervous system and sense organs is in the main part *eliminative* and not productive. Each person is at each moment capable of remembering all that has ever happened to him and of perceiving everything that is happening everywhere in the universe. The function of the brain and nervous system is to protect us from being overwhelmed and confused by this mass of largely useless and irrelevant knowledge, by shutting out most of what we should otherwise perceive or remember at any moment, and leaving only that very small and special selection

which is likely to be practically useful.' According to such a theory, each one of us is potentially Mind at Large. But in so far as we are animals, our business is at all costs to survive. To make biological survival possible, Mind at Large has to be funnelled through the reducing valve of the brain and nervous system. What comes out at the other end is a measly trickle of the kind of consciousness which will help us to stay alive [...]

These effects of Mescalin are the sort of effects you could expect to follow the administration of a drug having the power to impair the efficiency of the cerebral reducing valve. When the brain runs out of sugar, the undernourished ego grows weak, can't be bothered to undertake the necessary chores, and loses all interest in those spatial and temporal relationships which mean so much to an organism bent on getting on in the world. As Mind at Large seeps past the no longer watertight valve, all kinds of biologically useless things start to happen. In some cases there may be extra-sensory perceptions. Other persons discover a world of visionary beauty. To others again is revealed the glory, the infinite value and meaningfulness of naked existence, of the given, unconceptualized event. In the final stage of egolessness there is an 'obscure knowledge' that All is all – that All is actually each. This is as near, I take it, as a finite mind can ever come to 'perceiving everything that is happening everywhere in the universe'.

In this context, how significant is the enormous heightening, under mescalin, of the perception of colour! For certain animals it is biologically very important to be able to distinguish certain hues. But beyond the limits of their utilitarian spectrum, most creatures are completely colour blind. Bees, for example, spend most of their time 'deflowering the fresh virgins of the spring'; but, as von Frisch has shown, they can recognize only a very few colours. Man's highly developed colour sense is a biological luxury – inestimably precious to him as an intellectual and spiritual being, but unnecessarily to his survival as an animal. [...]

Mescalin raises all colours to a higher power and makes the percipient aware of innumerable fine shades of difference, to which, at ordinary times, he is completely blind. It would seem that, for Mind at Large, the so-called secondary characters of things are primary. Unlike [the mind described by the philosopher] Locke, it evidently feels that colours are more important, better worth attending to, than masses, positions and dimensions. [...]

Aldous Huxley, extracts from *The Doors of Perception* (London: Chatto & Windus, 1954); reprinted edition, *The Doors of Perception* and *Heaven and Hell* (London: Harper Collins, 1994) 6; 7; 9; 14–15.

And

white

appears. Absolute

white.

White

beyond all

whiteness.

White

of the coming of the

White.

White

without compromise, through exclusion, through total eradication of

non-white.

Insane, enraged

white,

screaming with

whiteness.

Fanatical, furious, riddling the retina. Horrible electric

white,

implacable, murderous.

White

in bursts of

white.

Henri Michaux, 'With Mescaline', 1956

[…] Himalayas spring up abruptly, higher than the highest mountain, tapering to a point, in fact not real peaks, just outlines of mountains, but no less high for all that, gigantic triangles with increasingly acute angles to the farthest edge of space, absurd but enormous. […]

The himalaying machine has stopped, then starts up again. Huge plowshares furrow away. Inordinately huge plowshares are making furrows with no reason to make furrows. Plowshares, and once again the giant scythes slashing nothingness from top to bottom, with big slashes repeated fifty, a hundred, a hundred and fifty times …

And 'White' appears. Absolute white. White beyond all whiteness. White of the coming of the White. White without compromise, through exclusion, through total eradication of nonwhite. Insane, enraged white, screaming with whiteness. Fanatical, furious, riddling the retina. Horrible electric white, implacable, murderous. White in bursts of white. God of 'white'. No, not a god, a howler monkey. (Let's hope my cells don't blow apart.)

End of white. I have a feeling that for a long time to come white is going to have something excessive for me. […]

Henri Michaux, extract from 'Avec mescaline', *Misérable Miracle* (Monaco: Éditions du Rocher, 1956); trans. David Ball, in *Darkness Moves: An Henri Michaux Anthology: 1927–1984*, ed. and trans. David Ball (Berkeley and Los Angeles: University of California Press, 1994) 198.

Yves Klein
War between Line and Colour, or Towards the Monochrome Proposition//1954

[…] Taking advantage of a need tested by the first man to project his mark outside of himself, line succeeded in introducing itself into the heretofore inviolate realm of colour.

Cain and Abel murder: dream reality.

Rapidly mastered, pure colour – the universal coloured soul in which the

human soul bathed when in the state of 'Earthly Paradise' – is imprisoned, compartmentalized, sheared and reduced to a slave. [...]

In the joy and delirium of its victory by trickery, line subjugates man and imprints him with its abstract rhythm that is at once intellectual, material and spiritual. Realism will soon appear.

After the first moment of stupefaction has passed, prehistoric man realizes that he has just lost his vision. He recovers his balance and discovers figurative form. At first it is his own figurative form and then that of all that surrounds him – especially the animals and plant life.

Realism and abstraction combine in a horrible Machiavellian mixture that becomes human, earthly life. It is really living death, 'the horrible cage' that van Gogh spoke about several thousand years later. Colour is enslaved by line that becomes writing.

From a false reality, physical, figurative reality. Line organizes itself in the conquered terrain. Its aim: to open the eyes of man to the exterior world of matter that surrounds him and to put him on the path towards realism. Far off within man, his lost inner vision withdraws, unable to leave him entirely. In its place is a void that is atrocious for some and confusing or marvellously romantic for others. It takes this position to become the inner life, the soul torn apart by the presence of line.

Nevertheless, throughout the centuries, colour – tainted, humiliated and conquered – prepares a revenge, an uprising that will be stronger than anything.

Thus the history of the very long war between line and colour begins with the history of the human world. Heroic colour makes signs to man every time he feels the need to paint. It calls to him from deep within and from beyond his own soul … It winks to him but is enclosed by drawing inside of forms. Millions of years will pass before man understands these signs and puts himself suddenly and feverishly to work in order to free both colour and himself.

Paradise is lost. The entanglement of lines becomes like the bars of a veritable prison 'that is, moreover, increasingly one's psychological life'. Man can hardly feel any longer. He is exiled far from his coloured soul. He is in the drama of inevitable death, where the stormy coexistence of line and colour in war will lead him. It is the birth of art, this fight for eternal and above all 'immortal' creation.

In order to attain transmutation in the object, the form, the sound, or in the shaping of the image, this universal coloured soul, which is life itself, is conquered, invaded, teased by line – that power of evil and darkness because it kills.

From the stylization of figurative forms and the enchantment that man feels in separating drawing from colour (which always gives him a vague impression of remorse), writing is born. [...]

Line has disappeared, or rather is transformed into shapes that are almost

stripped of their contours. They fill the whole surface in a nearly uniform manner ... No more psychological, linear bars. Before the coloured surface one finds oneself directly in front of the raw material of the soul.

Drawing is writing within a painting. One draws a tree but it would be the same to paint a colour and write 'tree' alongside.

Fundamentally, the true painter of the future will be a mute poet who will not write anything but who will narrate an immense, limitless painting, without articulating, in silence.

Yves Klein, extracts from draft for film titled *La Guerre, de la ligne et de la couleur, ou vers la proposition monochrome* (Paris, 1954); trans. in Sidra Stich, *Yves Klein* (Cologne: Museum Ludwig, 1995) n.p. Yves Klein © ADAGP, Paris 2007.

Yves Klein
The Evolution of Art towards the Immaterial//1959

How did I happen to enter this blue period? Towards the end of 1955, I exhibited at the Colette Allendy Gallery a score of monochromatic surfaces, all of different colours: green, red, yellow, violet, blue, orange. That was the beginning, or at least the first public showing, of this style. I was attempting to show colour, and I realized at the opening of the exhibition that the public, enslaved by visual habit, when presented with all those surfaces of different colours on the walls, reassembled them as components of polychromatic decoration. The public could not enter into the contemplation of the colour of a single painting at a time, and that was very disappointing to me, because I precisely and categorically refuse to create on one surface even the interplay of two colours.

In my judgment two colours juxtaposed on one canvas compel the observer to see the spectacle of this juxtaposition of two colours, or of their perfect accord, but prevent him from entering into the sensitivity, the dominance, the purpose of the picture. This is a situation of the psyche, of the senses, of the emotions, which perpetuates a sort of reign of cruelty (laughter), and one can no longer plunge into the sensibility of pure colour, relieved from all outside contamination.

Some will no doubt protest that my development has taken place very rapidly, in barely four years, and that nothing can occur in such a short time ... I reply that, although indeed I did begin to exhibit my painting only in 1954 in Paris, I had already been working for a long time in that style, since 1946. This

prolonged wait demonstrates precisely what I had been prepared to wait for. I had waited for something to become stable within me before I could reveal or verify what it was. The few friends of that time who encouraged me are aware of it; I had begun monochromatic painting, in addition to the everyday activities of painting which were influenced by my parents, both of them artists, because it seemed that while working colour kept winking at me. It enchanted me, besides, because in front of any painting, figurative or non-figurative, I felt more and more that the lines and all their consequences, the contours, the forms, the perspectives, the compositions, became exactly like the bars on the window of a prison. Far away, amidst colour, dwelt life and liberty. And in front of the picture I felt imprisoned, and I believe it is because of that same feeling of imprisonment that van Gogh exclaimed, 'I long to be freed from I know not what horrible cage!'

The painter of the future will be a colourist of a kind never seen before, and that will occur in the next generation. And without doubt it is through colour that I have little by little become acquainted with the Immaterial. The outward influences which have impelled me to pursue this monochromatic path as far as the immateriality of today, are multiple: the reading of the Journal of Delacroix, that champion of colour, whose work lies at the source of contemporary lyric painting; then a study of the position of Delacroix in relation to Ingres, champion of an academic art which fostered line and all its consequences, which in my opinion have brought today's art to the crisis of form, as in the beautiful and grandiose but dramatic adventure of Malevich or Mondrian's insoluble problem of spatial organization, which has encouraged the polychrome architecture from which our contemporary urban developments suffer so atrociously; finally, and above all, I received a profound shock when I discovered in the Basilica of Saint Francis of Assisi frescoes which are scrupulously monochromatic, uniform and blue, which I believe may be attributed to Giotto (but which might be by one of his pupils, or else by some follower of Cimabue or even one of the artists of the school of Siena, though the blue of which I speak is just of the same character and the same quality as the blue in the skies of Giotto which may be admired in the same basilica on the floor above). Were one to acknowledge that Giotto may have had only the figurative intention of showing a clear, cloudless sky, *that intention is nevertheless definitely monochromatic.*

I unhappily did not have the pleasure of discovering the writings of Gaston Bachelard till very late, only last year in the month of April 1958. To the question which is often asked me – why did you choose blue? – I will reply by borrowing yet again from Gaston Bachelard that marvellous passage concerning blue from his book *Air and Dreams.* This is primarily a Mallarméan document in which the poet, living in 'contented world-weariness amidst oblivious tarns', suffers from the irony of blueness. He perceives an excessively hostile blueness which strives

indefatigable hand to 'fill the gaping blue holes wickedly made by birds'. ...ealm of the blue air more than anywhere else one feels that the world is accessible to the most unlimited reverie. It is then that a reverie assumes true depth. The blue sky yawns beneath the dreams, the dream escapes from the two-dimensional image; soon in a paradoxical way the airborne dream exists only in depth, while the two other dimensions, in which picturesque and painted reverie are entertained, lose all visionary interest. The world is thus on the far side of an unsilvered mirror, there is an imaginary beyond, a beyond pure and insubstantial, and that is the dwelling place of Bachelard's beautiful phrase: 'First there is nothing, next there is a depth of nothingness, then a profundity of blue.' ...

Blue has no dimensions, it is beyond dimensions, whereas the other colours are not. They are pre-psychological expanses, red, for example, presupposing a site radiating heat. All colours arouse specific associative ideas, psychologically material or tangible, while blue suggests at most the sea and sky, and they, after all, are in actual, visible nature what is most abstract. [...]

Yves Klein, extract from transcript of lecture, 3 June 1959, the Sorbonne, Paris, trans. in *Yves Klein* (London: Gimpel Fils, 1973); reprinted in *Art in Theory 1900–2000*, ed. Charles Harrison and Paul Wood (Oxford: Blackwell, 2003) 818–20. Yves Klein © ADAGP, Paris 2007.

Piero Manzoni
Free Dimension//1960

New conditions and problems imply different methods and standards and the necessity of finding original solutions. One cannot leave the ground just by running and jumping: one needs wings. Changes are not sufficient; the transformations must be total.

This is why I do not understand painters who, whilst declaring themselves receptive to contemporary problems, still stand in front of a canvas as if it were a surface needing to be filled in with colours and forms, in a more or less personalized and conventional style. They draw a line, step back, stare complacently at their work with their head to one side, closing one eye. They approach it once again, draw another line, apply another stroke. This exercise continues until the canvas is covered: the painting is complete. A surface with limitless possibilities has been reduced to a sort of receptacle in which inauthentic colours, artificial expressions, press against each other. Why not

empty the receptacle, liberate this surface? Why not try to make the limitless sense of total space, of a pure and absolute light, appear instead?

To suggest, to express, to represent: these are not problems today. I wrote about this some years ago; whether or not a painting is a representation of an object, of a fact, of an idea, or of a dynamic phenomenon, it is uniquely valuable in itself. It does not have to say anything, it only has to be. Two matched colours, or two tones of the same colour are already an alien element in the concept of a single, limitless, totally dynamic surface. Infinity is strictly monochromatic, or better still, colourless. Strictly speaking, does not a monochrome, in the absence of all rapport between colours, eventually become colourless?

The artistic problematic which has recourse to composition, to form, is deprived of all value; in total space, form, colour and dimensions have no sense. Here, the artist has achieved total freedom: pure matter is transformed into pure energy. Blue on blue or white on white to compose or to express oneself; both obstacles of space and subjective reactions cease to exist: the entire artistic problematic is surpassed.

This is why I cannot understand artists of today who scrupulously fix the limits in which they place forms and colours, according to a rigorous balance. Why worry about the position of a line in space? Why determine this space? Why limit it? The composition of forms, their position in space, spatial depth, are all problems that do not concern us. A line can only be drawn, however, long, to the infinite; beyond all problems of composition or of dimensions. There are no dimensions in total space.

Furthermore, the questions concerning colour, chromatic relations (even if this only involves nuances) are shown to be useless. We can only open out a single colour or present a continuous and uninterrupted surface (excluding all interference of the superfluous, all possibility of interpretation). It is not a question of painting the contrary of everything. My intention is to present a completely white surface (or better still, an absolutely colourless or neutral one) beyond all pictorial phenomena, all intervention alien to the sense of the surface. A white surface which is neither a polar landscape, nor an evocative or beautiful subject, nor even a sensation, a symbol or anything else: but a white surface which is nothing other than a colourless surface, or even a surface which quite simply 'is'. Being (the total being which is pure Becoming). [...]

Piero Manzoni, 'Libera dimensione', *Azimuth*, 2 (Milan, January 1960); trans. 'Free Dimension', in *Art in Theory 1900–2000*, ed. Charles Harrison and Paul Wood (Oxford: Blackwell, 2003) 723–4.

Roland Barthes
Plastic//1957

[...] More than a substance, plastic is the very idea of its infinite transformation; as its everyday name indicates, it is ubiquity made visible. And it is this, in fact, which makes it a miraculous substance: a miracle is always a sudden transformation of nature. Plastic remains impregnated throughout with this wonder: it is less a thing than the trace of a movement.

And as the movement here is almost infinite, transforming the original crystals into a multitude of more and more startling objects, plastic is, all told, a spectacle to be deciphered: the very spectacle of its end-products. [...]

But the price to be paid for this success is that plastic, sublimated as movement, hardly exists as substance. Its reality is a negative one: neither hard nor deep, it must be content with a 'substantial' attribute which is neutral in spite of its utilitarian advantages: *resistance*, a state which merely means an absence of yielding. In the hierarchy of the major poetic substances, it figures as a disgraced material, lost between the effusiveness of rubber and the flat hardness of metal; it embodies none of the genuine produce of the mineral world: foam, fibres, strata. It is a 'shaped' substance: whatever its final state, plastic keeps a floculent appearance, something opaque, creamy and curdled, something powerless ever to achieve the triumphant smoothness of Nature. But what best reveals it for what it is is the sound it gives, at once hollow and flat; its noise is its undoing, as are its colours, for it seems capable of retaining only the most chemical-looking ones. Of yellow, red and green, it keeps only the aggressive quality, and uses them as mere names, being able to display only concepts of colours. [...]

Roland Barthes, extracts from 'Plastic', *Mythologies* (1957); trans. Annette Lavers (London: Jonathan Cape/New York: Hill and Wang, 1972) 97–9. Translation © 1972 Jonathan Cape Ltd. Reprinted by permission of the Random House Group Ltd.

Donald Judd
Andy Warhol//1963

[...] The best thing about Warhol's work is the colour. The colours are often stained; they look like coloured inks, and often black is stencilled over them, which produces a peculiar quality. The stained alizarin and the black of some repeated Martinson Coffee cans is interesting, for example. The painting with repeated heads of M.M. [Marilyn Monroe] has an orange ground. The hair is yellow, the face is a purplish pink and the eye-shadow is a greenish cerulean. The black image is stencilled over the flat areas. M.M. is lurid. [...]

Donald Judd, extract from 'In the Galleries' column, *Arts Magazine* (New York, January 1963); reprinted in Judd, *Complete Writings 1959–1975* (Halifax: The Press of the Nova Scotia College of Art and Design/New York: New York University Press, 1975) 70.

Barnett Newman
Frontiers of Space//1962

Dorothy Gees Seckler Are you concerned with the void, as, for example, the painter Yves Klein appears to be?

Barnett Newman I have always hated the void, and in certain of my work of the forties I always made it clear. In my work of that time, I notice, I had a section of the painting as a kind of void from which and around which life emanated – as in the original Creation – for example, *Gea*, done in 1945, and *Pagan Void*, 1946.

When I started moving into my present concern or attitude in the mid-forties, I discovered that one does not destroy the void by building patterns or manipulating space or creating new organisms. A canvas full of rhetorical strokes may be full, but the fullness may be just hollow energy, just as a scintillating wall of colours may be full of colour but have no *colour*. My canvases are full not because they are full of colours but because colour makes the fullness. The *fullness thereof* is what I am involved in. It is interesting to me to notice how difficult it is for people to take the intense heat and blaze of my colour. If my paintings were empty they could take them with ease. I have

always worked with colour without regard for existing rules concerning intensity, value or nonvalue. Also, I have never manipulated colours – I have tried to create *colour*. [...]

Barnett Newman and Dorothy Gees Seckler, extract from 'Frontiers of Space: Interview with Dorothy Gees Sackler', *Art in America*, 50, no. 2 (New York, summer 1962); reprinted in Barnett Newman, *Selected Writings and Interviews*, ed. John P. O'Neill (New York: Alfred A. Knopf, Inc., 1990) 249.

Hélio Oiticica
Colour, Time and Structure//1960

With the sense of colour-time, the transformation of structure became essential. Already, it was no longer possible to use the plane, that old-fashioned element of representation, even when virtualized, because of its 'a priori' connotation of a surface to be painted. Structure rotates, then, in space, becoming itself also temporal: 'structure time'. Structure and colour are inseparable here, as are time and space, and the fusion of these four elements, which I consider dimensions of a single phenomenon, comes about in the work.

Dimensions: Colour, Structure, Space, Time
It is not an 'interlocking' of these elements which takes place here, but a fusion, which exists already from the first creative moment; fusion, not juxtaposition. 'Fusion' is organic, whereas juxtaposition implies a profoundly analytical dispersal of elements.

Colour
To pigment-based colour, material and opaque by itself, I attempt to give the sense of light. The sense of light can be given to every primary colour, and other colours derived from them, as well as to white and to grey; however, for this experience one must give pre-eminence to those colours most open to light: colour-light: white, yellow, orange, red-light.

White is the ideal colour-light, the synthesis-light of all colours. It is the most static, favouring silent, dense, metaphysical duration. The meeting of two different whites occurs in a muffled way, one having more whiteness, and the other, naturally, more opaqueness, tending to a greyish tone. Grey is, therefore, little used, because it is already born from this unevenness of luminosity between

one white and another. White, however, does not lose its sense in this unevenness and, for this reason, there remains for grey a role in another sense, which I will speak of when I come to this colour. The whites which confront each other are pure, without mixture, hence also their difference from a grey neutrality.

Yellow, contrary to white, is the least synthetic, possessing a strong optical pulsation and tending towards real space, detaching itself from the material structure, and expanding itself. Its tendency is towards the sign, in a deeper sense, and towards the optical signal, in a superficial sense. It is necessary to note that the meaning of the signal does not matter here, since coloured structures function organically, in a fusion of elements, and are a separate organism from the physical world, from the surrounding space-world. The meaning of the signal would be that of a return to the real world, being, thus, a trivial experience, consisting only of the signalizing and virtualizing of real space. The meaning of the signal, here, is one of internal direction, for the structure and in relation to its elements, the sign being its profound, non-optical, temporal expression. Contrary to white, yellow also resembles a more physical light, more closely related to earthly light. The important thing here is the temporal light sense of colour; otherwise it would still be a representation of light.

Orange is a median colour par excellence, not only in relation to yellow and red, but in the spectrum of colours: its spectrum is grey. It possesses its own characteristics which distinguish it from dark-yolk-yellow and red-light. Its possibilities still remain to be explored within this experiment. Red-light distinguishes itself from blood-red, which is darker, and possesses special characteristics within this experiment. It is neither light-red nor sanguineous vibrant-red, but a more purified red, luminous without arriving at orange since it possesses qualities of red. For this very reason, in the spectrum, it is found in the category of dark colours; but pigmentarily it is hot and open to light. It possesses a grave, cavernous sense of dense light.

The other derivative and primary colours: blue, green, violet, purple and grey, can be intensified towards light, but are by nature opaque colours, closed to light, except grey, which is characterized by its neutrality in relation to light. I will not deal with these colours now, since they harbour more complex relations, yet to be explored. Up to now, we have only looked at the relation beween colours of the same quality, in the sense of light. The colour-light of various qualities has not been jointly explored, since this will depend on a slow development of colour and structure. [...]

Hélio Oiticica, extract from 'Cor, tempo e estrutura', *Jornal do Brasil* (Rio de Janeiro, 26 November 1960); reprinted in *Hélio Oiticica* (Paris: Galerie nationale du Jeu de Paume/ Rio de Janeiro: Projeto Hélio Oiticica/Rotterdam: Witte de With, 1992) 34–5.

Harmony

Colour systems usually lead to the conclusion that certain constellations within a system provide colour harmony. They indicate that this is mainly the aim and the end of colour combination, of colour juxtaposition.

As harmony and harmonizing is also a concern of music, so a parallelism of effect between tone combinations and colour combinations seems unavoidable and appropriate. Although a comparison of composed colours with composed tones is very challenging, it should be mentioned that, while it can be helpful, it is often misleading. This is because different basic conditions of these media result in different behaviour.

Tones appear placed and directed predominantly in time from *before* to *now* to *later*. Their juxtaposition in a musical composition is perceived within a prescribed sequence only. Vertically, so to say, one tone, or several simultaneously, sound for a varying but restricted length of time. Horizontally, the tones follow each other, perhaps not in a straight line, but of necessity in a prescribed order and only in one direction – forwards. Tones heard earlier fade, and those farther back disappear, vanish. We do not hear them backwards.

Colours appear connected predominantly in space. Therefore, as constellations they can be seen in any direction and at any speed. And as they remain, we can return to them repeatedly and in many ways.

This remaining and not remaining, or vanishing and not vanishing, shows only one essential difference between the fields of tone and colour.

The accuracy of perception in one field is matched by the durability of retention in the other, demonstrating a curious reversal in visual and auditory memory.

Tone juxtapositions can be defined by their acoustical relationship and thus measured precisely by wave length.

Consequently, a graphic registration of tones in musical composition has been developed.

Colour, also, can be measured, at least to some extent, and particularly so when it is presented as direct colour – as the physicist registers it, by optical wave length.

Reflected colour, however, coming from paint and pigment – our main medium – is much more difficult to define.

When analysed with an electrical spectrograph reflected colour shows that it contains all visible wave lengths. Therefore, any reflected colour – not just white – consists of all other colours. [...]

Colour, when practically applied, not only appears in uncountable shades and tints, but is additionally characterized by shape and size, by recurrence and placement, and so on, of which particularly shape and size are not directly applicable to tones.

All this may signify why any colour composition naturally defies such diagrammatic registration as notation in music and choreography in dance.

With regard to constellation, tone intervals, such as third, fifth, and octave, differentiate exact vertical distance. We say 'vertical' probably because tones are described as low and high. Slide deflections (aberrations), such as in flat and sharp, remain equally precise. Colour terms which could be considered parallel to tone intervals are complementaries, split complementaries, triads, tetrads and octads. Though these characterize distance and constellation within colour systems, their deflections, such as incomplete triads and incomplete tetrads, indicate that their measure is only arbitrary.

Significantly, complementaries, though they are the basic colour contrast or interval, are topographically quite vague.

In principle, a complementary is a colour accompanied by its after-image.

However, the complement of a specific colour, when placed in different systems, will look different.

Similarly, a triad or tetrad of one system will hardly fit into another system.

Usually, illustrations of harmonic colour constellations which derive from authoritative systems look pleasant, beautiful, and thus convincing. But it should not be overlooked that they are usually presented in a most theoretical and least practicable manner, because normally all harmony members appear in the same quantity and the same shape, as well as in the same number (just once) and sometimes even in similar light intensity. Such outer equalization may unify them, but at the expense of the more important inner relatedness – namely, as colour only.

When applied in practice, these harmony sets appear changed. In addition to quantity, form and recurrence, wider aspects exert still more changing influences. These are:

Changed and changing light – and, even worse, several simultaneous lights; reflection of lights and of colours; direction and sequence of reading; presentation in varying materials; constant or altering juxtaposition of related and unrelated objects.

With these and other visual displacements, it should not be a surprise that the sympathetic effect of the original 'ideal' colour combination often appears changed, lost, and reversed.

Observe the interior and exterior, the furniture and textile decoration following such colour schemes, as well as commercialized colour 'suggestions' for innumerable do-it-yourselves.

Our conclusion: we may forget for a while those rules of thumb of complementaries, whether complete or 'split', and of triads and tetrads as well. They are worn out.

Second, no mechanical colour system is flexible enough to precalculate the manifold changing factors, as named before, in a single prescribed recipe.

Good painting, good colouring, is comparable to good cooking. Even a good cooking recipe demands tasting and repeated tasting while it is being followed. And the best tasting still depends on a cook with taste.

By giving up preference for harmony, we accept dissonance to be as desirable as consonance.

In searching for new colour organization – colour design – we have come to think that quantity, intensity or weight, as principles of study, can lead similarly to illusions, to new relationships, to different measurements, to other systems, as do transparence, space and intersection. Besides a balance through colour harmony, which is comparable to symmetry, there is equilibrium possible between colour tensions, related to a more dynamic asymmetry.

Again: knowledge and its application is not our aim; instead, it is flexible imagination, discovery, invention – taste.

With this study of colour effects, that is, of colour deception, a special interest in quantity – amount as well as recurrence – has developed.

Josef Albers, extract from *Interaction of Colour* (New Haven: Yale University Press, 1963) 39–43.

Helen Frankenthaler
Interview with Henry Geldzahler//1965

Henry Geldzahler Was there any postwar European painting you were interested in?

Helen Frankenthaler Miró. Matisse. But more Miró. As I've said I've been touched, in the work of Miró and Pollock, by a Surrealist – by Surrealist I mean 'associative' – quality. It's what comes through in association after your eye has experienced the surface as a great picture; it is incidental but can be enriching.

Gorky too has affected me this way, but in Gorky, though it fascinated me, it often got in my way. I was too much aware of, let's say, what read as sex organs arranged in a room.

I liked the big 1961 Miró *Blue II* in the Guggenheim show several years ago very much. He often has that thing I respond to in Pollock. It's the role that the image plays; in a sense it is totally irrelevant to the aesthetics of a work of art, but in another sense it adds a profound dimension, as certain webs of Pollock's became decipherable characters.

It isn't the image that makes it work for me, it is that they are great abstract pictures. I leave it out of my own pictures more and more as I become increasingly involved with colours and shapes. But it is still there.

Geldzahler How do you name your pictures?

Frankenthaler I'm very poor at naming them. I don't like numbers because I don't remember them. The only number I've ever remembered is Pollock's *No. 14*, which to me has a sort of 'fox in the woods' in it. I usually name them after an image that seems to come out of the pictures, like *Blue Territory*, or I look and see *Scattered Shapes*, or *Red Burden*. I don't like sentimental titles. A picture like *Small's Paradise* had a Persian shape in it; also I'd been to that night club recently. One names a picture in order to refer to it. In 1951 I did a picture called *Ed Winston's Tropical Gardens*. It was a juke box bar on 8th Street, filled with celluloid palm trees and five-and-ten-cent store Hawaiian décor. The painting is 18 feet long. I had the memory of the place and did a sunny green and yellow landscape. It's more difficult to title more abstract pictures.

Geldzaher Do you start your pictures with a plan or look in mind?

nkenthaler I will sometimes start a picture feeling 'What will happen if I work with three blues and another colour, and maybe more or less of the other colour than the combined blues?' And very often midway through the picture I have to change the basis of the experience. Or I add and add to the canvas. And if it's over-worked and beyond help I throw it away.

I used to try to work from a given, made shape. But I'm less involved now with the shape as such. I'm much more apt to be surprised that pink and green within these shapes are doing something. After 1951–54 I had a long involvement with lines and black. Then that got played out.

Geldzahler What do you mean by gesture?

Frankenthaler When I say gesture, my gesture, I mean what my mark is. I think there is something now I am still working out in paint; it is a struggle for me to both discard and retain what is gestural and personal, 'Signature'. I have been trying, and the process began without my knowing it, to stop relying on gesture, but it is a struggle.

'Gesture' must appear out of necessity not habit. I don't start with a colour order but find the colour as I go.

I'd rather risk an ugly surprise than rely on things I know I can do. The whole business of spotting; the small area of colour in a big canvas; how edges meet; how accidents are controlled; all this fascinates me, though it is often where I am most facile and most seducible by my own talent.

The gesture today is surely more purely abstract than it was. There is a certain moment when one can look so pure that the result is emptiness – many readings of a work of art are eliminated and you are left with one note that may be real and pure but it's only that, one shaft. For example, the best Mondrians, Newmans, Nolands or Louises are deep and beautiful and get better and better. But I think that many of the camp followers are empty.

When you first saw a Cubist or Impressionist picture there was a whole way of instructing the eye or the subconscious. Dabs of colour had to stand for real things; it was an abstraction of a guitar or of a hillside. The opposite is going on now. If you have bands of blue, green and pink, the mind doesn't think sky, grass and flesh. These are colours, and the question is what are they doing with themselves and with each other. Sentiment and nuance are being squeezed out so that if something is not altogether flatly painted then there might be a hint of edge, chiaroscuro, shadow, and if one wants just that pure thing these associations get in the way.

Geldzahler How do you feel about being a woman painter?

Frankenthaler Obviously, first I am involved in painting not the who a wonder if my pictures are more 'lyrical' (that loaded word!) beca woman. Looking at my paintings as if they were painted by a woman superficial, a side issue, like looking at Klines and saying they are bohemian. The making of serious painting is difficult and complicated for all serious painters. One must be oneself, whatever. [...]

Helen Frankenthaler and Henry Geldzahler, extract from 'An Interview with Helen Frankenthaler', *Artforum*, vol. 4, no. 2 (Los Angeles, October 1965) 36–8.

Sonia Delaunay
On Colour//1966

The issue is learning again how to paint and finding new means of doing it. Technical and plastic means. Colour liberated from descriptive, literary use; colour grasped in all the richness of its own life.

A vision of infinite richness awaits the person who knows how to see the relations of colours, their contrasts and dissonances, and the impact of one colour on another. Add to this the essential element – Rhythm – which is its structure, movement based on number.

As in written poetry, it is not the aggregation of words which counts, but the mystery of creation which yields or does not yield feeling. As in poetry, so with colours. It is the mystery of interior life which liberates, radiates and communicates. Beginning there, a new language can be freely created.

Sonia Delaunay, untitled text for portfolio of prints (Milan: Galleria Schwartz, 1966); trans. David Shapiro and Arthur A. Cohen, in *The New Art of Colour: The Writings of Robert and Sonia Delaunay*, ed. Arthur A. Cohen (New York: The Viking Press, 1978) 213–14.

Jules Olitski
Painting in Colour//1966

Painting is made from inside out. I think of painting as possessed by a structure – i.e., shape and size, support and edge – but a structure born of the flow of colour feeling. Colour *in* colour is felt at any and every place of the pictorial organization; in its immediacy – its particularity. Colour must be felt throughout.

What is of importance in painting is paint. Paint can be colour. Paint becomes painting when colour establishes surface. The aim of paint surface (as with everything in visual art) is appearance – colour that *appears* integral to material surface. Colour is of inherent significance in painting. (This cannot be claimed, however, for any particular type of paint, or application of paint.)

I begin with colour. The development of a colour structure ultimately determines its expansion or compression – its outer edge. Outer edge is inescapable. I recognize the line it declares, as drawing. This line delineates and separates the painting from the space around and appears to be on the wall (strictly speaking, it remains in front of the wall). Outer edge cannot be visualized as being in some way within – it is the outermost extension of the colour structure. The decision as to where the outer edge is, is final, not initial.

Wherever edge exists – both within a painting and at its limits – it must be felt as a necessary outcome of the colour structure. Paint can be colour and drawing when the edge of the painting is established as the final realization of the colour structure.

The focus in recent painting has been on the lateral – a flat and frontal view of the surface. This has tended towards the use of flat colour areas bounded by and tied inevitably to a structure composed of edges. Edge is drawing and drawing is on the surface. (Hard-edge or precision-made line is no less drawing than any other kind.) Because the paint fills in the spaces between the edges, the colour areas take on the appearance of overlay. Painting becomes subservient to drawing. When the conception of internal form is governed by edge, colour (even when stained into raw canvas) appears to remain on or above the surface. I think, on the contrary, of colour as being seen in and throughout, not solely on, the surface.

Jules Olitski, 'Painting in Colour', slightly revised and expanded version of a catalogue statement written for the XXXIII Venice Biennale (June 1966); *Artforum* (New York, January 1967) 20.

Robert Morris
Notes on Sculpture//1966

Part I
[...] The term 'detail' is used here in a special and negative sense and should be understood to refer to all factors in a work that pull it towards intimacy by allowing specific elements to separate from the whole, thus setting up relationships within the work. Objections to the emphasis on colour as a medium foreign to the physicality of sculpture have also been raised previously, but in terms of its function as a detail a further objection can be raised. That is, intense colour, being a specific element, detaches itself from the whole of the work to become one more internal relationship. The same can be said of emphasis on specific, sensuous material or impressively high finishes. [...]

Robert Morris, extract from 'Notes on Sculpture' (1966) *Artforum*, vol. 4 no. 6 (New York, February 1966) 42.

Ad Reinhardt
Black as Symbol and Concept//1967

[...] I want to stress the idea of black as intellectuality and conventionality. There's an expression 'the dark of absolute freedom' and an idea of formality. There's something about darkness or blackness that I don't want to pin down. But it's aesthetic. And it has not to do with outer space or the colour of skin or the colour of matter. As a matter of fact, the glossier, texturier, gummy black is a sort of an objectionable quality in painting. It's one reason I moved to a sort of dark grey. At any rate it's a matt black. And the exploitation of black as a kind of quality, as a material quality, is really objectionable. Again I'm talking on another level, on an intellectual level. [Shiny black] reflects, and it has unstable quality for that reason. It's quite surreal. If you have a look at a shiny black surface it looks like a mirror. It reflects all the activity that's going on in a room. As a matter of fact, it's not detached then.

The reason for the involvement with darkness and blackness is, as I said, an aesthetic-intellectual one, certainly among artists. And it's because of its non-

olour is always trapped in some kind of physical activity or
...ess of its own; and colour has to do with life. In that sense it may be
or folk art or something like that.

Clive Bell made it clear that there was an aesthetic emotion that was not any
other kind of emotion. And probably you could only define that negatively. [...]

Ad Reinhardt, 'Black as Symbol and Concept', transcript of contribution to phone conference
discussion between Reinhardt, Aldo Tambellini, Michael Snow, et al., commissioned by and
published in *artscanada* (Toronto, October 1967); reprinted in *Art as Art: The Selected Writings of Ad
Reinhardt*, ed. Barbara Rose (Berkeley and Los Angeles: University of California Press, 1975) 86–8.

Barnett Newman
On *Who's Afraid of Red, Yellow and Blue*//1969

I began this, my first painting in the series *Who's Afraid of Red, Yellow and Blue*,
as a 'first' painting, unpremeditated. I did have the desire that the painting be
asymmetrical and that it create a space different from any I had ever done, sort
of – off balance. It was only after I had built up the main body of red that the
problem of colour became crucial. when the only colours that would work were
yellow and blue.

It was at this moment that I realized I was now confronting the dogma that
colour must be reduced to the primaries, red, yellow and blue. Just as I had
confronted other dogmatic positions of the purists, neoplasticists and other
formalists, I was now in confrontation with their dogma, which had reduced red,
yellow and blue into an idea-didact, or at best had made them picturesque. Why
give in to these purists and formalists who have put a mortgage on red, yellow
and blue, transforming these colours into an idea that destroys them as colours?

I had, therefore, the double incentive of using these colours to express what
I wanted to do – of making these colours expressive rather than didactic and of
freeing them from the mortgage.

Why should anybody be afraid of red, yellow and blue?

Barnett Newman, statement on the painting series *Who's Afraid of Red, Yellow and Blue I–IV*
(1966–69), in *Art Now: New York* (New York, March 1969); reprinted in Barnett Newman, *Selected
Writings and Interviews*, ed. John P. O'Neill (New York: Alfred A. Knopf, Inc., 1990) 192.

Daniel Buren
Beware!//1969

Colour

In the same way that the work which we propose could not possibly be the image of some thing (except itself, of course), and [...] could not possibly have a finalized external form, there cannot be one single and definitive colour. The colour, if it was fixed, would mythify the proposition and would become the zero degree of colour x, just as there is navy blue, emerald green or canary yellow.

One colour and one colour only, repeated indefinitely or at least a great number of times, would then take on multiple and incongruous meanings. All the colours are therefore used simultaneously, without any order of preference, but systematically.

That said, we note that if the problem of form (as pole of interest) is dissolved by itself, the problem of colour considered as subordinate or as self-generating at the outset of the work and by the way it is used, is seen to be of great importance. The problem is to divest it of all emotional or anecdotal import.

We shall not further develop this question here, since it has only recently become of moment and we lack the required elements and perspective for a serious analysis. At all events, we record its existence and its undeniable interest. We can merely say that every time the proposition is put to the eye, only one colour (repeated on one band out of two, the other being white) is visible and that it is without relation to the internal structure or the external form which supports it and that, consequently, it is established *a priori* that: white=red=black=blue=yellow=green=violet, etc. [...]

Daniel Buren, extract from 'Achtung!', *Conception/Konzeption*, curated by Udo Kittelmann (Leverkusen, Germany: Stätliches Museum Leverkusen, 1969); trans. Charles Harrison and Peter Townsend, 'Beware!', in Buren, *Five Texts* (New York: John Weber Gallery/London: Jack Wendler Gallery, 1973) 15.

Maurice Merleau-Ponty
Eye and Mind//1960

[...] 'I believe Cézanne was seeking depth all his life', says Giacometti.[1] Says Robert Delaunay, 'Depth is the new inspiration.'[2] Four centuries after the 'solutions' of the Renaissance and three centuries after Descartes, depth is still new, and it insists on being sought, not 'once in a lifetime' but all through life. It cannot be merely a question of an unmysterious interval, as seen from an aeroplane, between these trees nearby and those further away. Nor is it a matter of the way things are conjured away, one by another, as we see so vividly portrayed in a perspective drawing. These two views are very explicit and raise no problems. The enigma, though, lies in their bond, in what is between them. The enigma consists in the fact that I see things, each one in its place, precisely because they eclipse one another, and that they are rivals before my sight precisely because each one is in its own place – in their exteriority, known through their envelopment, and their mutual dependence in their autonomy. Once depth is understood in this way, we can no longer call it a third dimension. In the first place, if it were a dimension, it would be the *first* one; there are forms and definite planes only if it is stipulated how far from me their different parts are. But a first dimension that contains all the others is no longer a dimension, at least in the ordinary sense of a *certain relationship* according to which we make measurements. Depth thus understood is, rather, the experience of the reversibility of dimensions, of a global 'locality' in which everything is in the same place at the same time, a locality from which height, width and depth are abstracted, a voluminosity we express in a word when we say that a thing is *there*. In pursuing depth, what Cézanne is seeking is this deflagration of Being, and it is all in the modes of space, and in form as well. Cézanne already knew what Cubism would restate: that the external form, the envelope, is secondary and derived, that it is not what makes a thing to take form, that that shell of space must be shattered – the fruit bowl must be broken. But then what should be painted instead? Cubes, spheres, and cones – as he said once? Pure forms having the solidity of what could be defined by an internal law of construction, forms which taken together, as traces or cross-sections of the thing, let it appear between them like a face in the reeds? This would be to put Being's solidity on one side and its variety on the other. Cézanne had already made an experiment of this kind in his middle period. He went directly to the solid, to space – and came to find that inside this space – this box or container too large for them – the things began to move, colour against colour; they began to modulate in the

instability.[3] Thus we must seek space and its content together. The pro, becomes generalized; it is no longer solely that of distance, line, and form; it ι also, and equally, the problem of colour.

Colour is the 'place where our brain and the universe meet', he says in that admirable idiom of the artisan of Being which Klee liked to quote.[4] It is for the sake of colour that we must break up the form qua spectacle. Thus the question is not of colours, 'simulacra of the colours of nature'.[5] The question, rather, concerns the dimension of colour, that dimension which creates – from itself to itself – identities, differences, a texture, a materiality, a something ...

Yet there is clearly no one master key of the visible, and colour alone is no closer to being such a key than space is. The return to colour has the virtue of getting somewhat nearer to 'the heart of things',[6] but this heart is beyond the colour envelope just as it is beyond the space envelope. The *Portrait of Vallier* sets white spaces between the colours which take on the function of giving shape to, and setting off, a being more general than yellow-being or green-being or blue-being. Similarly, in the watercolours of Cézanne's last years, space (which had been taken to be self-evidence itself and of which it was believed that the question of where was not to be asked) radiates around planes that cannot be assigned to any place at all: 'a superimposing of transparent surfaces', 'a flowing movement of planes of colour which overlap, advance and retreat.'[7]

As we can see, it is not a matter of adding one more dimension to those of the flat canvas, of organizing an illusion or an objectless perception whose perfection consists in simulating an empirical vision to the maximum degree. Pictorial depth (as well as painted height and width) comes 'I know not whence' to alight upon, and take root in, the sustaining support. The painter's vision is not a view upon the outside, a merely 'physical-optical'[8] relation with the world. The world no longer stands before him through representation; rather, it is the painter to whom the things of the world give birth by a sort of concentration or coming-to-itself of the visible. Ultimately the painting relates to nothing at all among experienced things unless it is first of all 'autofigurative'.[9] It is a spectacle of something only by being a 'spectacle of nothing',[10] by breaking the 'skin of things'[11] to show how the things become things, how the world becomes world. Apollinaire said that in a poem there are phrases which do not appear to have been *created*, which seem to have *shaped themselves*. And Henri Michaux said that sometimes Klee's colours seem to have been born slowly upon the canvas, to have emanated from some primordial ground, 'exhaled at the right spot'[12] like a patina or a mould. Art is not construction, artifice, the meticulous relationship to a space and a world existing outside. It is truly the 'inarticulate cry', as Hermes Trismegistus said, 'which seemed to be the voice of the light'. And once it is present it awakens powers dormant in ordinary vision, a secret of pre-existence.

h the water's thickness I see the tiled bottom of the pool, I do not
 the water and the reflections; I see it through them and because of
re were no distortions, no ripples of sunlight, if it were without that
saw the geometry of the tiles, then I would cease to see it as it is and
where it is – which is to say, beyond any identical, specific place. I cannot say
that the water itself – the aqueous power, the syrupy and shimmering element
– is in space; all this is not somewhere else either, but it is not in the pool. It
inhabits it, is materialized there, yet it is not contained there; and if I lift my eyes
towards the screen of cypresses where the web of reflections plays, I must
recognize that the water visits it as well, or at least sends out to it its active,
living essence. This inner animation, this radiation of the visible, is what the
painter seeks beneath the words *depth, space and colour.* [...]

1 [footnote 34 in source] Charbonnier, *Le monologue*, 176.
2 [35] Delaunay, *Du cubisme*, 109.
3 [36] F. Novotny, *Cézanne und das Ende der wissenschaftlichen Perspective* (Vienna, 1938).
4 [37] W. Grohmann, *Paul Klee* (Paris, 1954) 141.
5 [38] Delaunay, *Du cubisme*, 118.
6 [39] Klee, *Journal*. French trans. P. Klossowski (Paris, 1959).
7 [40] George Schmidt, *Les aquarelles de Cézanne*, 21.
8 [41] Klee, *Journal*.
9 [42] 'The spectacle is first of all a spectacle of itself before it is a spectacle of something outside
 of it.' – Translator's note from Merleau-Ponty's 1961 lectures.
10 [43] C.P. Bru, *Ésthétique de l'abstraction* (Paris, 1959) 99, 86.
11 [44] Henri Michaux, *Aventures de lignes*.
12 [45] Ibid.

Maurice Merleau-Ponty, extract from 'Eye and Mind' (1960); trans. Carleton Dallery, in Merleau-
Ponty, *The Primacy of Perception*, ed. James M. Edie (Evanston, Illinois: Northwestern University
Press, 1964) 179–82.

Johannes Itten
The Elements of Colour//1961

[...] Colour is life: for a world without colours appears to us as dead. Colours are
primordial ideas, children of the aboriginal colourless light and its counterpart,

colourless darkness. As flame begets light, so light engenders colours. Colours are the children of light, and light is their mother. Light, that first phenomenon of the world, reveals to us the spirit and living soul of the world through colours.

Nothing affects the human mind more dramatically than the apparition of a gigantic colour corona in the heavens. Thunder and lightning frighten us; but the colours of the rainbow and the northern lights soothe and elevate the soul. The rainbow is accounted a symbol of peace.

The word and its sound, form and its colour, are vessels of a transcendental essence that we dimly surmise. As sound lends sparkling colour to the spoken word, so colour lends psychically resolved tone to form.

The primaeval essence of colour is a phantasmagorical resonance, light becomes music. At the moment when thought, concept, formulation, touch upon colour, its spell is broken, and we hold in our hands a corpse. [...]

In any attempt to account for subjective colour, we must attend to the most minute traits; but the essential factor is the 'aura' of the person.

Some examples will illustrate different subjective colour types:

Light blond types with blue eyes and pink skin incline towards very pure colours, often with a great many clearly distinguished colour qualities. Contrast of hue is the basic feature. Depending on the forcefulness of the individual, the colours may be more or less luminous.

A very different type is represented by people with black hair, dark skin and dark eyes, for whom black plays an important part in the harmony. [...]

The blond type should be assigned such subjects as Springtime, Kindergarten, Baptism, Festival of Bright Flowers, Garden in the Morning. Nature subjects should be vivid, without light and dark contrasts.

Good assignments for a dark type would be Night, Light in a Dark Room, Autumn Storm, Burial, Grief, The Blues, etc. [...]

The total personality can rarely be quite comprehended in the subjective concords; sometimes the physical, sometimes the mental or spiritual, is dominant, or any number of numerous composites. The emphasis varies with individual temperament and disposition.

Teachers, physicians and vocational counsellors can draw many valuable inferences from subjective colours.

One student's subjective colours were light violet, light blue, blue-grey, yellow, white and a touch of black. His fundamental 'tone' was hard, cold and somewhat brittle. When he was discussing his choice of vocation with me, I suggested that he had a natural affinity for metals, particularly silver, and for glass. 'You may be right, but I have decided to become a cabinetmaker', he rejoined. He did

afterwards design furniture, and incidentally created the first modern steel chair. He ultimately became a highly successful architect in concrete and glass.

Another student's subjective colour chords and compositions contained orange-brown, ochre, red-brown and some black. Green, blue, violet and grey tones were quite absent. When I asked him about his vocation, he said confidently, 'I'm going to be a woodworker'. He instinctively perceived his natural calling.

The subjective concords of a third student consisted of sonorous light-violet, yellowish and gold-brown tones. In their arrangement, these colours produced an effect of radiant splendor, suggesting great powers of concentration. The shading of warm yellow into light violet indicated a religious tendency of thinking. He served as sacristan to an important church, and was a consummate engraver in gold and silver besides. [...]

Johannes Itten, extracts from *Kunst der Farbe* (Ravensburg: Otto Maier, 1961); trans. Ernst van Hagen, *The Elements of Colour* (London: Chapman & Hall, 1970) 8; 20; 24–5.

Claude Lévi-Strauss
The Raw and the Cooked//1964

[...] Devotees of painting will no doubt protest againt the privileged position I have accorded to music, or at least will claim the same position for the graphic and plastic arts. However, I believe that from the formal point of view the materials used – that is, sounds and colours – are not on the same level. To justify the difference, it is sometimes said that music is not normally imitative or, more accurately, that it never imitates anything but itself; whereas the first question that springs to the mind of someone looking at a picture is: what does it represent? But if the problem is formulated in this way at the present time, we are faced with the anomaly of nonfigurative painting. In defence of his efforts, would not the abstract painter be justified in appealing to the precedent of music and in claiming the right to organize forms and colours, if not with absolute freedom, at least in accordance with a code independent of sense experience, as is the case in music with its sounds and rhythms?

Anyone proposing this analogy has fallen victim to a serious illusion. Whereas colours are present 'naturally' in nature, there are no musical sounds in nature, except in a purely accidental and unstable way; there are only noises. Sounds and

colours are not entities of the same standing, and the only legitimate comparison is between colours and noises – that is, between visual and acoustic modes of nature. And it happens that man adopts the same attitude to both, since he is unwilling to allow either to remain in a random state. There are confused noises just as there are medleys of colour, but as soon as it is possible to perceive them as patterns, man at once tries to identify them by relating them to a cause. Patches of colour are seen as flowers nestling in the grass, crackling noises must be caused by stealthy movement, or by the wind in the trees, and so on.

There is no true equality, then, between painting and music. The former finds its materials in nature: colours are given before they are used, and language bears witness to their derivative character through the terms that describe the most subtle shades – midnight blue, peacock blue, petrol blue; sea green, jade green; straw colour, lemon yellow; cherry red, etc. In other words, colours exist in painting only because of the prior existence of coloured objects and beings; and only through a process of abstraction can they be separated from their natural substrata and treated as elements in an independent system.

It may be objected that what applies to colours is not true of forms. Geometrical forms and all others derived from them have already been created by culture when the artist becomes aware of them; they are no more the product of experience than musical sounds are. But an art limited to the exploitation of such forms would inevitably take on a decorative character. Without ever fully existing in its own right, it would become anaemic, unless it attached itself to objects as adornment, while drawing its substance from them. It is, then, as if painting had no choice but to signify beings and things by incorporating them in its operations or to share in the significance of beings and things by becoming incorporated with them.

It seems to me that this congenital subjection of the plastic arts to objects results from the fact that the organization of forms and colours within sense experience (which, of course, is itself a function of the unconscious activity of the mind) acts, in the case of these arts, as an initial level of articulation of reality. Only thanks to it are they able to introduce a secondary articulation which consists of the choice and arrangement of the units, and in their interpretation according to the imperatives of a given technique, style or manner – that is, by their transposition in terms of a code characteristic of a given artist or society. If painting deserves to be called a language, it is one in that, like any language, it consists of a special code whose terms have been produced by combinations of less numerous units and are themselves dependent on a more general code. Nevertheless, there is a difference between it and articulate speech, with the result that the message of painting is grasped in the first place through aesthetic perception and secondly through intellectual perception,

whereas with speech the opposite is the case. As far as articulate speech is concerned, the coming into operation of the second code wipes out the originality of the first. Hence the admittedly 'arbitrary character' of linguistic signs. [...]

Claude Lévi-Strauss, extract from *Le Cru et le cuit* (Paris: Librairie Plon, 1964); trans. John and Doreen Weightman, *The Raw and the Cooked* (London: Jonathan Cape, 1970) 18–20 [footnotes not included].

Robert Smithson
The Crystal Land//1966

[...] The terrain is flat and loaded with 'middle income' housing developments with names like Royal Garden Estates, Rolling Knolls Farm, Valley View Acres, Split-Level Manor, Babbling Brook Ranch-Estates, Colonial Vista Homes – on and on they go, forming tiny box-like arrangements.

Most of the houses are painted white, but many are painted petal pink, frosted mint, buttercup, fudge, rose beige, antique green, Cape Cod brown, lilac, and so on. The highways crisscross through the towns and become man-made geological networks of concrete. In fact, the entire landscape has a mineral presence. From the shiny chrome diners to glass windows of shopping centres, a sense of the crystalline prevails. [...]

[...] Robert Smithson, 'The Crystal Land', *Harper's Bazaar* (New York, May 1966); reprinted in Robert Smithson, *The Collected Writings*, ed. Jack Flam (Berkeley and Los Angeles: University of California Press, 1996) 8.

Stan Brakhage
Metaphors on Vision//1963

Imagine an eye unruled by man-made laws of perspective, an eye unprejudiced by compositional logic, an eye which does not respond to the name of everything but which must know each object encountered in life through an adventure of perception. How many colours are there in a field of grass to the

crawling baby unaware of 'Green'? How many rainbows can light create for the untutored eye? How aware of variations in heat waves can that eye be? Imagine a world alive with incomprehensible objects and shimmering with an endless variety of movement and innumerable gradations of colour. Imagine a world before the 'beginning was the word'. [...]

Stan Brakhage, extract from 'Metaphors on Vision', *Film Culture*, no. 30 (New York, 1963). Courtesy of the Estate of Stan Brakhage.

Italo Calvino
Cosmicomics//1965

Before forming its atmosphere and its oceans, the Earth must have resembled a grey ball revolving in space. As the Moon does now; where the ultraviolet rays radiated by the Sun arrive directly, all colours are destroyed, which is why the cliffs of the lunar surface, instead of being coloured like Earth's, are of a dead, uniform grey. [...]

Among the countless indispensible things we had to do without, the absence of colours – as you can imagine – was the least of our problems; even if we had known they existed, we would have considered them an unsuitable luxury. The only drawback was the strain on your eyes when you had to hunt for something or someone, because with everything equally colourless no form could be clearly distinguished from what was behind it or around it. You could barely make out a moving object: a meteor fragment as it rolled, or the serpentine yawning of a seismic chasm, or a lapillus being ejected from a volcano.

That day I was running through a kind of amphitheatre of porous, spongy rocks, all pierced with arches beyond which other arches opened; a very uneven terrain where the absence of colour was streaked by distinguishable concave shadows. Among the pillars of these colourless arches I saw a kind of colourless flash running swiftly, disappearing, then reappearing further on: two flattened glows that appeared and disappeared abruptly; I still hadn't realized what they were, but I was already in love and running, in pursuit of the eyes of Ayl. [...]

I put my hands to my deafened ears, and at the same moment I also felt the need to cover my nose and mouth, so as not to breathe the heady blend of oxygen and

nitrogen that surrounded me, but strongest of all was the impulse to cover my eyes, which seemed ready to explode.

The liquid mass spread out at my feet had suddenly turned a new colour, which blinded me, and I exploded in an articulate cry which, a little later, took on a specific meaning: 'Ayl! The sea is blue!'

The great change so long awaited had finally taken place. On the Earth now there was air and water. And over that newborn blue sea, the Sun, also coloured, was setting, an absolutely different and even more violent colour. So I was driven to go on with my senseless cries, like: 'How red the Sun is, Ayl! Ayl! How red!' Night fell. Even the darkness was different. I ran looking for Ayl, emitting cries without rhyme or reason, to express what I saw: 'The stars are yellow, Ayl! Ayl!'

I didn't find her that night or the days and nights that followed. All around, the world poured out colours, constantly new, pink clouds gathered in violet cumuli which unleashed gilded lightning; after the storms long rainbows announced hues that still hadn't been seen, in all possible combinations. And chlorophyll was already beginning its progress: mosses and ferns grew green in the valleys where torrents ran. This was finally the setting worthy of Ayl's beauty; but she wasn't there! And without her all this varicoloured sumptuousness seemed useless to me, wasted. [...]

'Ayl! Where are you? Try to come over to this side quickly, before the rock settles!' And I ran along the wall looking for an opening, but the smooth, grey surface was compact, without a fissure.

An enormous chain of mountains had formed at that point. As I had been projected outwards, into the open, Ayl had remained beyond the rock wall, closed in the bowels of the Earth.

'Ayl!' Where are you? Why aren't you out here?' and I looked around at the landscape that stretched away from my feet. Then, all of a sudden, those pea-green lawns where the first scarlet poppies were flowering, those canary-yellow fields which striped the tawny hills sloping down to a sea full of azure glints, all seemed so trivial to me, so banal, so false, so much in contrast with Ayl's person, with Ayl's world, with Ayl's idea of beauty, that I realized her place could never have been out here. And I realized, with grief and fear, that I had remained out here, that I would never again be able to escape those gilded and silvered gleams, those little clouds that turned from pale blue to pink, those green leaves that yellowed every autumn, and that Ayl's perfect world was lost forever, so lost I couldn't even imagine it any more, and nothing was left that could remind me of it, even remotely, nothing except perhaps that cold wall of grey stone.

Italo Calvino, extract from *Le cosmicomiche* (Turin: Giulio Einaudi Editore, 1965); trans. William Weaver, *Cosmicomics* (London: Jonathan Cape/NY: Harcourt Brace & Co., 1968) 51; 52; 57; 59–60.

Jean Baudrillard
Atmospheric Values: Colour//1968

Traditional Colour

In the traditional system colours have psychological and moral overtones. A person will 'like' a particular colour, or have 'their' colour. Colour may be dictated by an event, a ceremony, or a social role; alternatively, it may be the characteristic of a particular material – wood, leather, canvas or paper. Above all it remains circumscribed by form; it does not seek contact with other colours, and it is not a free value. Tradition confines colours to its own parochial meanings and draws the strictest of boundary-lines about them. Even in the freer ceremonial of fashion, colours generally derive their significance from outside themselves: they are simply metaphors for fixed cultural meanings. At the most impoverished level, the symbolism of colours gets lost in mere psychological resonance: red is passionate and aggressive, blue a sign of calm, yellow optimistic, and so on; and by this point the language of colours is little different from the languages of flowers, dreams or the signs of the Zodiac.

The traditional treatment of colour negates colour as such, rejects it as a complete value. Indeed, the bourgeois interior reduces it for the most part to discreet 'tints' and 'shades'. Grey, mauve, garnet, beige – all the shades assigned to velours, woollens and satins, to the profusion of fabrics, curtains, carpets and hangings, as also to heavier materials and 'period' forms, imply a moral refusal of both colour and space. But especially of colour, which is deemed too spectacular, and a threat to inwardness. The world of colours is opposed to the world of values, and the 'chic' invariably implies the elimination of appearances in favour of being: black, white, grey – whatever registers zero on the colour scale – is correspondingly paradigmatic of dignity, repression and moral standing.

'Natural' Colour

Colours would not celebrate their release from this anathema until very late. It would be generations before cars and typewriters came in anything but black, and even longer before refrigerators and washbasins broke with their universal whiteness. It was painting that liberated colour, but it still took a very long time for the effects to register in everyday life. The advent of bright red armchairs, sky-blue settees, black tables, multicoloured kitchens, living-rooms in two or three different tones, contrasting inside walls, blue or pink façades (not to mention mauve and black underwear) suggests a liberation stemming from the overthrow of a global order. This liberation, moreover, was contemporary with

that of the functional object (with the introduction of synthetic materials, which were polymorphous, and of non-traditional objects, which were polyfunctional). The transition, however, did not go smoothly. Colour that loudly announced itself as such soon began to be perceived as over-aggressive, and before long it was excluded from model forms, whether in clothing or in furnishing, in favour of a somewhat relieved return to discreet tones. There is a kind of obscenity of colour which modernity, after exalting it briefly as it did the explosion of form, seems to end up apprehending in much the same way as it apprehends pure functionality: labour should not be discernible anywhere – neither should instinct be allowed to show its face. The dropping of sharp contrasts and the return to 'natural' colours as opposed to the violence of 'affected' colours reflects this compromise solution at the level of model objects. At the level of serially produced objects, by contrast, bright colour is always apprehended as a sign of emancipation – in fact it often compensates for the absence of more fundamental qualities (particularly a lack of space). The discrimination here is obvious: associated with primary values, with functional objects and synthetic materials, bright, 'vulgar' colours always tend to predominate in the serial interior. They thus partake of the same anonymity as the functional object: having once represented something approaching a liberation, both have now become signs that are merely traps, raising the banner of freedom but delivering none to direct experience.

Furthermore – and this is their paradox – such straightforward and 'natural' colours turn out to be neither. They turn out to be nothing but an impossible echo of the state of nature, which explains why they are so aggressive, so naïve – and why they so very quickly take refuge in an order which, for all that it is no longer the old moral order with its complete rejection of colour, is nevertheless a puritanical order of compromise with nature. This is the order, or reign, of *pastels*. Clothing, cars, showers, household appliances, plastic surfaces – nowhere here, it seems, is the 'honest' colour that painting once liberated as a living force now to be found. Instead we encounter only the pastels, which aspire to be living colours but are in fact merely *signs* for them, complete with a dash of moralism.

All the same, even though these two compromises, the flight into black and white and the flight into pastels ultimately voice the same disavowal of pure colour as the direct expression of instinctual life, they do not do so in accordance with the same system. The first is systematized by reference to an unequivocally moral and anti-natural black/white paradigm, whereas the pastel solution answers to a system with a larger register founded *not on opposition to nature but on naturalness*. Nor do the two systems have the same function. Black (or grey) retains the meaning of distinction, of culture, as opposed to the whole range of vulgar colours. As for white, it remains largely pre-eminent in the 'organic' realm: bathrooms, kitchens, sheets, linen – anything that is bound up

with the body and its immediate extensions has for generations been the domain of white, a surgical, virginal colour which distances the body from the dangers of intimacy and tends to neutralize the drives. It is also in this unavoidable area of hygiene and down-to-earth tasks that the use of synthetic materials, such as light metals, formica, nylon, plastiflex, aluminium, and so forth, has experienced its most rapid growth and achieved a dominant position. Of course the lightness and practical utility of these materials have much to do with their success, but the very convenience they offer does not merely lighten the burden of work, it also helps to drain value from this whole basic area. The fluid, simplified lines of our refrigerators or similar machines, with their plastic or artificial lightweight material, operate likewise as a kind of 'whiteness' – as a non-stressed indicator of the presence of these objects that bespeaks the radical omission from our consciousness of the responsibilities they imply, and of bodily functions in general, which are never innocent. Little by little colour is making inroads here, too, but resistance to this development is very deeply felt. In any case, even if kitchens are blue or yellow, even if bathrooms are pink (or even black – a 'snobbish' black as a reaction to the former 'moral' white), we may still justifiably ask to what nature such colours allude. For even if they do not turn pastel, they do connote a kind of nature, one that has its own history: the 'nature' of leisure time and holidays.

It is not 'real' nature which suddenly transfigures the atmosphere of daily life, but holidays – that simulacrum of nature, the reverse side of everyday routine, thriving not on nature but on the Idea of Nature. It is holidays that serve as a model here, holidays whose colours devolve into the primary everyday realm. And it was indeed in the fake natural environment of holidays, with its caravan, tents and camping gear, experienced as a model and as a zone of freedom, that the tendency towards bright colours, to plasticity, to the ephemeral practicality of labour-saving gadgets, and so on, first came to the fore. We began by transplanting our little house into Nature, only to end up bringing the values of leisure and the idea of Nature back home with us. There has been a sort of flight of objects into the sphere of leisure: freedom and the absence of responsibilities are thus inscribed both in colours and in the transitory and insignificant character of materials and forms. [...]

Jean Baudrillard, extract from *Le Système des objets: la consommation des signes* (Paris: Gallimard, 1968) trans. James Benedict, *The System of Objects* (London and New York: Verso, 1996) 30–4.

DROWNED-MAN

GREEN

COAL TAR IMPOSSIBLE

ORANGE-BROWN

DEEP CHEAP-PERFUME

AQUAMARINE

CREAMY

CHOCOLATE

FBI-SHOE

BROWN

Thomas Pynchon, colour terms from Gravity's Rainbow, 1973

Thomas Pynchon
Some colour terms from *Gravity's Rainbow*//1973

Drowned-man green
Coal tar-impossible orange-brown
Deep cheap-perfume aquamarine
Creamy chocolate FBI-shoe brown

Thomas Pynchon, colour terms from the novel *Gravity's Rainbow* (New York: Viking, 1973) [lines 1 and 2] 693; [lines 3 and 4] 696.

Johnny Cash
The Man in Black//1971

Well you wonder why I always dress in black
Why you never see bright colours on my back
And why does my appearance seem to have a sombre tone
Well there's a reason for the things that I have on.

I wear black for the poor and the beaten down
Living in the hopeless and the hungry side of town.
I wear it for the prisoner who has long paid for his crime
But is there because he's a victim of his time.

I wear the black for those who've never read
Or listened to the words that Jesus said
About the road to happiness through love and charity
Why you'd think he's talking straight to you and me.

Well we're doing mighty fine I do suppose
In our streak-a-lightning cars and fancy clothes
But just so we're reminded of the ones who are held back
Up front there ought to be a man in black.

I wear it for the sick and lonely old
For the reckless ones whose bad trip left them cold
I wear the black in mourning for the lives that could have been
Each week we lose a hundred fine young men.

And I wear it for the thousands who have died
Believing that the Lord was on their side
I wear it for another hundred thousand who have died
Believing that we all were on their side.

Well there's things that never will be right I know
And things need changing every where you go
But until we start to make a move to make a few things right
You'll never see me wear a suit of white.

Oh I'd love to wear a rainbow every day
And tell the world that everything's ok
But I'll try to carry off a little darkness on my back
Till things are brighter I'll be the man in black.

William H. Gass
On Being Blue//1976

[...] It is intriguing to wonder whether the difficulties children have with colour, the quickness with which they pick up forms and functions and learn the names for bye-bye, truck, and auntie, yet at a late age (even five), without a qualm, call any colour by the name of any other, aren't found again in the history of our words, for oysters could not be oozier than these early designations. Blue is blue or green or yellow: what the hell. Or so it seems. Colours flood our space so fully that there isn't any. They allow us to discriminate among otherwise identical things (gold and green racing cars, football teams, jelly beans, red- brown- blond- and black-haired girls); however, our eye is always at the edge, establishing boundaries, making claims, so that colours principally enable us to

discern shapes and define relations, and it certainly appears that patterns and paths – first, last, and in between – are what we want and what we remember: useful contraptions, useful controls, and useful connections.

Yet the pig in the pigment is missing. Well, what do we need with all that fat? Our world could be grey as the daily paper and we'd not miss much in the way of shapes and sizes. An occasional bluebird might be overlooked fleeing extinction through a meadow – so what. As much an afterhue as afterthought, colours came to the movies as they came to the comics, and there they remain – surreal in their overlays – like bad printing. Hoopla is hoopla however it's hollered. Tinting that weed green or its trailer silver would not have improved my naked girl's grey and white image. No. Who cares for colour in a world of pure transmissions?

Children collect nouns, bugs, bottlecaps, seashells, verbs: what's that? what's it doing now? who's this? and with the greed which rushes through them like like rain down gulleys, they immediately grasp the prepositions of belonging and the pronouns of possession. But how often do they ask how cold it is, what colour, how loud, rare, warm, responsive, kind, how soft, how wet, how noxious, loving, indiscreet, how sour?

Measures, not immersions, concerned our sciences almost from the beginning, and we were scarcely out of the gate before Democritus was declaring fiercely that 'colour exists by convention, sweet by convention, bitter by convention; in truth nothing exists but the atoms and the void.' Although Anaxagoras had already claimed that we see nothing but light reflected in the pupil of the eye, the real organ of perception, all along, was Mind. It was the soul that saw for Plato, too, yet colour was a dissembling cosmetic, the tinted marble and the gilded thigh, perfume for the iris, spice for spoiled meat, and when the mind put a public face on, as Protagoras might, or Gorgias did, in pursuit of persuasion, it painted itself like an old whore for the light, and with one finger gooey from the colour pot circled its sockets with the pale cream and grey-blue grit of the shaven pubis, smearing on each cheek a paste which matched the several pallors of debauchery, though these undertoning blues and violets were startled sometimes by spots of cantharidian red, or else with the whole hand it spread a melancholy which gently purpled the spent body like a bruise. [...]

So – in short – colour is consciousness itself, colour is feeling, and shape is the distance colour goes securely, as in our life we extend ourselves through neighbourhoods and hunting grounds; while form in its turn is the relation of these inhabited spaces, in or out or up or down, and thrives on the difference between kitchen and pantry. This difference, with all its sameness, is yet another quality, alive in time like the stickiness of honey or the gently rough lap of the cat, for colour is connection. The deeds and sufferings of light, as Goethe says, are ultimately song and celebration. Praise is due blue, the preference of the bee.

But how many critics mimic Aristotle instead, although Aristotle's eyes were always in his reason: ' ... in painting: if someone should smear the picture with the most beautiful colours, but at random, he would not please us as much as if he gave us a simple outline on a white ground.' The Philosopher has his thumb on the scales. Which is more likely to hold our interest, he should have asked: beautiful colours laid on randomly, or any delicately graven scribble? because, to be fair, line should be matched against colour, not colour against outline. The unity of an outline is derivative anyway, borrowed from the object it presumably limns, and *that* unity may be quite imaginary. What unifies the shape of a typed 't' but function and familiarity? There is none in the mark itself. A colour's unity is inherent, however, since it is continuously, insistently, indivisibly present in what it is. Furthermore, every colour is a completed presence in the world, a recognizable being apart from any object, while a few odd lines (since a line is only an artificial edge), a few odd lines are: nothing – thin strings of hue ... and what of that white ground Aristotle asks for? deny him that and give him a black base for a white design instead ... then perhaps violet with green ... chartreuse with red, so he can see how character comes and goes with colour. [...]

Of the colours, blue and green have the greatest emotional range. Sad reds and melancholy yellows are difficult to turn up. Among the ancient elements, blue occurs everywhere: in ice and water, in the flame as purely as in the flower, overhead and inside caves, covering fruit and oozing out of clay. Although green enlivens the earth and mixes in the ocean, and we find it, copperish, in fire; green air, green skies, are rare. Grey and brown are widely distributed, but there are no joyful swatches of either, or any of exuberant black, sullen pink, or acquiescent orange. Blue is therefore most suitable as the colour of interior life. Whether slick light sharp high bright thin quick sour new and cool or low deep sweet thick dark soft slow smooth heavy old and warm: blue moves easily among them all, and all profoundly qualify our states of feeling. [...]

When the trumpet brays, Kandinsky hears vermilion. The violin plays green on its placid middle string. Blues darken through the cello, double bass and organ, for him, and the bassoon's moans are violet like certain kinds of gloom. He believes that orange can be rung from a steeple sometimes, while the joyous rapid jingle of the sleigh-bell reminds him of raspberry's light cool red. If colour is one of the contents of the world as I have been encouraging someone – anyone – to claim, then nothing stands in the way of blue's being smelled or felt, eaten as well as heard. These comparisons are only slightly relative, only somewhat subjective. No one is going to call the sounds of the triangle brown or accuse the tympanist of playing pink. [...]

The grander a cuisine is the less robust its hues will be. Still, we permit the appearance of our meats, sauces, fruits and vegetables to dominate our tongues

until it is difficult to divide a twist of lemon or a squeeze of lime from the colours of their rinds or separate yellow from its yolk or chocolate from the quenchless brown which seems to be the root, shoot, stalk and bloom of it. Yet I hardly think the eggplant's taste is as purple as its skin. In fact, there are few flavours at the violet end, odours either, for the acrid smell of blue smoke is deceiving, as is the tooth of the plum, though there may be just a hint of blue in the higher sauces. Perceptions are always profound, associations deceiving. No watermelon tastes red. [...]

William H. Gass, extracts from *On Being Blue: A Philosophical Inquiry* (Boston: David R. Godine, 1976) 61–3; 73–4; 75–7.

Faber Birren
Colour and Human Response//1978

Eyeless Sight
[...] In 1924 the French author Jules Romains published a book with the subtitle *Eyeless Sight*. While he never did enlist the support of the French Academy of Sciences, the success of his experiments was affirmed by many famous technical experts and scholars, among them Anatole France, who stoutly defended his theories. According to Romains, the skin of man was sensitive to light (a fact certainly true of virtually all forms of life, man included). This he called paroptic perception. Using specially designed screens so that light would reach various parts of the body, but not the eyes, he stimulated paroptic perception to action. I quote from his book: 'For example, if the hands are bare, the sleeves lifted to the elbows, the forehead clear, the chest uncovered, the subject reads easily at a normal speed, a page of a novel or a newspaper article, printed in ordinary print.'

Romains declared the hands to be most sensitive, then the neck and throat, cheeks, forehead, chest, back of neck, arms and thighs. Elemental images formed in the tactile nerves 'saw' colour as well as form. He explains, 'Our experiments place beyond doubt the existence in man of a *paroptic function*, that is, a function of visual perception of exterior objects (colour and form), without the intervention of the ordinary mechanism of vision through the eyes.' He contended that any intelligent person might be able to read the titles of a newspaper while blindfolded. 'Under normal illumination the qualitative perception of colours is perfect.' One might even 'smell' colours through one's

nose. 'Perception of colours by the nasal mucosa is not of an olfactory order; that is, it does not consist in a recognition of odours belonging to the colouring substances. It is a perception specifically optical.'

Not much progress was made for some time after Romains, for the world in which he lived was an incredulous one that demanded facts more substantial than the ones presented. About forty years later a fabulous lady (then others) was found who could read and distinguish colours with the tips of her fingers. This revived fascination with the phenomenon, and it gained international publicity.

An excellent account of modern eyeless sight is given in the Sheila Ostrander and Lynn Schroeder book *Psychic Discoveries Behind the Iron Curtain*. A Russian girl, Rosa Kuleshova, could see with her fingers! Doubting doctors witnessed her ability to read type and name colours 'as if she's grown a second set of eyes in her fingertips'. Rosa was taken to Moscow, where she continued to perform wonders under close scrutiny. She still could 'see' red, green, blue when the coloured sheets were covered with tracing paper, cellophane or glass. The great Russian Biophysics Institute of the Academy of Sciences was bewildered but had to admit Rosa's 'dermo-optics'. *Life* magazine at the time sent a reporter to Moscow and later ran an illustrated feature story.

Others appeared who had the same mystical ability, including a woman from Flint, Michigan, Mrs Patricia Stanley. It seemed that some colours were sticky, some smooth, some rough. As she noted in *Life* magazine (12 June 1964): 'Light blue is smoothest. You feel yellow as very slippery, but not quite as smooth. Red, green and dark blue are sticky. You feel green as stickier than red, but not as coarse. Navy blue comes over as the stickiest, and causes a braking feeling. Violet gives a greater braking effect that seems to slow the hand and feels even rougher.'

There is a relationship here to eidetic imagery: eyeless sight seems to be a natural endowment, for it is most noticeable in children from the ages of seven to twelve years. Could the blind be trained to see and distinguish colours with fingers, elbow, tongue, nose? Since Rosa Kuleshova the Russians have further investigated skin sight in the hopes that the blind could be given at least some 'visual' perception, even if weak. A few have been so trained. Perhaps as long as the true organ of perception is in the brain, not in the eye, clues from the body, the skin can be used by the blind to 'see' the world and its spectral hues. As Ostrander and Schroeder note, 'If certain critical objects like doorknobs, faucets, telephones, handles on pots, dishes, particularly movable objects were coloured, say, yellow in a room brilliantly lit with yellow bulbs, the blind might actually be able to see with their skin almost as easily as we locate a coffee pot with our eyes.' [...]

Faber Birren, extract from *Colour and Human Response* (New York: John Wiley and Sons, Inc., 1978) 28–9.

Theodor Adorno
Black as an Ideal//1970

If works of art are to survive in the context of extremity and darkness, which is social reality, and if they are to avoid being sold as mere comfort, they have to assimilate themselves to that reality. Radical art today is the same as dark art: its background colour is black. Much of contemporary art is irrelevant because it does not take note of this fact, continuing instead to take a childish delight in bright colours. The ideal of blackness is, in substantive terms, one of the most profound impulses of abstract art. It may well be that the naïve tinkering with sound and colours that is current now is a response to the impoverishment wrought by the ideal of blackness. It may also be that one day art will be able to invalidate that ideal without committing an act of treachery. Brecht may have had an inkling of this when he put down these verses: 'What an age is this anyway where/A conversation about trees is almost a crime/Because it entails being silent about so many misdeeds?' By being voluntarily poor itself, art indicts the unnecessary poverty of society. By the same token, art indicts asceticism, which is not a suitable norm for art. Along with the impoverishment of means brought on by the ideal of the black, if not by functionalist matter-of-factness, we also notice an impoverishment of the creations of poetry, painting and music themselves. On the verge of silence, the most advanced forms of art have sensed the force of this tendency.

One has to be downright naïve to think that art can restore to the world the fragrance it has lost, according to a line by Baudelaire. Baudelaire's insight is apt to fuel the scepticism as to whether or not art is still possible even though it does not send art crashing down. Already during the early Romantic period, an artist like Schubert, who later was to become the darling of affirmative ideologues of culture, had his doubts about whether or not there is such a thing as cheerful art. The injustice inherent in all cheerful art, especially in the form of entertainment, is an injustice against the stored-up and speechless suffering of the dead. All the same, black art has certain features which, if hypostatized, would perpetuate our historical despair. Therefore, as long as there is hope for change, these features may be regarded as ephemeral, too.

The old but battle-scarred hedonism in aesthetics has recently zeroed in on what it claims to be a perverse implication of the ideal of blackness, namely the notion that the dark aspects of art ought to yield something approximating pleasure, as is the case with black humour in the context of Surrealism. Actually, the ideal of darkness does no more and no less than postulate that art properly

understood finds happiness in nothing except its ability to stand its ground. This happiness illuminates the sensuous phenomenon from the inside. Just as in internally consistent works of art spirit penetrates even the most impermeable phenomena, redeeming them sensuously, as it were, so blackness too – the antithesis of the fraudulent sensuality of culture's façade – has a sensual appeal. There is more pleasure in dissonance than in consonance – a thought that metes out justice to hedonism, measure for measure. The discordant moment, dynamically honed to a point and clearly set off from the homogeneous mass of affirmative elements, becomes a stimulus of pleasure in itself. And it is this stimulus together with the disgust with feeble-minded affirmation that ushers modern art into a no-man's land, which is a plenipotentiary of a world made habitable. This aspect of modernism has been realized for the first time in Arnold Schönberg's *Pierrot lunaire*, where the imaginary essence of details and a dissonant totality are combined into one. Negation can pass over into pleasure but not into positivity. […]

Theodor Adorno, 'Black as an Ideal', extract from *Ästhetik Theorie* (Frankfurt am Main: Suhrkamp, 1970); trans. C. Lenhardt, *Aesthetic Theory* (London: Routledge & Kegan Paul, 1984) 58–60 [footnotes not included].

Julia Kristeva
The Triple Register of Colour//1972

In the search for a clue to artistic renewal, attention has often been given to the composition and geometrical organization of Giotto's frescoes. Critics have less frequently stressed the importance of colour in the pictorial 'language' of Giotto and of painters in general. This is probably because 'colour' is difficult to *situate* both within the *formal system* of painting and within painting considered as a *practice* – therefore, in relation to the painter. Although semiological approaches consider painting as a language, they do not allow an equivalent for colour within the elements of language identified by linguistics. Does it belong among phonemes, morphemes, phrases or lexemes? If it ever was fruitful, the language /painting analogy, when faced with the problem of colour, becomes untenable. Any investigation of this question must therefore start from another hypothesis, no longer structural, but *economic* – in the Freudian sense of the term. […]

Colour [...] can be defined as being articulated on a triple register within the domain of visual perceptions: an instinctual pressure linked to external visible objects; the same pressure causing the eroticizing of the body proper via visual perception and gesture; and the insertion of this pressure under the impact of censorship as a sign in a system of representation.

Matisse alludes to colour having such a basis in instinctual drives when he speaks of a '*retinal sensation* [that] destroys the calm of the surface and the contour'; he even compares it to that of voice and hearing: 'Ultimately, there is only a *tactile vitality* comparable to the "vibrato" of the violin or voice.'[1] And yet, although subjective and instinctual, this advent of colour (as well as of any other 'artistic device') is necessarily and therefore *objectively* occasioned and determined by the historically produced, formal system in which it operates:

> Our senses have an age of development which does not come from the immediate surroundings, but from a moment in civilization. We are born with the sensibility of a given period of civilization. And that counts for more than all we can learn about a period. The arts have a development which comes not only from the individual, but also from an accumulated strength, the civilization which precedes us. One can't do just anything. A talented artist cannot do just as he likes. If he used only his talents, he would not exist. We are not the masters of what we produce. It is imposed on us.[2]

One might therefore conceive colour as a complex economy effecting the condensation of an excitation moving towards its referent, of a physiologically supported drive, and of 'ideological values' germane to a given culture. Such values could be considered as the necessary historical decantation of the first two components. Thence, colour, in each instance, must be deciphered according to: (1) the scale of 'natural' colours; (2) the psychology of colour perception and, especially, the psychology of each perception's instinctual cathexis, depending on the phases the concrete subject goes through with reference to its own history and within the more general process of imposing repression; and (3) the pictorial system either operative or in the process of formation. A pre-eminently composite element, colour condenses 'objectivity', 'subjectivity', and the intrasystematic organization of pictorial practice. It thus emerges as a grid (of *differences* in light, energetic charge, and systematic value) whose every element is linked with several interlocking registers. Because it belongs to a painting's system, and therefore, to the extent that it plays a structural role in any subject-elaborated apparatus, colour is an index of value (of an objective referent) and an instinctual pressure (an erotic implication of the subject); it hence finds itself endowed with new functions it does not

possess outside this system and, therefore, outside pictorial practice. In a painting, colour is pulled from the unconscious into a symbolic order; the unity of the 'self' clings to this symbolic order, as this is the only way it can hold itself together. The triple register is constantly present, however, and colour's diacritical value within each painting's system is, by the same token, withdrawn towards the unconscious. As a result, colour (conpact within its triple dimension) escapes censorship; and the unconscious irrupts into a culturally coded pictorial distribution.

Consequently, the chromatic experience constitutes a menace to the 'self', but also, and to the contrary, it cradles the self's attempted reconstitution. Such an experience follows in the wake of the specular-imaginary self's formation-dissolution. Linked therefore to primary narcissism and to subject–object indeterminacy, it carries traces of the subject's instinctual drive toward unity (*Lust-Ich*) with its exterior surrounding, under the influence of the pleasure principle about to become reality principle under the weight of rejection, the symbolic function, and repression.[3] But chromatic experience casts itself as a turning point between the 'self's' conservative and destructive proclivities; it is the place of narcissistic eroticism (autoeroticism) and death drive – never one without the other. If that experience is a revival of the 'self' through and beyond the pleasure principle, such a revival never succeeds in the sense that it would constitute a subject *of* (or *under*) symbolic law. This is because the symbolic necessity, or the interdiction laid down by colour, are never absolute. Contrary to delineated *form* and *space*, as well as to *drawing* and *composition* subjected to the strict codes of representation and verisimilitude, colour enjoys considerable freedom. The colour scale, apparently restricted by comparison with the infinite variation of forms and figures, is accepted as the very domain of whim, taste and serendipity in daily life as much as in painting. If, nevertheless, the interplay of colours follows a particular historical necessity (the chromatic code accepted in Byzantine painting is not the same as that of the Renaissance) as well as the internal rules of a given painting (or any device whatsoever), still such a necessity is weak and includes its own transgression (the impact of instinctual drive) at the very moment it is imposed and applied.

Colour might therefore be the space where the prohibition foresees and gives rise to its own immediate transgression. It achieves the momentary dialectic of law – the laying down of One Meaning so that it might at once be pulverized, multiplied into plural meanings. Colour is the shattering of unity. Thus, it is through colour – colours – that the subject escapes its alienation within a code (representational, ideological, symbolic, and so forth) that it, as conscious subject, accepts. Similarly, it is through colour that Western painting began to escape the constraints of narrative and perspective norm (as with Giotto) as well as

representation itself (as with Cézanne, Matisse, Rothko, Mondrian). Matisse spells it in full: it is through colour – painting's fundamental 'device', in the broad sense of 'human language' – that revolutions in the plastic arts come about.

> When the means of expression have become so refined, so attenuated that their power of expression wears thin, it is necessary to return to *the essential principles which made human language*. They are, after all, the principles which 'go back to the source', which relive, which give us life. Pictures which have become refinements, subtle gradations, dissolutions without energy, call for *beautiful blues, reds, yellows* – matters to stir the *sensual depths in men*.[4]

The chromatic apparatus, like rhythm for language, thus involves a shattering of meaning and its subject into a scale of differences. These, however, are articulated within an area beyond meaning that holds meaning's surplus. Colour is not zero meaning; it is excess meaning through instinctual drive, that is, through death. By destroying unique normative meaning, death adds its negative force to that meaning in order to have the subject come through. As asserted and differentiating negativity, pictorial colour (which overlays the practice of a subject merely speaking in order to communicate) does not erase meaning; it maintains it through multiplication and shows that it is engendered as the meaning of a singular being. As the dialectical space of a psycho-graphic equilibrium, colour therefore translates an oversignifying logic in that it inscribes instinctual 'residues' that the understanding subject has not symbolized.[5] It is easy to see how colour's logic might have been considered 'empty of meaning', a mobile grid (since it is subjective), but outside of semantics, and therefore, as dynamic law,[6] rhythm, interval,[7] gesture. We would suggest, on the contrary, that this 'formal', chromatic grid, far from empty, is empty only of a 'unique or ultimate signified'; that it is heavy with 'semantic latencies' linked to the economy of the subject's constitution within significance.

Colour, therefore, is not the black cast of form, an undefilable, forbidden, or simply deformable figure; nor is it the white of dazzling light, a transparent light of meaning cut off from the body, conceptual, instinctually foreclosed. Colour does not suppress light but segments it by breaking its undifferentiated unicity into spectral multiplicity. It provokes surface clashes of varying intensity. Within the distribution of colour, when black and white are present, they too are colours; that is to say, instinctual/diacritical/representational condensations.

After having made manifest and analysed the 'mystery' of light and the chemical production of colours, science will no doubt establish the objective basis (biophysical and biochemical) of colour perception; just as contemporary linguistics, having discovered the phoneme, is seeking its corporeal,

physiological and, perhaps, biological foundation. Psychoanalytic research will then make it possible, proceeding not only from the objective basis of perception and of the phases of the subject's passage through chromatic acquisition parallel to linguistic acquisition, to establish the more or less exact psychoanalytic equivalents of a particular subject's colour scale. (These phases would include the perception of such and such a colour at a given stage; the state of instinctual drive cathexes during this period; the relationship to the mirror phase, to the formation of the specular 'I'; relationship to the mother; etc.) Given the present state of research, we can only outline certain general hypotheses on the basis of our observations concerning painting's relationship to the subject's signifying mode. In all likelihood, these hypotheses involve the observer much more than they can lay any claim to objectivity. [...]

1 [footnote 8 in source] Henri Matisse, Statements to Tériade (1929–30); reprinted in *Matisse on Art*, ed. Jack Flam (London: Phaidon Press, 1973) 58. My italics.

2 [9] Matisse, Statements to Tériade (1936), in *Matisse on Art*, op. cit., 74.

3 [10] Marcelin Pleynet has shown, in the case of Matisse, the connection between chromatic experience, relation to the mother, and above all the oral phase of infantile eroticism that dominates not only the pre-Oedipal experience, but also the phase preceding the 'mirror stage' (and therefore, the constitution of the specular 'I'), whose role proves to be capital, not only in elucidating the genesis of the symbolic function, but even more so, in structuring the 'artistic function'. Cf. Marcelin Pleynet, 'Le Système de Matisse', in *L'Enseignement de la peinture* (Paris: Seuil, 1971) 67–74. Reprinted in Pleynet, *Système de la peinture* (Paris: Seuil, 1977) 66–75.

4 [11] Matisse, Statements to Tériade (1936), in *Matisse on Art*, op. cit., 74. My italics.

5 [12] By that token, its function is related (in the domain of sight) to rhythm's function and, in general, to the musicality of the literary text, which, precisely in this way, introduces instinctual drive into language.

6 [13] *Physical* theories of colour have at times embraced this point of view. According to wave theory, each material atom is made up of a sub-atom of colour or sound whose connections are immaterial: *dharmas* or *laws*. Anaxagoras held that colours represent the interplay of an infinity of seeds corresponding to the infinity of luminous sensations.

7 [14] Plato maintained that 'what we say "is" this or that colour will be neither the eye which encounters the motion nor the motion which is encountered, but something which has arisen between the two and is peculiar to each percipient.' – *Theaetetus*, trans. F.M. Cornford, in *Collected Dialogues* (Princeton University Press, 1978) 858–9. [...]

Julia Kristeva, extracts from 'La Joie de Giotto', *Peinture*, no. 2–3 (Paris, January 1972); trans. Thomas Gora, Alice Jardine and Leon S. Roudiez, in Kristeva, *Desire in Language* (Berkeley and Los Angeles: University of California Press, 1980) 216; 219–22.

Jacques Derrida
Plato's Pharmacy//1972

[…] The illusionist, the technician of sleight-of-hand, the painter, the writer, the *pharmakeus*. This has not gone unnoticed: '… isn't the word *pharmakon*, which means colour, the very same word that applies to the drugs of sorcerers or doctors? Don't the casters of spells resort to wax figurines in pursuing their evil designs?'[1] Bewitchment (*l'envoûtement*) is always the effect of a representation, pictorial or scriptural, capturing, captivating the form of the other, par excellence his face, countenance, word and look, mouth and eye, nose and ears: the *vultus*. […]

Jacques Derrida, extract from *La Dissémination* (Paris: Éditions du Seuil, 1972); trans. Barbara Johnson, *Dissemination* (London: The Athlone Press, 1993) 140.

Roland Barthes
Colour//1975

Current opinion always holds sexuality to be aggressive. Hence the notion of a happy, gentle, sensual, jubilant sexuality is never to be found in any text. Where are we to read it, then? In painting, or better still: in colour. If I were a painter, I should paint only colours: this field seems to me freed of both the Law (no Imitation, no Analogy) and Nature (for after all, do not all the colours in Nature come from the painters?).

Roland Barthes, 'La couleur/Colour', from *Roland Barthes par Roland Barthes* (Paris: Éditions du Seuil, 1975); trans. Richard Howard, *Roland Barthes by Roland Barthes* (New York: Hill and Wang, 1977) 143. Translation © 1977 Farrar, Straus and Giroux.

Roland Barthes
Cy Twombly//1979

[...] It looks as if Cy Twombly is an 'anti-colourist'. But what is colour? A kind of bliss. That bliss is in Twombly. In order to understand him, we must remember that colour is *also* an idea (a sensual idea): for there to be colour (in the blissful sense of the word) it is not necessary that colour be subject to rhetorical modes of existence; it is not necessary that colour be intense, violent, rich, or even delicate, refined, rare, or again, thick-spread, crusty, fluid, etc.; in short, it is not necessary that there be affirmation, *installation* of colour. It suffices that colour appear, that it be there, that it be inscribed like a pinprick in the corner of the eye (a metaphor which in the *Arabian Nights* designates the excellence of a story), it suffices that colour lacerate something: that it pass in front of the eye, like an apparition – or a disappearance, for colour is like a closing eyelid, a tiny fainting spell. Twombly does not paint colour; at most, one might say that he *colours in*; but this colouring-in is rare, interrupted, and always instantaneous, as if one were trying out the crayon. This dearth of colour reveals not an effect (still less a verisimilitude) but a gesture, the pleasure of a gesture; to see engendered at one's fingertip, at the verge of vision, something which is both expected (I know that this crayon I am holding is blue) and unexpected (not only do I not know which blue is going to come out, but even if I knew, I would still be surprised, because colour, like the *event*, is new each time: it is precisely the *stroke* which makes the colour – as it produces bliss).

Furthermore, one suspects, colour is *already* in Twombly's paper in so far as that paper is *already* dirtied, tainted, with an unclassifiable luminosity. It is only a writer's paper which is white, which is 'clean', and that is not the least of his problems (Mallarmé's problem of the white page: often this whiteness, this blank provokes a panic: how to corrupt it?); the writer's misfortune, his difference (in relation to the painter, and especially to a painter of writing, like Twombly), is that he is forbidden graffiti: Twombly is, after all, a writer who has access to graffiti, with every justification and in sight of everyone. [...]

Roland Barthes, extract from 'Cy Twombly: Works on Paper' (1979) in *The Responsibility of Forms*, trans. Richard Howard (Berkeley and Los Angeles: University of California Press, 1985) 166–7.

Brice Marden
A Mediterranean Painting//1971

Deep blue, bright earth red, deep rich middle green

The Mediterranean painting ended up a glad day-glo dirge for a great dancing lady. A spot of deep mediterranean earth red is all that remains under an evasive flesh colour that fights its way back and forth between flesh life of death as a Daytona Beach tract house brown.

A right side: soft, very light, almost pissy green

– it must hold as a colour

Colour as character

Colour as weight

Colour as colour

Colour as value

Colour as light reflector

Colour as subcolour

I paint paintings in panels. They are not colour panels. Colour and surfaces must work together. They are painted panels.

A colour against a colour makes a colour situation.

How different situations work with each other.

How the colour relates to the outside edges of the painting.

What kind of tension exists across the shape of each panel. How these tensions relate across the whole plane of the painting.

Colour working as colour and value simultaneously.

A colour should turn back into itself.

It should reveal itself to you while, at the same time, it evades you.

I work with no specific theories or ideas.

I try to avoid interior decorating colour combinations.

A child mounts his tricycle and rides away into a tree.

Brice Marden, statement titled 'A Mediterranean Painting' (1971), in *Brice Marden: Paintings, Drawings and Prints 1975–80* (London: Whitechapel Art Gallery, 1981) 56.

Ane Truitt
Daybook//1974

12 October
This winter is bringing me to a confrontation with the truth behind truths, like the colour I know to lie just beyond colour.

I remember how startled I was when, early in 1962, I realized that I was becoming obsessed with colour as having meaning not only in counterpoint to the structures of fences and the bulks of weights – which were, I had thought, my primary concern – but also in itself, as holding meaning all on its own. As I worked along, making the sculptures as they appeared in my mind's eye, I slowly came to realize that what I was actually trying to do was to take paintings off the wall, to set colour free in three dimensions for its own sake. This was analogous to my feeling for the freedom of my own body and my own being, as if in some mysterious way I felt myself to *be* colour. This feeling grew steadily stronger until the setback of my experience in Japan when in despair that my work no longer materialized somewhere in my head, I began to concentrate on the construction of aspects of form, for me a kind of intellectual exercise. When we came back to America in 1967, I returned home to myself as well as to my country, abandoned all play with form for the austerity of the columnar structure, and let the colour, which must have been gathering force within me somewhere, stream down over the columns on its own terms. [...]

Anne Truitt, extract from *Daybook: The Journal of an Artist (1974–79)* (New York: Pantheon Books/Harmondsworth: Penguin Books, 1982) 81–2.

Gerhard Richter
Letter to E. de Wilde//1975

[...] At first (about eight years ago) when I painted a few canvases grey I did so because I did not know what I should paint or what there might be to paint, and it was clear to me when I did this that such a wretched starting point could only lead to nonsensical results.

But in time I noticed differences in quality between the grey surfaces and

also that these did not reveal anything of the destructive motivation. The pictures started to instruct me. By generalizing the personal dilemma they removed it; misery became a constructive statement, became relative perfection and beauty, in other words became painting.

Grey. Grey is the epitome of non-statement. It does not trigger off feelings or associations, it is actually neither visible nor invisible. Its inconspicuousness makes it suitable for mediation, for illustration, and in that way virtually as an illusion, like a photograph.

And like no other colour it is suitable for illustrating 'nothing'.

For me grey is the welcome and only possible equivalent for indifference, for the refusal to make a statement, for lack of opinion, lack of form. But because grey, just like shapelessness, etc., can only be notionally real, I can only produce a shade of colour that means grey but is not grey. The picture is then a mixture of grey as fiction and grey as a visible, proportioned colour surface. [...]

Gerhard Richter, extract from letter to E. de Wilde, 23 February 1975; reprinted in *Gerhard Richter* (London: Tate Gallery, 1991) 110–14.

Kenneth Noland
Colour, Format and Abstract Art:
Interview with Diane Waldman//1977

Diane Waldman Both you and Morris Louis were beginning to develop your own styles in the 1950s. You saw some of the values of Abstract Expressionism but also reacted against its self-conscious mannerisms.

Kenneth Noland [...] We were making abstract art, but we wanted to simplify the selection of materials, and to use them in a very economical way. To get to raw canvas, to use the canvas unstretched – to use it in more basic and fundamental ways, to use it as fabric rather than as a stretched surface.

To use paint, thinner and more economically, to find new paints, from the industrial system, like plastics. This is something that artists have always done. They've always used a minimum of the means of technology in any period. Art has never used the maximum of technology, only the least. Paint and canvas, or paint and wood, or clay, or stone, or waste steel, or paper. We've all of us had an instinct to use a minimum means. [...]

Waldman You've mentioned that the more recent of your new shaped canvases begin to have a sense of the circle again.

Noland Yes. There's a rotary movement, no longer the sense of a field. I've had to bear down on the activity of the shapes; therefore the colour is more structural than before. As the shape assumed more emphasis in my recent work, and I began to use fewer colours, I began to increase the density of the colours, so that the alignment of colour was replaced by the volume and density of colour.

Waldman Your recent paintings are not huge; has your concept of scale changed?

Noland No. I think part of the individual's right to be creative and expressive, for our generation, was to declare large spaces for art. Abstract art in particular began to spread and occupy more space as entities, and that demand for space went along with the instinct to make the art as 'bright' as possible, which still exists. Once the battle for space was won, we felt we could begin to paint smaller, more compactly. Hans Hofmann was significant in this respect because he didn't paint huge pictures. He painted compact pictures, used more tactility and substance than spread or field. Subsequently Olitski extended this.

I think that sculpture recently has been involved with that same impulse. Sculpture doesn't necessarily have to be so big; it can get dense and carry expressive force in terms of compactness.

Waldman Has your friendship with a number of prominent sculptors influenced you to make sculpture?

Noland The artists that I have been related to have been working friends and personal friends such as Morris Louis, Jules Olitski, Tony Caro, David Smith. Because of a long relationship with David Smith and then because Tony Caro lived and worked in Bennington for several years, I began to try my hand at sculpture.

Waldman How did that affect the recent shaped paintings? They seem to me to have more volume, more weight, more density, more texture, more cuts, than your first group of shaped works [1975].

Noland Actually they are more compact.

Waldman I don't think of your paintings as so-called shaped canvases. They're not built out, they don't become quasi-reliefs – half-sculpture, half-painting – or use the rectangle of the wall as a field to contain the shapes of the canvas.

Noland Yes, I want my pictures to stay intact, included in their own boundaries. Paintings have their own boundaries, their own zones, their own limits. The wall could become an issue if it were allowed to shape the space of a painting.

Waldman Unless I'm mistaken, I don't see you painting a sculpture. That is, taking qualities in your painting and adding them to sculpture.

Noland I've tried, but it doesn't work. Tony Caro and I tried to collaborate at several points and it hasn't been successful. As a matter of fact, recently Tony has made sculpture that I have painted. He has to make the sculpture before I can paint it. That means that the form is taking precedence – that the material takes precedence as a form, rather than colour establishing the form. It's not going too well but I'm working on it. There's something about colour that is so abstract that it is difficult for it to function in conjunction with solid form. Because if colour really worked three-dimensionally as colour, it would have worked three-dimensionally as art. It would have worked better in billboards or machinery that we see outside. But it hasn't really worked successfully in an artistic or expressive sense. Colour has properties of weight, density, transparency, and so forth. And when it also has to be compatible with things that have an actual density, a given form, it's very difficult. It's difficult enough to get colour to work with the form that's necessary to make paintings, let alone something that is three-dimensional, with those other added factors.

Waldman A lot of polychrome sculpture that I've seen has been unsuccessful because the colour has worked against the material.

Noland Caro's painted sculpture works because it's painted one colour. And the colour does help enhance the abstract, expressive qualities of the form. Tim Scott is the only sculptor so far who has used colour three-dimensionally in, I think, a successful way.

Waldman But you see it as a real problem.

Noland It's such a problem I'm not even interested in it! If you get involved with colour, the factors can become just as actual as those of weight and density. It's just as real. The slight difference of transparency in colours can be the difference of a thousand pounds of actual material.

Waldman In terms of that change in density or change in texture, when you apply a colour to canvas, when you buff it down with a buffing machine, when

you build up another surface with gels or with varnishes or whatever, do you do that to alter the relationship of the colours?

Noland Well, it's a simple fact, when you move from one colour space to another colour space, that if there's a value contrast you get a strong optical illusion. Strong value contrast can be expressive and dramatic, like the difference between high or low volume or the low keys and the high keys on the piano. But normally a composer doesn't go just from one extreme to the other. There are ranges of things, two notes being hit side by side, for example. Either or both are possible.

Actually, if you're moving from one flat colour to another flat colour, if there's a difference of texture – if one is matt and the other is shiny – that contrast of tactility can keep them visually in the same dimension. It keeps them adjacent – side by side. Another reason is that a matt colour and a shiny, transparent colour are emotionally different. If something is warm and fuzzy and dense we have a kind of emotional response to that. If something is clear and you can see through it, like yellow or green or red can be, we have a different emotional sensation from that. So there's an expressive difference you can get that gives you more expressive range.

Waldman I've noticed that the mood of your paintings changes from painting to painting depending on the selection and textures of the colours. And that no two paintings – given the fact that you often use a similar motif – ever look alike. Nor can one ever react identically to those paintings.

Noland It's precisely colour that makes it possible to use the same motifs.

Waldman Can you be more specific about the mood of the paintings on either an emotional or referential level, with regard to the meaning of colour?

Noland We tend to discount a lot of meaning that goes on in life that's non-verbal. Colour can convey a total range of mood and expression, of one's experiences in life, without having to give it descriptive or literary qualities.

Waldman Colour can be mood, can convey human meaning. These colour moods can be the essence of abstract art.

One other question to do with the shaped canvases: in so far as shaping was one of the last decisions that you always made, cropping when you finished painting, from the time of the circles all the way up to now, could that have influenced your decision to move away from the square or rectangular formats that you used for so long?

Noland Well, it had to do with getting the colour to do different things. It turns out that certain picture shapes don't allow you to use different kinds of quantity distributions of colour for different expressions. The quantities and configurations of colours are as important as the colours themselves. When I first started painting circles, I went fairly quickly to a 6-foot square module. I think de Kooning said in an interview or artists' discussion that he only wanted to make gestures as big as his arm could reach. It struck me that he was saying his physical size had to do with the expressive size of the pictures he wanted to make. And as far as I know, when I got to the 6-foot-square size, it was right in terms of myself and wasn't too much of a field. Or it was a field, yet it was still physical. And that's why I used it for so long. Most all the chevrons and a majority of the circles are 6 feet square. Then, from having chosen that size, I could work in many different scales – I could make the different bands of the circles smaller or larger, or thinner or wider, which would change the internal scale of the works. Later, I varied the size of the shapes themselves: sometimes I would make 3-foot, 4-foot, 7-foot, 8 foot, and up to 10-foot sizes. It made it possible to vary all different degrees of size along with differences of scale.

Those decisions began to influence all my later work. The horizontal paintings were the ones where I varied the formats the most – I made them extremely long or fat or square, varying the sizes and scales, to put everything through permutations. That was a very liberating thing. […]

Waldman When, in the horizontal stripe paintings, the structure of the painting was generated more by the colour than by 'layout', it seemed to me that's when you got the freedom to cut the shapes of the pictures however you wanted from the entire field, rather than just cropping the perimeters (as in the circles, for example). So this allowed you to change the basic shape of the painting altogether – just as in the recent work.

Noland The plaids, too, could be shaped out of a field depending on where I wanted a different emphasis to occur for expressive reasons. A colour could be on an edge of a picture or inside the space of a picture: the question of top, bottom, left, right, became totally flexible as did the question of parallel or vertical or horizontal. Diane, that was more than a good question, that was an insight. […]

Kenneth Noland and Diane Waldman, extracts from 'Colour, Format and Abstract Art', Interview, *Art in America*, 65, no. 3 (May–June 1977) 99–100.

Peter Halley
On Line//1985

[...] Colour and drawing. These are the watchwords of a certain kind of formalism in the visual arts. The emphasis on drawing reflects the modern omnipresence of the linear, but the importance given to the role of colour also has a meaning. Colour in modernism is sometimes seen as a means of enacting an ideal of hedonistic release – of the freeing of the bourgeois sensibility from the constraints of morality and the symbolic. But this emphasis on colour also reflects the crucial role that colour plays in the realm of the linear. In the planar universe, only colour is capable of coding the linear with meaning: Coloured lines on maps distinguish the character of highways. Wires are coloured to mark their purpose. In hospitals, one can even follow coloured bands on the floor through labyrinthine corridors to one's destination. [...]

Peter Halley, extract from 'On Line' (1985) in Halley, *Collected Essays 1981–87* (Zürich: Bruno Bischofberger, 1988) 158.

Manlio Brusatin
The Story of Colours//1986

[...] In modern cities, one sees the appearance and disappearance of the material colour of rusted metals and antioxidant paints, which take on the same reddish tones of the corrosive agent they are intended to fight (the Eiffel Tower, for example, or the metal scaffolding of Victorian train stations), or instead simulate as accurately as possible the sheen or greyness of soldered, shining metal. The contemporary industrial age seeks to display itself with the brilliance and shine of metal or with a covering of metallic colours: their garments appear as the lucid awareness of progress whose enamel is quickly stripped away by production. The specific research taking place concerning anti-corrosive treatments for alloys (nickel plating, bronzing, non-rusting steel, anodized aluminum) tends, like a mechanical skin, to cover the body and the fate of objects, artificially lengthening their lives under the sign of incorruptibility.

An 'eternal colour' appears everywhere in the brilliance and glass clarity of

varnishes and enamels, which give colour the startling effect of a 'new' object, fresh from the factory. With the near-exclusive use of shiny metal and plastic employed in its place, one achieves in reality a falsification of the concept of duration and the extermination of the more noble metals, which, more than usury, evoke the sense of ageing well and the patina of time: copper, brass, bronze, lead. And we are speaking not of a wider use of true metals but rather the spread of shiny metal surfaces as 'colours' that take on the aspect of polished glass, completely overtaking the colour prestige of other metals, which then appear simply as decorative or artistic details.

Alongside this aesthetic of 'shine' moving between object and product, the body of the modern city takes on a tonality within the range of grey, not simply due to the process of obfuscation and soiling accelerated nowadays from the dust and pollution of industry and traffic, but also because of the colourless construction materials being used, like asphalt or cement, in marked contrast to the tonalities of the nineteenth-century cities still visible today. The washing and bleaching of historic buildings and façades looking onto city streets in order to recover a truer colour has attempted to remove the layers of dust to reveal the clearer tones of artistic details, but only till they are once again covered with a new layer of city black. The absence of colour from metropolitan buildings during the day can be perfectly captured in black-and-white photography and is in marked contrast to its night-time appearance, made up of multicoloured flashing lights and ephemeral furnishings.

Finally, interior objects and furnishings have undergone a gamut of shades, unnatural colours, not without harmony but rather artificially harmonized to reflect their colourless space on the faces of those who live with them. The white of domestic appliances and bathroom furnishings represents the imposition of old visual norms concerning hygiene, but once imposed, the objective is more easily extended to personal clothing in more 'pleasing' shades. Other, similar products in the marketplace of furnishings and clothing propose, unmistakably, the shades of navy blue or light brown as the intermediaries of grey, even while the isolated, postmodern explosions of colour call forth a countermovement of even more tenacious neutrality. Within this tired atmosphere, which flattens imagination and recognition, the colouring of food and drink carry out a further process of denaturation of the product through external treatments that make use of colour through an artificial aesthetic that, we discover, actually endangers our health: colours are poisons. [...]

Manlio Brusatin, extract from *Histoire des couleurs* (Paris: Flammarion, 1986); trans. Robert H. Hopcke, *The Story of Colours* (Boston: Shambhala, 1991) 150–3.

Roland Barthes
Camera Lucida//1980

[…] It is often said that it was the painters who invented Photography (by bequeathing it their framing, the Albertian perspective, and the optic of the *camera obscura*). I say; no, it was the chemists. For the *noeme* 'That-has-been' was possible only on the day when a scientific circumstance (the discovery that silver halogens were sensitive to light) made it possible to recover and print directly the luminous rays emitted by a variously lighted object. The photograph is literally an emanation of the referent. From a real body, which was there, proceed radiations which ultimately touch me, who am here; the duration of the transmission is insignificant; the photograph of the missing being, as Sontag says, will touch me like the delayed rays of a star. A sort of umbilical cord links the body of the photographed thing to my gaze: light, though impalpable, is here a carnal medium, a skin I share with anyone who has been photographed.

It seems that in Latin 'photograph' would be said '*imago lucis opera expressa*'; which is to say: image revealed, 'extracted', 'mounted', 'expressed' (like the juice of a lemon) by the action of light. And if Photography belonged to a world with some residual sensitivity to myth, we should exult over the richness of the symbol; the loved body is immortalized by the mediation of a precious metal, silver (monument and luxury); to which we might add the notion that this metal, like all the metals of Alchemy, is alive.

Perhaps it is because I am delighted (or depressed) to know that the thing of the past, by its immediate radiations (its luminances), has really touched the surface which in its turn my gaze will touch, that I am not very fond of colour. An anonymous daguerreotype of 1843 shows a man and a woman in a medallion subsequently tinted by the miniaturists on the staff of the photographic studio: I always feel (unimportant what actually occurs) that in the same way, colour is a coating applied *later on* to the original truth of the black-and-white photograph. For me, colour is an artifice, a cosmetic (like the kind used to paint corpses). What matters to me is not the photograph's 'life' (a purely ideological notion) but the certainty that the photographed body touches me with its own rays and not with a super-added light. […]

Roland Barthes, extract from *La Chambre claire* (Paris: Gallimard, 1980); trans. Richard Howard, *Camera Lucida: Reflections on Photography* (New York: Hill and Wang, 1981) 80–1.
Translation © 1981 Farrar, Straus and Giroux.

Gilles Deleuze
On Antonioni//1985

[...] If Antonioni is a great colourist, it is because he has always believed in the colours of the world, in the possibility of creating them, and of renewing all of our cerebral knowledge. He is not an author who moans about the impossibility of communicating in the world. It is just that the world is painted in splendid colours, while the bodies which people it are still insipid and colourless. The world awaits its inhabitants, who are still lost in neurosis. But this is one more reason to pay attention to the body, to scrutinize its tiredness and neurosis, to take tints from it. The unity of Antonioni's work is the confrontation of the body-character with his weariness and his past, and of the brain-colour with all its future potentialities, but the two making up one and the same world, ours, its hopes and its despair. [...]

Gilles Deleuze, extract from *Cinéma 2: l'image-temps* (Paris: Les Éditions de Minuit, 1985); trans. Hugh Tomlinson and Robert Galeta, *Cinema 2: The Time–Image* (London: The Athlone Press, 1989) 197.

Thierry de Duve
Colour and Its Name//1984

'These strange beings which one calls colours'
[...] Even when it is adequately named, colour exceeds the word. It is a remainder or a supplement without a name, a 'something extra' that forms its 'essential element' and that forms painting's essential being. It is paradoxically because the painter resists it that the word can be the pivot of a foundational inverted metaphor of its own specificity. When one tries to establish the elements of a language, even a mute one like painting, one bumps up against the model of language as such. But when it is a question of ensuring that the essence of this language is unspeakable, it becomes necessary to expel the model when it has finished its job. For the model to have a truth under such conditions, and for the metaphor to be more than an analogical and reversible image, it is necessary that a secret link, irreducible to the linguistic nature of either pictorial language or language proper, tie up the one to the other. It is necessary that they

nave a common, ineffable being. It is this being that Kandinsky calls 'inner sound'. It is at the heart of words as well as the heart of colours; it is this being that authorizes the passage from words to colours and founds the respective specificity of painting and poetry in their necessary transspecificity. [...] In seeing the colour come out of the tube, Kandinsky witnessed the birth of a being that language, with all its limitations, could name colour and poetry could surround with all those epithets that would make it a work of art, even before the start of any actual pictorial activity. But the name of colour could refer to nothing but the metaphor of its being, which was also its metaphorical being, its 'inner sound'.

The issue at stake in the relationship between colour and its name in Kandinsky goes far beyond his specific case, since it was nothing less than the production of a foundational ideologeme, not only in Kandinsky's painting but also in the whole of abstract painting. It is what infused into the various definitions of painting – whether technical, historical, or aesthetic—a philosophical ambition, and even a metaphysical one, that abstract painting never left behind for fear of being consigned to the ranks of decorative art or of never 'going beyond the domain of the nerves', of confusing the visuality – in [Konrad] Fiedler's sense – of 'retinal painting' with the titillations of Op art. It was also what presided over the modernist project: to locate the specificity of painting in its irreducible being and to base subsequent developments of pictorial language on an elementary metaphor that would speak of art's essence. [...]

In any case, Kandinsky could imagine a pictorial language freed of all referential obligations only by basing his semiotic project on an ontological dimension. The possibility of 'pure' or 'absolute' painting begins in the revelation of its 'essentially metaphorical' character. This means that there is no language that does not begin with an inaugural metaphor, but also that there is no metaphor that is not linguistic in essence. Colour, which with form – and before it – is the semiotic element of the painter, manifests an essential solidarity with the word that names it. If we were forced to admit that the being – the visual being, that is – of colour ceased to communicate with its name, this would be the end of pictorial language; the abandonment of figuration and the passage to abstraction would say nothing, and one could just as well abandon painting. [...]

Faced with the same 'discovery' as Kandinsky – that of the essentially metaphoric quality of painting – Duchamp gave it a supplementary turn of the screw that turned it back on itself. If metaphor is the being of painting, what, in painting, is the being of metaphor? Its name as painting. If the name transmits the being of colour, what is the being of the name of colour? Its name, once again. The revelation of the Symbolic comes when the 'word does not say anything except that it is a word' – when the signifier has no other signification than its own being as a signifier, when naming names only its naming function. [...]

'Colours that one talks about'

[...] Painting is not to be read. And colour does not speak, since it is, as for Kandinsky, short of or in excess of the language that names it, short of or in excess of the 'grammar' that it, in turn, is supposed to name. But, in contrast to Kandinsky's case, this deficiency or this excess is not its essential quality. Colour, mute yet visible, does not situate itself in the original or archlinguistic dimension of pure designation, as the very being of sense and meaning, sensible but as yet meaningless, attributed to it by the phenomenological tradition and by those painters who adhere to it.

It is words that are primary, or 'prime'. Colour has no being that it could share with its name, since as soon as it is designated, it is named. If it is necessary that an entire 'sentence' of the right part of [Duchamp's painting] *Tu m'* names a single grammatical relation that a specific sample of the left part designates, it is necessary, in turn, to use all the relations designated on the left to read a single 'sentence' on the right. The circuit of seeing and saying is interminable and begins nowhere, especially not in the act of primitive designation by a subject who is still *infans*.

As we know, the arbitrariness of the names for colours is the favourite example of linguists who want to show the primacy of language (*langue*) over speech (*parole*), of the system over the syntagm. The colour spectrum is continuous, and it is language that cuts it up. It is neither in nature nor in our eye that orange ceases to be orange and becomes red, nor in the speaking subjects who, faced with such a sample of colour, decide its name. It is in the language that gave them the choice of words.

If the English language had not placed orange between yellow and red, how are we to know that the perception of it would not have been different? If there is a link between colour and its name, this link could only be that of language in its totality, the law in its implacable pre-existence. Hence the possibility of short-circuiting the interminable circuit of seeing and saying: that which names the orange and specifies its experience in perception are the yellow and the red that frame it. And what names this red if not the orange and the purple that, on its right and its left, delimit its perception?

In short, the name of a colour is never anything but the result of a segmenting made by other colours, and so on. In this process in which words segment words, the name of a colour risks losing its designated referent, even though it vouches for that to which it corresponds. To red corresponds crimson, vermilion, and many others. The name of a colour is the name of a name, along the lines of the nominalist paradox of infinite regression illustrated in *Tu m'* by the perspectival arrangement of the colour samples. The question that remains is that of its vanishing point and of what this point avoids. Either it is imaginary

and it avoids the Symbolic, and we then have Kandinsky's 'solution', or it is symbolic and it avoids the Imaginary and we have 'Duchamp's 'solution'. [...]

Thierry de Duve, extracts from *Nominalisme pictural: Marcel Duchamp, La peinture et la modernité* (Paris: Les Éditions de Minuit, 1984); trans. Dana Polan with the author, *Pictorial Nominalism: On Marcel Duchamp's Passage from Painting to the Readymade* (Minneapolis: University of Minnesota Press, 1991) 122; 124; 125; 134–5.

Umberto Eco
How Culture Conditions the Colours We See//1985

Colour is not an easy matter. James Gibson, in *The Senses Considered as Perceptual Systems*, says that 'the meaning of the term colour is one of the worst muddles in the history of science'.[1] If one uses the term 'colour' to mean the pigmentation of substances in the environment, one has not said anything about our chromatic perception. Johannes Itten, in his *Kunst der Farbe*, distinguishes between pigments as chromatic reality and our perceptual response as chromatic effect.[2] The chromatic effect, it seems, depends on many factors: the nature of surfaces, light, contrast between objects, previous knowledge, and so on.

I do not have any competence about pigments and I have very confused ideas about the laws governing chromatic effect; moreover I am neither a painter, nor an art critic. My personal relationship with the coloured world is a private affair as much as my sexual activity, and I am not supposed to entertain my readers with my personal reactivity towards the polychromous theatre of the world.

Thus, as far as colours are concerned, I take the privilege of considering myself a blind man. I shall be writing about colours from a merely theoretical point of view, namely, from the point of view of a general semiotic approach.

Since I have assumed myself to be blind or at least a Daltonist, I shall mistrust my visual experience. I shall start from a verbal text, chapter 26, Book II of Aulus Gellius' *Noctes Acticae*, a Latin encyclopaedia of the second century A.D.

To deal with colours by making recourse to a text of this period is rather challenging. We are facing linguistic terms for colours, but we do not know what chromatic effects these words refer to. We know much about Roman sculpture and architecture, but very little about Roman painting. The colours we see today in Pompeii are not the colours the Pompeians saw; even if the pigments are the same, the chromatic responses are not. In the nineteenth century, Gladstone

suggested that Greeks were unable to distinguish blue from yellow. Goetz and many others assumed that Latin speakers did not distinguish blue from green. I have found also somewhere that Egyptians used blue in their paintings but had no linguistic term to designate it; Assyrians, in order to name the colour blue, could do no better than transform the noun 'uknu', naming lapis lazuli, into an adjective.

All of this is highly speculative, but we need not test every case. Let me concentrate on the following passage from Aulus Gellius. The reader is advised to hold his temper, since the passage is highly confusing.

Gellius is reporting a conversation he had with Fronto, a poet and grammarian, and Favorinus, a philosopher. Favorinus remarked that eyes are able to isolate more colours than words can name. Red (*rufus*) and green (*viridis*), he said, have only two names but many species. He was, without knowing it, introducing the contemporary scientific distinction between identification (understood as categorization) and discrimination, of which I shall speak later.

Favorinus continues: *rufus* is a name, but what a difference between the red of blood, the red of purple, the red of saffron, and the red of gold! They are all differences of red but, in order to define them, Latin can only make recourse to adjectives derived from the names of objects, thus calling *flammeus* the red of fire, *sanguineus* the red of blood, *croceus* the red of saffron, *aureus* the red of gold. Greek has more names, Favorinus says, but Fronto replies that Latin, too, has many colour terms and that, in order to designate *russus* and *ruber* (red), one can also use *fulvus, flavus, rubidus, poeniceus, rutilus, luteus, spadix*.

Now if one looks at the whole history of Latin literature, one notices that *fulvus* is associated by Virgil and other authors with the lion's mane, with sand, wolves, gold, eagles, but also with jasper. *Flavae*, in Virgil, are the hair of the blonde Dido, as well as olive leaves; and the Tiber river, because of the yellow-grey mud polluting its waters, was commonly called *flavus*. The other terms all refer to various gradations of red, from pale rose to dark red: notice, for instance, that *luteus*, which Fronto defines as "diluted red", is referred by Pliny to the egg-yolk and by Catullus to poppies.

In order to add more precision, Fronto says that *fulvus* is a mixture of red and green, while *flavus* is a mixture of green, red and white. Fronto then quotes another example from Virgil (*Georgica*, III, 82) where a horse (commonly interpreted by philologists as a dapple-grey horse) is *glaucus*. Now *glaucus* in Latin tradition stands for greenish, light-green, blue-green and grey-blue; Virgil uses this adjective also for willow trees and for *ulva* or sea lettuce, as well as for waters. Fronto says that Virgil could also have used for his same purpose (his grey horse) *caerulus*. Now this term is usually associated with the sea, skies, the eyes of Minerva, watermelons and cucumbers (Propertius), while Juvenal employs it to describe some sort of rye bread.

And things get no better with *viridis* (from which comes the Italian *verde*, green), since in the whole of Latin tradition, one can find *viridis* associated with grass, skies, parrots, sea, trees.

I have suggested that Latin did not clearly distinguish blue from green, but Favorinus gives us the impression that Latin users did not even distinguish blue-green from red, since he quotes Ennius (*Annales*, XIV, 372–3) who describes the sea at the same time as *caeruleus* and *flavus* as marble. Favorinus agrees with this, since – he says – Fronto had previously described *flavus* as a mixture of green and white. But one should remember that, as a matter of fact, Fronto had said that *flavus* was green, white and red, and a few lines before that, had classified *flavus* among various gradations of red!

Let me exclude any explanation in terms of colour blindness. Too easy. Gellius and his friends were erudites; they were not describing their own perceptions, they were elaborating upon literary texts coming from different centuries. Can one say that they were considering cases of poetic invention – where, by a provocative use of language, fresh and uncommon impressions are vividly depicted? If that were the case, we would expect from them more excitation, more marvel, more appreciation for these stylistic tours deforce. On the contrary, they propose all these cases as examples of the most correct and precise use of language.

Thus the puzzle we are faced with is neither a psychological nor an aesthetic one: it is a cultural one, and as such it is filtered through a linguistic system. We are dealing with verbal language in so far as it conveys notions about visual experiences, and we must, then, understand how verbal language makes the non-verbal experience recognizable, speakable and effable.

To solve Aulus Gellius' puzzle, we must pass through the semiotic structure of language. In fact, colour blindness itself represents a social puzzle, difficult both to solve and detect, for linguistic reasons. Let me quote this important passage from Arthur Linksz, which is later commented upon by Marshall Sahlins:

To suppose colour terms merely name differences suggested by the visible spectrum, their function being to articulate realities necessarily and already known as such is something like the idea that genealogical relations comprise a *de facto* grid of 'kinship types', inevitably taken in this significance by all societies, which differ merely in the way they classify (cope with) such universal facts of 'relationship'. The point, however, in colour as in kinship, is that the terms stand in meaningful relations with other terms, and it is by the relations between terms within the global system that the character of objective reference is sedimented. Moreover, the concrete attributes thus singled out by the semantic differentiation of terms then function also as *signifiers* of social relations, not simply as the

signifieds of the terms. In the event, it is not even necessary that those who participate in a given natural order have the same substantive experience of the object, so long as they are capable of making some kind of sensory distinction at the semiotically pertinent boundaries. Hence the cultural facility of colour blinds, functioning on differences in brightness – in a world that everyone else sees as differentiated by hue. Red-and-green colour-blind people talk of reds and greens and all shades of it [sic] using the same words most of us assign to objects of a certain colour. They think and talk and act in terms of 'object colour' and 'colour constancy' as do the rest of us. They call leaves green, roses red. Variations in saturation and brilliance of their yellow gives [sic] them an amazing variety of impressions. While we learn to rely on differences of hue, their minds get trained in evaluating brilliance ... Most of the red-and-green blind do not know of their defect and think we see things in the same shades they do. They have no reason for sensing any conflict. If there is an argument, they find us fussy, not themselves defective. They heard us call the leaves green and whatever shade leaves have for them they call green. People of average intelligence never stop to analyse their sensations. They are much too busy looking for what these sensations mean.[3]

Commenting on this passage in his beautiful essay on 'Colours and Cultures', Sahlins not only insists on the thesis that colour is a cultural matter, but remarks that every test of colour discrimination is rooted in a sort of referential fallacy.[4] Psychologists frequently assume that classifications of colours and utterance of colour names are linked to the representation of an actual experience; they assume that colour terms in the first instance denote the immanent properties of a sensation. Therefore, many tests are contaminated by this confusion between meaning and reference. When one utters a colour term one is not directly pointing to a state of the world (process of reference), but, on the contrary, one is connecting or correlating that term with a cultural unit or concept. The utterance of the term is determined, obviously, by a given sensation, but the transformation of the sensory stimuli into a percept is in some way determined by the semiotic relationship between the linguistic expression and the meaning or content culturally correlated to it.

Our problem, to quote Sahlins again, is 'how then to reconcile these two undeniable yet opposed understandings: colour distinctions are naturally based, albeit that natural distinctions are culturally constituted? The dilemma can only be solved by reading from the cultural meaning of colour to the empirical tests of discrimination, rather than the other way around.' [...]

It has been said that colour discrimination, under laboratory conditions, is probably the same for all peoples no matter what language they speak, though psychologists also suggest that there is not only an ontogenetic but also a

phylogenetic increase in discriminatory competence. The Optical Society of America classifies a range of between 7.5 and 10 million colours which can theoretically be discriminated.

A trained artist can discriminate and name a great many hues, which the pigment industry supplies and indicates with numbers, to indicate an immense variety of colours easily discriminated in the industry. But the Famsworth-Munsell test, which includes 100 hues, demonstrates that the average discrimination rate is highly unsatisfactory. Not only do the majority of subjects have no linguistic means with which to categorize these 100 hues, but approximately 68 per cent of the population (excluding colour defectives) make a total error score of between 20 and 100 on the first test, which involves rearranging these hues on a continuous gradation scale. Cases of superior discrimination (only 16 per cent) scored from zero to 16. The largest collection of English colour names runs to over 3000 entries (Maerz and Paul),[5] but only eight of these commonly occur (Thorndike and Lorge).[6]

Thus average chromatic competence is better represented by the seven colours of the rainbow [...] This segmentation does seem to correspond to our common experience, though it was not the experience of Latin speakers, if indeed it is true that they did not clearly distinguish between green and blue. It seems that Russian speakers segment the range of wavelengths we call 'blue' into different portions, *goluboj* and *sinij*. Hindus consider red and orange a unified pertinent unit. And against the 3000 hues that, according to David Katz,[7] the Maori of New Zealand recognize and name by 3000 different terms, there are, according to Howard Conklin, the Hanunóo of the Philippines, with a peculiar opposition between a public restricted code and more or less individual, elaborated ones:

> Colour distinctions in Hanunóo are made at two levels of contrast. The first, higher, more general level consists of an all-inclusive coordinate, four-way classification which lies at the core of the colour system. The four categories are mutually exclusive in contrastive contexts, but may overlap slightly in absolute (i.e., spectrally) or in other measureable terms. The second level, including several sublevels, consists of hundreds of specific colour categories, many of which overlap and interdigitate. Terminologically, there is 'unanimous agreement' (Lenneberg, 1953, 469) on the designations for the four Level I categories, but considerable lack of unanimity, with a few explainable exceptions, in the use of terms of Level II.[8]

Let us disregard Level II, which seems a case of many elaborated codes differing from males to females and even from individual to individual. Let us consider the various formats of Level II as idiolectal and quasi-professional codes.

The three-dimensional colour solid is divided by this Level I categorization into four unequal parts; the largest is *mabi:ru*, the smallest *malatuy*. While boundaries separating these categories cannot be set in absolute terms, the focal points (differing slightly in size, themselves) within the four sections, can be limited more or less to black, white, orange-red and leaf-green respectively. In general terms, *mabi:ru* includes the range usually covered in English by black, violet, indigo, blue, dark green, grey, and deep shades of other colours and mixtures; *malagti*, white and very light tints of other colours and mixtures; *marara*, maroon, red, orange, yellow, and mixtures in which these qualities are seen to predominate; *malatuy*, light green and mixtures of green, yellow and light brown. All colour terms can be reduced to one of these four, but none of the four is reducible. This does not mean that other colour terms are synonyms, but that they designate colour categories of greater specification within four recognized colour realms.[9]

Hanunóo segmentation follows our basic English paradigm only to a limited extent, since it involves black, white and grey in different ways. What is important for our present study is that the pertinentization of the spectrum depends on symbolic, i.e., cultural principles. Note that these cultural pertinentizations are produced because of practical purposes, according to the material needs of the Hanunóo community.

The basis of this Level I classification appears to have certain correlates beyond what is usually considered the range of chromatic differentiation, and which are associated with linguistic phenomena in the external environment.

First, there is the opposition between light and dark, obvious in the contrast of ranges of meaning of *lagti* and *biru*. Second, there is an opposition between dryness or desiccation and wetness or freshness (succulence) in visible components of the natural environment which are reflected in the terms *rara* and *latuy* respectively. This distinction is of particular significance in terms of plant life. Almost all living plant types possess some fresh, succulent and often 'greenish' parts. To eat any kind of raw, uncooked food, particularly fresh fruit or vegetables, is known as *sag-laty-un* (*latuy*). A shiny, wet, brown-coloured section of newly cut bamboo is *malatuy* not *marara*. Dried-out or matured plant material such as certain kinds of yellowed bamboo or hardened kernels of mature or parched corn are *marara*. To become desiccated, to lose all moisture, is known as *mamara* < *para* 'desiccation'. A third opposition, dividing the two already suggested, is that of deep, unfading, indelible, and hence often more desired material as against pale, weak, faded, bleached or 'colourless' substance, a distinction contrasting *mabi:ru* and *marara* with *malagti* and *malatuy*.[10]

We have then a system of cultural units (lightness, darkness, wetness, dryness) which are expressed by four fundamental colours; these colours are, in turn, four cultural units expressed by four linguistic terms. This double organization of the content depends, as does any such organization, on a system of disjunctions: it represents a structure. Just as a 'mouse', within a semantic space concerning rodents, is everything which is not a 'rat', and vice versa, so the pertinent content space of malatuy is determined by its northern borderline beyond which there is *marara*, and its southern borderline, below which there is *mabi:ru*.

Geopolitically speaking, Holland is a negative concept: it is the class of all points adjacent to, but not, Germany, Belgium or the North Sea. The same principle holds for all other geopolitical expressions such as Germany or Italy or the Soviet Union. In any system, whether geopolitical or chromatic or lexical, units are defined not in themselves but in terms of opposition and position in relation to other units. There can be no units without a system. The different ways in which cultures make the continuum of colours pertinent, thereby categorizing and identifying hues or chromatic units, correspond to different content systems. This semiotic phenomenon is not independent of perception and discrimination ability; it interacts with these phenomena and frequently overwhelms them. [...]

At this point we can probably tackle Aulus Gellius' puzzle. Rome, in the second century A.D., was a very crowded crossroads of many cultures. The Empire controlled Europe from Spain to the Rhine, from England to North Africa and the Middle East. All these cultures, with their own chromatic sensitivities, were present in the Roman crucible. Diachronically speaking, Aulus Gellius was trying to put together the codes of at least two centuries of Latin literature and, synchronically speaking, the codes of different non-Latin cultures. Gellius must have been considering diverse and possibly contrasting cultural segmentations of the chromatic field. This would explain the contradictions in his analysis and the chromatic uneasiness felt by the modern reader. His colour-show is not a coherent one: we seem to be watching a flickering TV screen, with something wrong in the electronic circuits, where tints mix up and the same face shifts, in the space of a few seconds, from yellow to orange or green. Determined by his cultural information, Gellius cannot trust to his personal perceptions, if any, and appears eager to see gold as red as fire, and saffron as yellow as the greenish shade of a blue horse. [...]

1 James Gibson, *The Senses Considered as Perceptual Systems* (London: Allen & Unwin, 1968).

2 Johannes Itten, *Kunst der Farbe* (Ravensburg: Otto Mair, 1961).

3 Arthur Linksz, *Physiology of the Eye* (New York: Grune & Stratton, 1952) vol. 2.

4 Marshal Sahlins, 'Colours and Their Cultures', *Semiotics*, vol. 15, no. 1 (1975) 1; 22.

5 [footnote 7 in source] A. Maerz and R. Paul, *A Dictionary of Colour* (New York: (

6 [8] E.L. Thorndike and I. Lorge, *The Teacher's Word Book of 30,000 Words* (New
 University Press, 1962).

7 [9] David and Rose Katz, *Handbuch der Psychologie* (Basel: Schwabe, 1960) vol. 2.

8 [10] Harold C. Conklin, 'Hanunóo Colour Categories', *Southwestern Journal of Anthropology*, vol.
 II (1955) 339–44.

9 [11] Ibid., 341–2.

10 [12] Ibid., 342.

Umberto Eco, extracts from 'How Culture Conditions the Colours We See' (1985) in *On Signs*, ed.
Marshall Blonsky (London: Basil Blackwell, 1985) 157–60; 167–71.

C.L. Hardin
Colour for Philosophers//1988

[...] What is it about colours that seems to obstruct our understanding? They are given to visual experience along with shapes, yet we have no similar difficulties with shapes. A crucial difference seems to be that the essential character of shapes is amenable to mathematical representation, but the essential nature of colours resists it; the one appears quantitative, the other qualitative. Shapes are given to more than one sense, and we are much inclined to suppose that the only sort of characteristics that can be accessible to more than one sensory mode are those which bear a *structure*. The study of structures is, of course, the special province of that form of discursive thinking par excellence, mathematics. And, it goes without saying, everything mathematizable is a proper object of scientific study.

Colours, on the other hand, have a brute factuality about them. From Locke and Hume to Moore and Russell, they have been taken to be the paradigmatic instances of simple unanalysable qualities. But the supposed unanalysability of colours, obvious though it has seemed to many reflective people, does not coexist comfortably with the equally apparent 'internal relatedness' of colours, whereby they exclude – yet intimately involve – each other. There is no variation of magnitude, intensive or extensive, that connects every colour with every other colour. And yet colours are as systematically related to each other as are lengths or degrees of temperature. Red bears on its face no reference to the character of green. Yet red categorically excludes green while at the very same time resembling it in an incommensurably closer fashion than the resemblance

ther red or green to any shape or sound. Furthermore, we can always find a place among the hues for a Humean 'missing shade of blue'; but could there also be a place there for a quality that is neither bluish, nor reddish, nor greenish, nor yellowish, but resembles blue, red, green and yellow as much as they resemble one another? We may reply that there cannot, since the hue circle is closed; there is no 'logical space' for a radically novel hue. But how, given the simple unanalysable character of each of the determinate hues, can we proceed to justify such an answer?

One way of getting clearer about the nature of colours and the relations they bear to each other would be to show that colour, like heat, could be subsumed under some wider set of phenomena through which it might be explicated. Because we understand heat to be random kinetic energy, we can liberate it from conceptual bondage to our feelings of warmth and coolness, find new ways to measure it, explain the thermal behaviour of bodies by appealing to their micro-structure, and appreciate the role of heat in physical, chemical and biological processes far removed from the domain of human sensation. And so, if colour proves to be some complex set of physical properties that underlie the dispositions of bodies to reflect visible light in such and such a way, we shall be able to study colour independently of the idiosyncrasies of our visual systems. Our limited epistemic access to colours would not then betoken an ontological isolation of colours from the general order of physical processes. According to this view, once colours can be properly identified with, or nomically related to, some congeries of material properties, those properties should give us the clue to the nature of the relations colours bear to each other as well as provide us with additional means of making epistemic contact with them. We might suppose that the advocates of such a chromatic materialism would appeal to the best scientific work to spell out the locus of colours in the material world and how we perceive them and would then go on to explicate the network of chromatic 'internal relations' by means of an appropriate set of material relations. But this expectation has been largely disappointed. Materialists' writing about colours has been more often directed to polemic or programme or pronouncing oaths of fealty to a scientific world view than to delivering the actual scientific goods and putting them to philosophical work.

Those who are unpersuaded by chromatic materialism accept the conceptual insularity of the domain of colours. Colours, they say, are proprietary to sight alone; the quality of a colour is, by the nature of the case, inconceivable to even the most sensitive and intellectually gifted of the congenitally blind. So the only way to understand colours is to examine in detail how the members of the chromatic family relate to one another and to study the empirical conditions under which coloured objects appear to the senses. This mode of investigating

the problem is suitable to phenomenalists and epiphenomenalists alike, and one might have expected that at least some of them, along with those who label themselves phenomenologists, would have engaged in a thorough inquiry into the phenomenology of colour, or at least have attended to the writings of the scientists and artists who do. All the more surprising, then, to find that there seems to be so little concern in these quarters for patiently uncovering and spelling out the detailed phenomenal facts of chromatic structure. For instance, a recent writer (McGinn, 1980) finds objectivist accounts of colour wanting, insists that the explanation for some puzzling chromatic relationships is that they depend upon 'a rich system of phenomenal laws', and then neglects to tell us what those laws are.

So those who urge the phenomenal nature of colours don't do much of the phenomenology, and the 'scientific' materialists don't pay much attention to the science. Conceptual analysis and ingenious argument carry the freight, and the data base is pretty nearly that which was available to John Locke. The result is not only that the issue of the ontological status of colours is about where it was in the eighteenth century, but that questions about the resemblances and exclusions of colours are at a dead end. Beyond that, the general understanding of how colour experience relates to colour language is mired in confusion.

What does science have to say to philosophy about colours? In fact, a great deal. But philosophers have not supposed so, perhaps in part for reasons of simple cultural lag: the science they have looked at is twenty-five years out of date. In the eyes of the scientifically literate public, colour science has never had the panache of theoretical physics or molecular biology, and few scientists outside the field realize that it underwent a theoretical revolution more than a generation ago, when the opponent-process theory became established. Opponent-process theory is to the study of colour vision what the theory of continental drift is to geology. In both fields, a great deal of solid and lasting work was done before those theories became established, and, in both fields, disputes continue about the exact form and scope that the theory should have, and just what mechanisms underlie it. But, in each case, after the theory became established, research problems and methodology moved in fresh directions, novel phenomena were uncovered and old phenomena newly understood, and the entire discipline took on a unity and focus it had hitherto lacked. It is not unreasonable to expect that, when we turn a theoretically informed eye to the rag-bag collection of philosophical problems about colour, they too will prove to be connected in a manner that had previously eluded our gaze.

In the pages that follow [in *Colour for Philosophers*] we shall sketch some of the scientific facts about the colour-relevant properties of physical objects and processes which lie outside the organism. It will quickly become apparent that

the classification of objects by colour depends quite as much on the operating characteristics of visual systems as on the physical properties of objects; so we shall proceed to scrutinize those operating characteristics. In so doing, we shall find that visual science has delineated much of the phenomenology of colours and, with the assistance of neurophysiology, has explained a good deal of that phenomenology while showing real promise of explaining more. This will not only help us to ascertain the place of colour in the natural order, but will also open new avenues for understanding how and why colours both resemble and exclude each other, as well as how it is that they form a closed family and how it is that they need not do so. We will be able to suggest some conditions under which it would be reasonable to claim that the qualitative character of colour experience is reducible to neural processes, and what to say about colour sensing in other animals. Finally, we shall see how, contrary to what the Wittgensteinians seem to have supposed, the semantics of ordinary colour terms is powerfully constrained by the physiology of the human visual system. At every turn we shall discover that colour science is able to cast new light into corners that have long been in shadow. [...]

C.L. Hardin, extract from Introduction, *Colour for Philosophers: Unweaving the Rainbow* (Indianapolis: Hackett Publishing Co., 1988) xxxix–xlii.

Jacqueline Lichtenstein
The Eloquence of Colour//1989

The Iconoclastic Gesture as Inauguration of Metaphysics
[...] Painting has always held a strange appeal for philosophers, such that the battle between attraction and rejection, between fascination and censure, has never ceased. This mixture of forms and materials, in which the subtlest contour joins the richest colours to produce the enigmatic unity of a representation, inevitably disturbs the harmony of thought based on the principles of pure reason. Since the time of Plato, painting has experienced the philosophical fluctuations surrounding the more general question of the image to which its destiny has been bound. Banished from the realm of metaphysics, deprived of any real position, the image ended up being reduced by the very act that made possible the constitution of philosophical discourse, to a simulacrum on the walls of a cavern, a mere shadow. Yet it was never effectively suppressed, for it

has haunted philosophy ever since, as the dead man's figure haunts a criminal: just a shadow.

Philosophy could, under certain conditions, tolerate this image that was but a shadow of itself, the image of an image. As the shadow moved even farther from reality, the image became metaphor and spent itself in figures of speech. Destined to be heard rather than seen, poetic and rhetorical figures pose no threat to the primacy of language. On the contrary, they heighten its power by expanding it to reach new domains. The visible itself becomes an effect of discourse, perceptible only through the evocative power of the verb. Metaphor can inscribe the image within the ranks of theoretical legitimacy seemingly without endangering discourse. Such representation is the illusion of an image that becomes a figure only through words. Already we see the ambiguity of this recognition, which meets the demands of philosophy and respects its definitions: it sidesteps the domain of the visible, effaces the image in its own reality. And it thus pushes painting to the edge of a domain that painting then can only penetrate by means of metaphoric trespassing. But visual images have a diabolical propensity for exploiting this trespassing potential.

Plato lacked neither lucidity nor coherence. He knew that to grant the image anything meant that the image would sooner or later take hold of the whole in order to destroy it. He was one of the few truly to have taken images seriously, that is, to have believed in the force of their powers. Thus he would have liked to forbid all of them, whatever their nature and in whatever guise they might present themselves, entrance into his realm. And in this he was, from his perspective, undoubtedly right. For behind the figures of discourse came a long procession of real images – first those of the body in its visible presence, then representations painted on walls, and later on canvas – a whole universe of silent figures that gradually invaded this territory in which the sound of words most often took the place of a gaze.

What was originally a confrontation between discourse and image soon became an affront that forced painting to assume a strangely theoretical role to which it was not inherently destined. But the contest was unequal, for it took place on the territory of language; language invented the game, set the rules, and played according to its own stakes. This battle was internal to philosophical discourse, which not only demarcated the battlefield and distributed the roles but even assigned the places and furnished the combatants' arms. Did not the force of Platonic metaphysics lie in having itself produced all the oppositions that it deemed fatal, in having developed otherness within itself, so that this otherness would not linger dangerously outside, beside, and thus necessarily against it? By integrating conflicts as internal differences and defining their nature, roles and positions, it nullified their danger and kept control of the game.

It invented an image of the image, whose fluctuations would follow the rules of its discourse. Philosophy gave itself the image it needed to keep the identity of its own image intact. For this opposing image could not exist without the discourse that condemned it. Its place was determined inside a space that had drawn its own differentiations, so as not to have an outside: the philosophical realm in which identities could clash because their clashes posed no real danger.

But this battlefield on which the enemies were accomplices, united in a scheme whose secret was held by the master alone, was the site of a conflict that was infinitely more serious because it was real. This time the combatants came from different horizons; they were painters and orators. Both groups practised in the domains of the diverse and of appearance, of the multiple and of emotion, of the body and of passions. Both favoured a reality to which the unifying and abstract word of philosophical discourse can scarcely assign a place: the atypical dimension of the heterogeneous that unfurls in the visible space of representations. The image developed in philosophical compost as a worm develops in fruit, corrupting the *logos* to which it owed its birth and affirming qualities incompatible with the conditions that determined its filiation. An illegitimate child of dualist metaphysics, the visible vindicated the marks of its bastardy and rejected a paternity that could not recognize images without subjecting them to its authority.

It is no surprise that such a vindication should have manifested itself in the domain of painting – an art in which the material dimension of representation presents itself in the form of the visible – and should, furthermore, have always been expressed through praise of colour. The hierarchies imposed by Platonism allowed colour to become the locus of an anti-Platonism in painting, which, in fact, expressed the anti-Platonism of painting.

Within painting, this anti-Platonic revolt has long exercised its resistance in a muffled and clandestine way. It took shape as an offensive, both in theory and in practice, at the end of the fifteenth century in Italy and after a slight lull resumed in the second half of the seventeenth century in France. The colourists led this revolt against the partisans of drawing.

Their disputes raised issues of infinitely greater consequence than those of a mere hierarchy of pictorial precedence. The quarrel largely exceeded the circumscribed limits of painting. The colourists threatened the mastery of discourse as much as the favour of drawing, the hegemony of a metaphysical conception of the image as well as the primacy of the idea in representation. They attacked the principles of morality and the pedagogical virtues of rules alike. Brash, they defended the purely material qualities of representation. Indecent, they advanced an apology for cosmetics, pleasure and seduction. Libertine, they praised colour for the incomparable effects that its simulacra

produced. They were accused of being sophists. Their position was, unequivocally, anti-Platonic.

We cannot understand the philosophical importance of this debate without taking into account the difficult role that colour has always been forced to assume in the permanent conflict between theoretical reason and the visible universe in the diversity of its forms. Colour has always displayed a tension that runs through all theories of representation. For colour is the material in, or rather of, painting, the irreducible component of representation that escapes the hegemony of language, the pure expressivity of a silent visibility that constitutes the image as such. The impotence of words to explain colour and the emotions that it provokes – the commonplace of all discourse on painting – betrays a more fundamental disarray in the face of this visible reality that baffles the usual procedures of language. Fascinated by painting, philosophical thought has always burned itself in the fire of colour. Each time it has left the safe ground of abstract theories that reflect upon the ends or modalities of art in general to take up plastic representation – a less risky subject than individual works – it has inevitably favoured drawing, whose most ardent defenders have come from 'the philosophers'. Perhaps Hegel alone, among all metaphysicians, could talk about colour. But Hegel legitimated its appeal by taking the perspective of absolute knowledge, where all determinations are surpassed by a synthetic unity.

Certainly, in the wake of Heidegger and Merleau-Ponty things have changed, and philosophers today have a great deal to say about painters and painting. Centuries behind the work of painters and their most discriminating admirers, philosophers have discovered the pleasures of the visible and the delicacies of colour. Still, their discourse is often struck by a kind of blindness. Overlooking the material qualities of representation, they decipher it as they would a text in order to recover in the image the discursive procedures that they themselves put there. As for those exceptions to the rule who recognize the virtues of colour, which they can today safely celebrate, they still risk philosophical suicide. And their dilemma would be absurd if it did not demonstrate the permanence of a dualism whose terms have merely been inverted. Caught between a silence in which philosophy confesses its impotence and a discourse in which the word itself collapses its philosophical pretensions, colour bears a striking resemblance to the god of negative theology that the categories of rationality can never adequately apprehend and of which the only way to speak is to say nothing. Whether they keep quiet or speak, philosophers inevitably belong to a tradition that hardly allows for the conception of colour.

It is indeed a conception born of a rationality that hunts down simulacra and impugns appearances, a conception of metaphysics and of science to which philosophy has bound its destiny and one that collapses at the mere touch of a

pure coloured surface. Antonin Artaud understood this better than many others and stated it admirably in his text on Vincent van Gogh:

> But how can I make a scientist understand that there is something definitely insane in differential calculus, in the quantum theory, or in the obscene and absurd liturgical ordeals of the equinoctial precessions – because of that shrimp-coloured eiderdown that Van Gogh froths up so gently in a chosen spot on his bed, because of the Veronese green, and the azure-drenched insurrection of that boat in front of which a washerwoman of Auvers-sur-Oise rises to her feet after work, because of that sun screwed behind the gray angle of the pointed village steeple over there.[1]

It is the factors that make colour, to borrow Artaud's expression, the little 'insurrection' big enough to upset the discourse of truth, that we have tried to understand here. Yet this insurrection of colour that starts with painting also took place within painting. Thus we must investigate the long-standing alliance between a metaphysical idea of truth that has dominated our history and a conception of painting that has always relegated colour to the background, although the practice of painting contradicts such a hierarchy. This alliance has determined the course of painting and drawn its contours.

The history of Western art is inseparable from a history of theories of art because the invention of plastic forms is inextricably linked to the constitution of a discourse on forms. As we will attempt to demonstrate, the discursive conditions imposed by philosophical reason have played a decisive part in the unfolding of the history of painting. That is why the stakes of the debates provoked by the question of colour are necessarily double, are both aesthetic and philosophical. Colour would have presented fewer theoretical problems had it not appeared from the start as the principle of pictorial representation's autonomy, offering painting the means to free itself from the conditions imposed on its history by philosophical reason and allowing the visual to escape the grasp of discourse.

Yet analysis reveals strange similarities between the problems posed for and by painting through its use of colour, and the difficulties raised by and for rhetoric through its corporeal eloquence. They have a common source in representation's resistance to the hegemonic tendencies of philosophical recognition. The emphasis that Ciceronian eloquence gave to corporeal action, to the voice, and, above all, to the gesture not only justified all of metaphysics' precautions with regard to oratorical art but also caused a permanent tension within rhetoric itself. How could rhetoric legitimate an eloquence expressed through the image of a body that falls silent in order to offer itself without words to the eyes of its audience? The entire history of rhetoric is marked by a debate concerning the

status of mute eloquence, eloquence's visible aspect, of which the body incarnates the real presence, translates the affections, and manifests the powers.

Thus we can understand that the eloquent body and pictorial colour provoked similar perplexities in different domains that are centuries apart. For the philosophical opposition between reason and image was reproduced within rhetoric and painting. In both cases, it spawned internal divisions that reveal the power of a *logos* capable of turning its opponents against one another to increase its control over them. In painting, colour had the same relation to drawing that the body had to discourse in rhetoric: the same uncomfortable place that Platonic metaphysics assigned to the visible and its images. Internalizing the criteria of philosophical discourse, rhetoric and painting sought to fit the demands of theoretical recognition by modifying the part of their nature that had come under attack. And in both, the same tension resulted, marked by the imbalance of the opposing forces present. Each in its turn, in very different periods of history that yet corresponded to the same moment in their own histories – when the twofold imperative of autonomy and legitimacy exerted the most force – experienced analogous hesitations between tendencies that metaphysics labelled not complementary but antagonistic. Rhetoric wished to control its eloquence within regulated discourse; painting, to inscribe the rules of discourse within its images. The one attempted to limit the place of the body in rhetoric by insisting on figures of speech and thought that owed nothing to elocutionary artifice; the other, to reduce the importance of the specifically visible dimension of painting, its colours and materials, by favouring the more abstract qualities of its conception and drawing. And both attempts came up against a resistance whose leaders had, paradoxically, been raised in the school of philosophical reason.

This fundamental ambiguity marks the relations of philosophy, rhetoric and painting and undoubtedly explains various vicissitudes of their common history. The representations of rhetoric and painting would have been less troublesome if they had not allowed the very forces that the philosophers wished to exclude an almost hallucinatory reappearance: precisely, in images. The insistent presence of these overly material forms of representation reveals a permanent internal conflict that reason could neither resolve or ignore. To this excluded reality that philosophy had called an illusory world, the orators and painters were truly to lend a body and a face. They were to prove its existence in the simplest, most undeniable way – that is, by showing it. […]

Jacqueline Lichtenstein, extracts from *La Couleur éloquente: rhétorique et peinture à l'âge classique* (Paris: Flammarion, 1989); trans. Emily McVarish, *The Eloquence of Colour: Rhetoric and Painting in the French Classical Age* (Berkeley and Los Angeles: University of California Press, 1993) 1–7.

Stephen Melville
Colour Has Not Yet Been Named//1993

[...] We know how to describe colour in strictly physical terms. We know also something about how to analyse it semiotically, and indeed colour can easily appear a prime candidate for semiological investiture, displaying the full force of 'cultural construction'. The physical phenomenon in its relation to our nomination of it seems to map directly onto Saussure's diagrammatic representation of the double continua of world and sound into which language cuts, freeing the prospect of articulation, and the arbitrariness of this cutting seems readily evident in the variety of colour terms found in existing natural languages. But colour can also seem bottomlessly resistant to nomination, attaching itself absolutely to its own specificity and the surfaces on which it has or finds its visibility, even as it also appears subject to endless alteration arising through its juxtaposition with other colours. Subjective and objective, physically fixed and culturally constructed, absolutely proper and endlessly displaced, colour can appear as an unthinkable scandal. The story of colour and its theory within the history of art is a history of oscillations between its reduction to charm or ornament and its valorization as the radical truth of painting. From these oscillations other vibrations are repeatedly set in motion that touch and disturb matters as purely art-historical as the complex interlocking borders among and within the individual arts and as culturally far-reaching as codings of race and gender and images of activity and passivity. This movement of colour in painting is a movement in or of deconstruction. And if deconstruction can in some sense feel at home in reading the texts of colour as they pass from the Renaissance through de Piles and Goethe and Chevreul, it is in a much harder place when it comes to actually speaking the work and play of colour – not because that work and play are ineffable but because its 'speaking' just is the work of art and its history.

We also know colour only as everywhere bounded, and we may think to register this boundedness as its necessary submission to the prior constraint of design. But colour repeatedly breaks free of or refuses such constraint, and where it does so it awakens questions of frame and support as urgent issues for painting just in so far as they show themselves to be not prior to but emergent within colour itself. Colour is then no longer simply contained within the painting but is also that which, within the painting, assigns it its frame, even as it conceals itself as the source of that assignment. In so far as colour is and is not the historical bearer of a certain truth of painting that is and is not the truth of the frame in which it is contained, colour bids to pass beyond itself. Colour, in

deconstruction, may appear as colour-without-colour, a hitch or problem in what one might call the look of things. Duchamp, in de Duve's powerful account, would be a central pivot here, but the problematic perhaps becomes fully explicit only with the postmodern move that seeks to pass definitively beyond painting in the name of drawing – only to turn itself over to Lacan's belated inheritance of Goethe and Hegel on light and the ontogeny of color. This could count as a history: we would, passing from Morris Louis through a certain engagement with sculpture to the postmodern centrality of photography, still be in the midst of a negotiation with colour that we can only barely recognize as such. [...]

Colour has not yet been named. But then nothing has. This is what it is that things happen, in art history and elsewhere.

Stephen Melville, extract from 'Colour Has Not Yet Been Named: Objectivity in Deconstruction', in *Deconstruction in the Visual Arts*, ed. P. Brunette and D. Wills (Cambridge: Cambridge University Press, 1993); reprinted in *Seams: Art as a Philosophical Context – Essays by Stephen Melville*, ed. Jeremy Gilbert–Rolfe (Amsterdam: G+B Arts/OPA, 1996) 141–2 [footnotes not included].

Mike Kelley
Playing with Dead Things: The Uncanny//1993

Colour

Historically, literalness has been considered the enemy of art. Along with material itself, colour is one of the most loaded signs of the quotidian. The literal use of material is a non-sequitur in art. No one would seriously consider the idea of sculpting a body out of actual flesh, or carving a rock out of stone. What would be the purpose of such a redundant exercise? Colour is thus set at a different conjunction between sign and signified, a problem that is negated in painting because it operates in two-dimensional mental space – which is why painting has been king of Western art history, with sculpture relegated to the role of its idiot cousin. Naturalistically coloured dolls, mannequins, automata, and wax portrait figures are not included in the generally accepted version of Western art history, and polychrome religious statuary is on the lowest rung of the art hierarchy. Until recently, it would be difficult to come up with much of a list of polychrome figurative sculpture from the fine art of the last century. Even the Realist movement produced almost nothing. I can think of no single nineteenth-century polychrome realist sculpture. The closest might be Degas' *The Little*

Dancer of Fourteen Years (1880–81) – a slightly smaller than life-size bronze figure with painted clothes and a skirt made of real cloth.[1] [...]

Besides the Degas, there is little that could be said to have been influenced by these popular sculptural developments. Most realist sculpture of the period concentrated on social subject matter to evoke 'realism', substituting members of the working classes or 'great men' for the nobility that were the subject of previous heroic sculpture. Only the coloured sculpture of the academic Jean-Léon Gérôme breaks with the monochrome trend. Gérôme's *The Ball Player* (1902) represents a female nude carved from marble, tinted naturalistically and covered with wax, giving the surface a skin-like quality.[2] Gérôme was an admirer of the painted figures unearthed at the Boeotian town of Tanagra, which had further upset the myth of pure white Greek sculpture. Appropriately enough, another tinted sculpture (though now bleached white) by Gérôme offers a version of the myth of Pygmalion and Galatea. Recounted by Ovid in the *Metamorphoses*, the story tells of a sculptor who falls in love with one of his statues, which is then brought to life by Venus.[3]

Not much more is to be found in the twentieth century either – and most of that can be seen as an extension of painting. I would say that the painted wooden sculpture of the German Expressionists, the patchy archaism of Manuel Neri and Marino Marini, and the 'beat' collage works of Robert Rauschenberg, such as his famous *Monogram* (1959), which includes an expressionistically painted stuffed goat, all serve primarily to extend notions of painting – either by treating three-dimensional objects as analogous to the painting support, or by producing three-dimensional embodiments of painterly, gestural distortion.

By and large, modernist works continue on with the 'Greek prejudice' – the neo-classical misconception that classical Greek sculpture was uncoloured. Modernist essentialism understands this colourlessness as one of the 'truth[s] to materials' it defended – the truth of the archetypal, not specific, representation. Thus, a bronze or stone sculpture is left unadorned to reveal its 'true' colouration. Or, if the female form is alluded to in a Hans Arp or Brancusi, for example, reference is not made to a specific body, but to the form of femininity in general. Truth arises from the base material, gives rise to archetypal meaning, and issues in timeless truths. The sign for the timeless is monochrome. It isn't until Surrealism, and later Pop art, that the truthfulness of an image is examined in relation to daily experience, either as a psychologically determined phenomenon, or simply as the modest by-product of culturally produced clichés. Truth is not a timeless given but a socially constructed fact.

Whilst others fish with craft for great opinion
I with great truth catch mere simplicity;

Whilst some with cunning gild their
copper crowns,
With truth and plainness I do wear mine bare.
(Troilus speaking to Cressida)[4]

Citing this passage, psychoanalyst Janine Chasseguet-Smirgel suggests that 'idealization is only a thin film disguising an unchanged material, a mechanism aiming at masking the self. It also shows that there are human beings that prefer truth to mendacity.'[5] The context here is a discussion of fetishism and perversion, which are 'connected with sham, counterfeit, forgery, fraudulence, deceit, cheating, trickery, and so on – in short with the world of semblance.[6] Perverts tend toward aestheticism, she maintains; they often have a love of art and beauty, and this is likened to the infant's wonder at the accessible parts of their own bodies, and their love of shiny and animate *external* objects – like dangling pieces of coloured glass. Such external beauty is compared to the embalming of corpses, where make-up is applied to give the imitation of life, and, in the case of Egyptian funerary practice, this decorating impulse is continued with jewels and other precious materials until the dead body is sculpted into a god – that is, a fetish, an idealized substitution for something secret and shielded.

This example recalls a recent account of the actions of the murderer and grave robber, Ed Gein who, after his mother's death, dug up the graves of women roughly her age and brought pieces of them home.[7] Gein found solace in these body parts which seemed to him like dolls, and in some cases he even wore them, becoming a surrogate for his mother's living being as he went about his daily life. Searching Gein's house, investigators found boxes of body parts, some dabbed with silver paint and decorated with bits of ribbon. Chasseguet-Smirgel's examples present surface decoration in this kind of pathological light, tying her aesthetic to modernism's stripped-down essentialism. Her moralism here strikes me as somewhat surprising, in that one would imagine that a psychoanalyst would have more sympathy for the complexities, and poetics, of the interrelationship between psychic and daily reality. In her account, colour is false and pathological: it represents lies. This idea of colour as misrepresentation is quite different from my own understanding of the tendency toward non-colouration in modernism, which I interpret as a sublimation of surface variance and complexity reaching for an idealized, though shadowy, essential reality.

On the social level, Chasseguet-Smirgel's moralistic take on colouration is beautifully illustrated by an occurrence in Beverly Hills, a wealthy city within the Los Angeles city limits. In the 1970s a mansion was purchased there by a rich Saudi Arabian sheik, Mohammed Al-Fassi. The sheik decorated his house in a

thoroughly garish manner, including, for example, a row of copies of classical statuary painted naturalistically – right down to the pubic hair. These works initiated an ongoing battle between Al-Fassi, his neighbours, and city government, that ended only when the house was burnt down by an arsonist.[8] Even though we now know that Greek statues were painted when they were made, their present function as a popular sign of taste and order will not allow this fact to be recognized. The timeless order of the neo-classical conception is an appropriate symbol for the upper classes. Kitsch, outwardly characterized by gaudy colours, is a cheap and false version of the true, made for and consumed by the underclass. What was most dangerous about Al-Fassi's painted statuary was that it hinted at presentness, a here and now that always entertains the possibility of a loss of position and power. The sheik's sculptures were symbolically unsuitable objects for the decoration of a Beverly Hills mansion. No wonder, then, that aesthetic arguments can shift into violence when the politics of the sign are so loaded. [...]

1 [footnote 22 in source] See Linda Nochlin, *Realism* (Harmondsworth: Penguin, 1971) 269, note 134.

2 [26] Gerald Ackerman in Peter Fusco and H.W. Janson, *The Romantics to Rodin: French Nineteenth-Century Sculpture from North American Collections* (Los Angeles: LA County Museum of Art/New York: Braziller, 1980) 289–91.

3 [27] The story of Pygmalion is in Ovid, *Metamorphoses*, trans. A.D. Melville (New York: Oxford University Press, 1988) 232–4.

4 [28] William Shakespeare, Troilus and Cressida, Act IV, Scene 4; cited in Chasseguet-Smirgel, *Creativity and Perversion* (London: Free Association Books, 1984) 100.

5 [29] *Creativity and Perversion*, 100.

6 [30] Ibid., 81.

7 [31] See Robert H. Gollmar, *America's Most Bizarre Murderer, Edward Gein* (New York: Pinnacle Books, 1981). Gollmar was the judge in the Gein case.

8 [32] For further details, see Scott Harris, 'Sheik, Prattle and Dough: On the Trail of the Elusive Saudi', *The Los Angeles Times* (6 May 1989, section 2) 3.

Mike Kelley, extract from 'Playing with Dead Things: The Uncanny', originally written for *The Uncanny*, catalogue for exhibition curated by the artist for Sonsbeek '93 (Arnhem: Gemeentemuseum, 1993); revised for Mike Kelley, *Foul Perfection: Essays and Criticism*, ed. John C. Welchman (Cambridge, Massachusetts: The MIT Press, 2003); reprinted in *The Uncanny*, curated by Mike Kelley (Liverpool: Tate Liverpool/Cologne: Verlag der Buchhandlung Walther König, 2004) 29–31.

Paul Auster
Leviathan//1992

[...] Since the age of fourteen, she had saved all the birthday presents that had ever been given to her – still wrapped, neatly arranged on shelves according to the year. As an adult, she held an annual birthday dinner in her own honour, always inviting the same number of guests as her age. Some weeks, she would indulge in what she called 'the chromatic diet', restricting herself to foods of a single colour on a given day. Monday orange: carrots, cantaloupe, boiled shrimp. Tuesday red: tomatoes, persimmons, steak tartare. Wednesday white: flounder, potatoes, cottage cheese. Thursday green: cucumbers, broccoli, spinach – and so on, all the way through the last meal on Sunday. [...]

Paul Auster, extract [on Sophie Calle] from *Leviathan* (London and Boston: Faber & Faber, 1992) 60.

Peter Halley
Interview with Kathryn Hixon//1992

Kathryn Hixon [...] You began using Day-Glo colours in 1981 and 82. Why did you decide to use Day-Glo pigment straight out of the jar?

Peter Halley The work has always had a cinematic or narrative quality. Specifically I began to think that some form of energy was moving through the conduits and illuminating the cells. I started using Day-Glo red to make the cells glow. I was trying to emphasize technologically-derived materials and I also liked Day-Glo's connection to Pop and Psychedelia, in a nostalgic sense. The quality of the glow that it produced seemed very artificial, unnatural and eerie to me. In a quite traditional way, I have always been interested in light in painting.

Hixon It seems similar to the difference between film as reflected and video as emitted light. The light from your paintings seems to be emitted from the surface, instead of reflected from other sources of light. It is sort of a post-Pop use of light – to turn the manipulation of light from being aesthetic or transcendental to being an acrid glow, a more contemporary, claustrophobic light.

Halley Various artists since the 1960s have been very concerned with capturing a certain kind of alienating bizarre industrial light, such as Bruce Nauman, Dan Flavin, Donald Judd and Robert Smithson. For me it was important, for quite a long time, that the colour and choice of paints were entirely from found sources. It connected me back to Pop-Fluxus-Minimalist decision-making, in which the artists intentionally tried to use materials that were given to them by the culture.

Hixon Is this a strategy to relinquish control, in order to be relieved of having to consider 'aesthetic' decisions separately ?

Halley Rather than fight the culture, you allow the culture in as much as possible. That act of non-judgemental embrace can flip around to become a critical act.

Hixon Using found sources also has to do with a desire to become reconnected to contemporary popular culture.

Halley That is what I wanted to emphasize. During that time I was really quite troubled by the themes and materials artists had taken up since the minimalist era. I have a unique view of recent art history in which I see the change between minimalist impersonality and the post-minimalist emphasis on personal sensibility as being crucial. Post-minimalism began a sequence of events that ended up with neo-expressionism as its most debased progeny. Minimalist and Pop art posited that art should deal with a public, sociological world, using materials produced by technological society and themes from the media and the commercial arenas.

Hixon Was your use of unmixed Day-Glo colours and commercial products such as Roll-a-Tex a way to once again address social issues ?

Halley I always tried to work that way. There is a very important underlying issue here, about how one views the psyche. Traditional liberal humanism says that somehow we have a private psyche that is separate from the social. In my early years in New York, I developed the intuition that one's psychic life was inseparable from one's social identity. This issue is of paramount importance to my work. [...]

Hixon How would you describe the interactions of the colours that you use?

Halley It is not about colour, but rather how the colour combines. It is entirely linguistic. [...]

Hixon Within traditional painting, do you think of the colour's associations with different aspects of culture? Putting a dull brown next to a pale blue is almost nauseating.

Halley After I do them I sometimes think of the associations with bad taste. But what really specifically interests me is that the use of colour can be transgressive. I find it exciting if I can make some awkward colour or combination of colours work. The other thing I have been interested in since 1988 is the idea of spatial ambiguity, a confusion between background and form, that's like the phenomenon of synaesthesia or psychedelic overload.

Hixon Each of your paintings is viscerally direct and has immediate impact as a unified whole.

Halley I strongly believe in making art that can be looked at quickly. We live in a society of informational and cultural overload. The idea of a Cézanne, for example, which you can study for hours and various nuances are revealed, seems very out of touch, at least with my own psychic life. I want to make something explosive and immediate. And hopefully explosive and immediate each time you go by and take a quick look at it.

Peter Halley and Kathryn Hixon, extracts from 'Interview with Peter Halley', in *Peter Halley* (Pully/Lausanne: FAE Musée d'art contemporain, 1992) 20–1; 25; 28; 30.

Donald Judd
Some Aspects of Colour in General
and Red and Black in Particular//1994

Material, space and colour are the main aspects of visual art. Everyone knows that there is material that can be picked up and sold, but no one sees space and colour. Two of the main aspects of art are invisible. The integrity of visual art is not seen. The unseen nature and integrity of art, the development of its aspects, the irreducibility of thought, can be replaced by falsifications, and by verbiage about the material, itself in reality unseen. The discussion of science is scientific; the discussion of art is superstitious. There is no history. [...]

The development of space is within the last thirty years. For one hundred

years the most powerful aspect [of art] has been colour. The one hundred years of the primacy of colour is still only a beginning. Basically the present international art developed from the traditional representational art of Europe. The necessities of representation inhibited the use of colour. An object is pale in the light and dark in the shade, allowing full colour only in between, usually in smaller areas than the light and shade and usually well back from the frontal plane of the picture, to where the full colour is subdued by aerial perspective. Chinese, Korean and Japanese painting is also representational, but without the simulation of unified space, and is usually subdued to depict space. Japanese prints are an important exception to the attrition of colour, as well as paintings on screens and the illustration of novels, all flat and bright. Goya said: 'In art there is no need for colour; I see only light and shade.' The simulation of appearance, the depiction of objects in their space, upon a flat surface, a simulation of reality that must be believed by the viewer, is not compatible with a developed interest in colour. The painting by Zeuxis that the birds pecked at could not have been like the painting on Attic vases, flat areas of red and black. It had to be a better version of the kind of depiction in the frescoes at Pompeii. The red and black of the vase painting is colour; the colour in the frescoes is an accompaniment. Romanesque painting, which has clear and strong and well organized areas of colour, has always been safe from birds. I can imagine a Romanesque painter being horrified by Cimabue's modulation into representatipon of the areas of colour. Since the painter represented the universe, he must have thought it decadent (at the beginning of the Renaissance) to represent an individual. The areas of colour in Giotto's paintings are due to the past and are more important than the newly modelled faces, feet and hands. Despite the high quality of the subsequent painting, colour was a declining interest. But it is too particular and especially too important in organization to become minor, just secondary. [...]

The discussion of colour is greater than the discussion of space, and unlike the missing particularities of space, it describes to redundancy the particularities of colour. Primarily this has been because with the creation of science in the seventeenth century the study of colour has been part of science. And like astronomy it has been cursed with its own astrology. The discussion of colour has not been leisurely, like that of space. Instead of millenia, the speed has been in generations. There is a history of colour, first in philosophy and then in science. Aristotle said that there was in the category of substance an entity that might have an aspect of the category of quality: material was primary, colour was secondary. He also said, to quote Copleston, that 'matter is at once the principle of individuation and unknowable in itself'. There is a history of colour in art. Every other generation has a new idea of colour. However, this is a

generation without ideas. At the present space and colour have in common complete neglect. Despite the primary importance of colour for more than a hundred years there are now no theories. The last philosophy of colour, which is what it was, as well as being factual, and the mixture may be unavoidable, at least in art, was that of Josef Albers in *The Interaction of Colour* of 1963. In Part I, Albers begins:

> If one says 'Red' (the name of a colour)
> and there are 50 people listening,
> it can be expected that there will be 50 reds in their minds.
> And one can be sure that all these reds will be very different.

That is a philosophy, and it does not agree with what Albers was taught in the Bauhaus.

I knew as a child that certain colours were supposed to produce certain feelings. I didn't understand why a bull should be mad at red. Johannes Itten and Kandinsky taught in their important colour courses at the Bauhaus that colours always produce the same emotions, and also that colours always correspond to certain shapes, the two together agreeing on the emotion. The idea I like best is Kandinsky's that a pentagon combines a square, which is red, with triangles, which are yellow, to make orange. The idea should be sent to Washington so that the newly painted Pentagon could be the first to use colour in war. The square is death; the triangle is vehemence. The circle is blue and is infinite and peaceful. As with God and patriotism, I didn't take the attributions of colour seriously enough to contemplate. I don't remember such ideas being discussed in the fifties or after. In contrast, the terms 'warm' and 'cool' are still used as description, but also as thermometers of feeling. The more vague an idea, the longer it lasts; in decay it becomes even more vague and lasting.

A basic problem for artists at the beginning is that while colour is crucial in their work, its development being a force, the information about colour is extensive and occurs in many forms, partly technical and partly philosophical. The technical information is irrelevant and uninteresting until it is needed. The philosophy seldom fits. There is a limit to how much an artist can learn in advance. An artist works only step by step into the unknown while the particular knowledge of colour exists and is vast; the particulars of the world are infinite. This is overwhelming in an urgent situation. Colour is very hard to learn, since it is hard to know what is useful. The particulars must be the artist's own. Nevertheless, colour should be taught to the beginning artist, first, as knowledge which may be relevant, secoind, as knowledge of the history of art, which is the history of the activity and of the history of colour in that activity, and third, as

day-to-day new knowledge for the new artist, who should only be taught from the beginning as an artist. [...]

The last real picture of real objects in a real world was painted by Courbet. After that no one was so sure about the real world, so that when it came to keeping a colour or an undescriptive shape at the cost of accurate representation, the latter lost. From Manet onward the concerns of painting itself developed quickly. This is the conventional history of recent painting. Nothing like this happened in sculpture, since being in space there was no conflict, and there was no colour. It was conservative and was not bothered by the problem of how the world is known. The trouble and cost of its making had to have been a factor. The history of the increasing emphasis on the means of painting is very large and detailed. More than the so-called form, or the shapes, colour is the most powerful force. In retrospect, and only so, the expansion of colour is logical until the 1960s, concluding with the painting of Pollock, Newman, Still and Rothko. The need for colour, the meaning of that need, more than anything, destroyed the earlier representational painting, whether in Europe or Asia. In the work of all the well-known painters, colour is amplified beyond anything seen for centuries, even in the work of Münch, whose work is not considered abstract. In the work of most – Matisse, Mondrian, Malevich, Léger, the four just mentioned – colour is the dominant aspect, as black and white photographs show. Colour is an immediate sensation, a phenomenon, and in that leads to the work of Flavin, Bell and Irwin. [...]

Johannes Itten wrote in 1916: 'Form is also colour. Without colour there is no form. Form and colour are one.' It never occurred to me to make three-dimensional work without colour. I took Itten's premise, which I had not read, for granted. Sculpture itself was a distant idea to me, that it be only white or grey was a notion of the academy. This is why so much of this essay is about space. Colour and space occur together. I consider black, grey and white to be colour, as Leonardo did, despite, as he says, philosophers, and despite Mondrian and van Doesburg. Aside from the scientific view of light as colour and its absence as the absence of colour, which is true of course, it is also true that the whole range from white through the colours to black can be seen in light. Colour as the spectrum and colour as material, so to speak, are not the same. Black can be seen in the light. And also, again, all materials, grey and tan, are coloured. [...]

When I was making the paintings and the first three-dimensional works I knew how far I had to go and how new the work had to be to be my own. Pollock, Newman, Mondrian, and all first-rate artists establish that distance. The negative force, like Locke's 'uneasiness', is that it is not possible to understand borrowed colours and forms sufficiently to make new first-rate work. Many artists in the sixties and at the present think that it is enough to go next door;

even to the neighbours. Some in New York in the sixties looked at Pollock and the others and made passable work for a few years and then once secure did what they wanted to do in the first place, as did Warhol, or they didn't know what to do, as Stella doesn't. They were made by the high situation in New York and then they helped to destroy it, which in general is the story of art appreciation in New York. Earlier, for example, but better, the work of Guston and Kline was made by the situation. Most work was not unusual enough to be anyone's; most was not sufficient. It was not enough to vary the predictable; it was not enough to renovate old brushwork.

Pollock, Newman, Rothko and Still were the best artists and could not be matched in painting, which therefore could not continue at that level. Noland and especially Louis are good artists but their work is not equal. I didn't think when I said thirty years ago that painting was finished that it would be so thoroughly finished. The achievement of Pollock and the others meant that the century's development of colour could continue no further on a flat surface. Its adventitious capacity to destroy naturalism also could not continue. Perhaps Pollock, Newman, Rothko and Still were the last painters. I like Agnes Martin's paintings. Someday, not soon, there will be another kind of painting, far from the easel, far from beyond the easel, since our environment indoors is four walls, usually flat. Colour to continue had to occur in space. [...]

Colour will always be interpreted in a new way, so that I hardly think my use is final, in fact I think it is a beginning. Infinite change may be its constant nature. Colour is opposite to the projection of feeling described to [*sic.*] Goethe, Hoelzel and Itten. The idealism of Mondrian is very different. The attitude of Albers is different again. No immediate feeling can be attributed to colour. Nothing can be identified. If it seems otherwise, usually the association is cultural, for example,, the light blue and white, supposedly the colours of peace, of the cops and the United Nations. If there were an identifiable feeling to red or to red and black together they would not be usable to me.

Colour is like material. It is one way or another, but it obdurately exists. Its existence as it is is the main fact and not what it might mean, which may be nothing. Or rather, colour does not connect alone to any of the several states of the mind. I mention the word 'epistemology' and stop. Colour, like material, is what art is made from. It alone is not art. Itten confused the components with the whole. Other than the spectrum, there is no pure colour. It always occurs on a surface which has no texture or which has a texture or which is beneath a transparent surface.

In the sheet-aluminum works I wanted to use more and diverse bright colours than before. As I will describe later, there are many combinations, some old as I listed, and some my own from earlier work. I wanted to avoid both of

these. I especially didn't want the combinations to be harmonious, an old and implicative idea, which is the easiest to avoid, or to be inharmonious in reaction, which is harder to avoid. I wanted all of the colours to be present at once. I didn't want them to combine. I wanted a multiplicity all at once that I had not known before. This was very difficult. The construction of the work in panels limited the use of ratio, the extent of one colour to another; but this is perhaps just as well.

After a few decades the discussion of colour is so unknown that it would have to begin with a spot. How large is it? Is it on a flat surface? How large is that? What colour is that? What colour is the spot? Red. If a second spot is placed on the surface, what colour is it? Black? What if both spots were red, or black? How far away is the black spot from the red spot? Enough for these to be two discrete spots, one red and one black? Or near enough for there to be a pair of spots, red and black? Or apart enough for this to be uncertain?

What if the red and black spots are next to each other? And of course, which red? cadmium red medium, and which black? ivory black. The red could also be cadmium red light, the medium, cadmium red dark or alizarin crimson. In a way, side by side, the red and the black become one colour. They become a two-colour monochrome. Red and black together are so familiar that they almost form a new unity. Every easily known colour paired with either black or white forms such a monochrome: orange, yellow, blue, green. Because of the black and white, also a pair, these pairs have a somewhat flat quality, are somewhat monochromatic.

The contrasting pairs are just as well known: red and blue, red and green, red and yellow, blue and green, blue and yellow. Some are not: red and orange, yellow and orange. This list is finite, since it is of primaries and secondaries. The other possible pairs are infinite, as is colour, whether in the spectrum or materially mixed. All colours of the same value, such as light yellow and light green, make pairs. All values of the same colour make pairs. Full colours pair, such as cadmium red medium, cadmium orange medium, and cadmium yellow medium. A group of colours, without an adjective like 'full', that I especially like is of course cadmium red light, cerulean blue, chartreuse and permanent green. In 1964 another work on the floor was painted chartreuse with half of an inset iron pipe sprayed cream yellow, a somewhat sharp and acid colour opposed to one white and full. Words to describe colours are scarce. The really acid colours, clear, sharp and dark, are pthalocyanine blue and green. Also clear and sharp and not as dark are the seemingly stained colours like those used by El Greco: alizarin crimson, ultramarine blue and viridian. These also occur in the Hours of Jeanne d'Evreux opposed to grisaille. The somewhat soft colours correspond. These are full but seem to have white mixed in them, which they don't: cadmium red medium, cadmium yellow light, emerald green, and especially cobalt blue. Dull or greyed colours, the ochres, the oxides, all form pairs, united

by value. And, as in the chartreuse work, there are pairs opposed: cobalt blue and cerulean blue, cobalt blue and cadmium red light.

There are also monochromatic triads, red and black and white, and there are contrasting triads. There are sequential triads of colour and value: cadmium red light, medium and dark. And then colour becomes complicated: red, black and cadmium yellow light, medium or dark. Then perhaps red and black and the pair (A+B) or (B+C) or (A+B) + (B+C) + (C+D) or (A+B) + (C+D) + (E+F). The schemes for the large works with coloured panels are very complicated. Often they require all possible combinations of four colours or eight colours. The colours cannot touch side by side or end to end. In the work the relationships of the colours are differently intelligible. One above another they are easy to see as a pair; diagonally they are not. Basically I want the pairs and the sequences and the possibilities to be only colour. The structure is part of the whole. Chaos would not achieve what I want. It requires a greater number, which if great enough becomes order. First, the parts would touch, and second, the colours would not be distributed more or less evenly. But mainly the initial selection of colours prohibits randomness. In a note of 1965 I wrote that form, which I don't like so much as a word, and colour should be 'intelligent without being ordered'.

Colour of course can be an image or a symbol, as is the peaceful blue and white, often combined with olive drab, but these are no longer present in the best art. By definition, images and symbols are made by institutions. A pair of colours that I knew of as a child in Nebraska was red and black, which a book said was the 'favourite' of the Lakota. In the codices of the Maya, red and black signify wisdom and are the colours of scholars.

The painting of the generation in Europe after Mondrian and Matisse was obscured by World War II, as everything civilized is obscured by war, which is a consequence delightful to soldiers, so that the continuity and the innovation of the new art was not considered. The artists who especially developed colour were Olle Baertling, who also developed space in his sculpture, and Richard Paul Lohse. In the United States, where art is always obscure, partly because of the permanent military, in addition to Albers, from Bottrop and Reinhardt, there was especially Al Jensen, from Guatemala, from among the Maya.

Donald Judd, extracts from 'Some Aspects of Colour in General and Red and Black in Particular', the artist's last public statement before his death in February 1994; Donald Judd memorial issue, *Artforum* (Summer 1994) 70–8; 110; 113.

Bridget Riley
Perception and the Use of Colour:
Interview with Ernst Gombrich//1995

Ernst Gombrich [...] We all know that if you put two colours side by side, the contrast may enhance them, or there may be what has been called the spreading effect: they may spread into each other visually, and therefore change in the other direction. I'm sure that in your work you must experience this all the time, and be both delighted and sometimes perhaps disappointed by this mutual effect of colour.

Bridget Riley Yes, that is true, very much so, but it is also true of black and white. In my earlier work during the 1960s I found that they, along with greys, behave in a way somehow similar to colours, that is to say activities such as contrast, irradiation and interaction were taking place there too. I think that painters have known this for a very long time – there are myriad sensations and one has to pick one's way through. There is a story of Delacroix running into Charles Blanc one night and explaining to him the secret of colour painting. He points at the muddy pavement, saying: 'If someone asked Veronese to paint a fair-haired woman with those colours, he would do just that, and *what* a beautiful blond he would make on his canvas!'[1]

Gombrich Wonderful, this is absolutely true, and in a way we may also describe it as scientifically correct. Even so, I am convinced that John Ruskin was also right, when he said that there are no rules by which you can predict these effects. If I may quote him at some length: 'While form is absolute ... colour is wholly relative. Every hue throughout your work is altered by every touch that you add in other places ... In all the best arrangements of colour, the delight occasioned by their mode of succession is entirely inexplicable. Nor can it be reasoned about. We like it, just as we like an air in music, but cannot reason any refractory person into liking it if they do not. And yet there's distinctly a right and a wrong in it, and a good taste and a bad taste respecting it, as also in music.'[2] [...]

Riley I think your account of those experiments [by neurologists on colour perception] just makes the precedence of Delacroix's observation so much more poignant. This probably dates back to his visit to North Africa. He noticed several interesting things happening in the appearance of objects. What his discoveries amount to is that taking a white cloth in sunlight for instance he saw there a violet

shadow and a fugitive green – but it also seemed to him that he saw more colours than just those two: was there not an orange there as well? Because, he argued, in the elusive green he found the yellow and in the violet the red. Delacroix was convinced that there were always three colours perceptually present in what we see, and he found more evidence in various other observations he made and concluded that the continual presence of three colours could be regarded as a 'law' in the perception of colour.[3]

Gombrich Have you had similar experiences to the one of Delacroix in looking at a white piece of linen or any other such objects in the sunlight?

Riley I have never re-run that purely as an experiment, but the second colour painting I made in 1967 – *Chant 2* – is all about this. I did not know anything of Delacroix's discoveries at the time, but as I worked on my studies I could see that something was beginning to happen: when the red and blue surrounded one another in stripes on the white ground they made two different violets and intermittently one saw a fugitive yellow – and I built the painting to articulate this visual energy, as I called it then. I saw this as an instance of the innate character of colour when set free from any sort of task of describing or depicting things. In nature this sort of thing happens more or less clearly quite often. In the Mediterranean landscape there is a quite common example that anyone can observe. If in the field of vision there should be a fair amount of ochre ground or rocks of an orange or an orange red, and maybe some strong green vegetation or turquoise green in the shallows of the sea, one will then see violets, particularly along any edges where the oranges and greens are seen one against the other. In Cornwall a few years ago I remember a spectacular instance: looking at the sea coining in over little rocks – which was basically a few greens and a great many blue violets produced by various reflections – there was also, and this is important, quite a lot of dull orange brown in the seaweed floating in the water. As a result the whole surface of the water was flecked with tiny fugitive crimson points. It seems that as sight is always in action – is working all the time – whatever one looks at one cannot help but look through one's own sight. [...]

1 [footnote 5 in source] Charles Blanc, 'Eugène Delacroix', *Gazette des Beaux Arts* (Paris, 1864) 6.
2 [6] John Ruskin, *The Elements of Drawing* (London, 1957), Letter III, section 153 and footnote to section 240.
3 [9] E.A. Piron, *Eugène Delacroix. Sa Vie et ses Oeuvres* (Paris, 1865) 416–18.

Bridget Riley and Ernst Gombrich, extracts from 'Perception and the Use of Colour: Talking to E.H. Gombrich', in Riley, *Dialogues on Art*, ed. Robert Kudielka (London: Zwemmer, 1995) 39–40; 43–4.

Jessica Stockholder
Statements//1995

I like there to be places where the material is forgotten, but also I love to force a meeting of abstraction with material. Colour is very good at this, always ready to assert itself as independent from the material. [...]

When the viewer moves around to the edge of this piece [*Recording Forever Pickled*, 1990], the reflected purple or violet between the wall I made and the wall of the gallery is seen as a volume of colour. The violet complements the yellow-orange on the floor. The colours are keyed to carry the eye around; they read across space. In this way the colour is very specific. [...]

This piece [untitled early work, 1982] was never finished; it was just rearranged. I was thinking about the colour being thrown around, an idea I'm still interested in. The planes of wood were throwing colour back and forth or reading across to each other. The colours bridge the space at a speed that's much quicker than walking. So the interaction of the colour starts to feel abstract, as though it's immaterial. And me moving, I'm another kind of material. [...]

Jessica Stockholder, statements from 'Lynne Tillman in conversation with Jessica Stockholder', *Jessica Stockholder* (London: Phaidon Press, 1995) 10; 13; 14.

Milan Kundera
Testaments Betrayed//1993

[...] The tendency of the novel in the last stages of its modernism: in Europe: the ordinary pursued to its utmost; sophisticated analysis of grey upon grey; outside Europe: accumulation of the most extraordinary coincidences; colours on colours. The dangers: in Europe, tedium of grey; outside Europe, monotony of the picturesque. [...]

Milan Kundera, extract from *Les Testaments trahis* (Paris: Gallimard, 1993); trans. Linda Asher, *Testaments Betrayed* (London: Faber & Faber, 1995) 31.

Derek Jarman
Chroma//1994

White Lies

[...] In 1942, I was born in Albion, a little white, middle-class boy, behind the great white cliffs of Dover, which defended us against the black-hearted enemy. As I was christened, the white knights fought an aerial battle through the cumulo-nimbus clouds above Kent. At four, my mother took me to see the sights – the great White Tower of London, no longer limewashed, but grey and sooty. Whitehall, where the Houses of Parliament were even blacker. I learnt quickly that power was white, even our American cousins had their own White House, built like the imperial monuments of antiquity in marble. Marble was expensive, and the living, out of respect for the dead, recorded their passing in marble monuments. One of the most lavish of these is the monument in Rome to Vittorio Emmanuele and the Risorgimento – a building in the worst of taste known by the Romans as the 'Wedding Cake'. On my fifth birthday I stood in front of this White Elephant awestruck. After a brief sojourn in Italy we returned home. I was six, my education began in earnest at Hordle House on a Hampshire cliff top in sight of the Needles. Behind a Fifties education lay the great White Imperial Burden. Privileged, we of the White Hope were to care, maybe even sacrifice ourselves, for the countries coloured pink in our school atlas. [...]

1960. In the white heat of Harold Wilson's Technological Revolution we reinstated white. Out came the white lino paint, and white emulsion covered the browns and greens our Victorian past and those Fifties pastels. Our rooms were empty, pure and dazzling, though difficult to keep that way as feet soon scuffed the white off the floorboards. In the middle of the room the black Braun fan heater whirred unsteadily – grandfather of the devilish black technology of the Eighties. The black at the centre of the white. at the cinema *The Knack*, with Rita Tushingham painting her room a pure white, art following our lives.

In this white we lived coloured lives. It was a brief moment. By 1967 the jumbled psychedelic rainbow flooded the room. [...]

Queer white. Jeans hugging tight arses. Sarah shouts from the garden: 'Oh, *that's* how the gay boys recognize each other in the night!' White Nights in Heaven, a gay bar, which would have thrilled Saint John, dazzling T-shirts and boxer shorts achieved after days spent poring over the washing machine's finer programme.

All this white inherited from sport – sportif. The white that contrasted with the green of the pitch. Note that green and white are together again. This white

needs self-control … you cannot spill a drink or mark the virgin cloth. Now only the foolish or the very rich wear white, to wear white you cannot mix with the crowd, white is a lonely colour. It repels the unwashed, has a touch of paranoia, what are we shutting out? It takes hard work whitewashing. [...]

In the first white light of dawn I turn white as a sheet, as I swallow the white pills to keep me alive … attacking the virus which is destroying my white blood cells. [...] The white seahorses have brought a madness here, irritable, straining at the bit. I hate white. [...]

Marsilio Ficino
[...] In the 1430s a fourteen-year-old boy could be burnt at the stake for an act of sodomy – this would not happen in Florence again. Platonism confirmed that it was right and proper to love someone of your own sex – a more practical way of viewing sexuality than the church's blueprint of DON'Ts. The modern world received the message with open arms and Botticelli, Pontormo, Rosso, Michelangelo and Leonardo stepped from the shadows.

I know this is a long way from light and colour … but is it? For Leonardo took the first step into light, and Newton, a notorious bachelor, followed him with *Opticks*. In this century Ludwig Wittgenstein wrote his *Remarks on Colour*. Colour seems to have a Queer bent! [...]

Derek Jarman, extracts from *Chroma* (London: Random House, 1994) 15–16; 17–18; 18; 19; 58.

Quentin Tarantino
Reservoir Dogs//1996

Joe [...] Okay, let me introduce everybody to everybody. But once again, at the risk of being redundant, if I even think I hear somebody telling or referring to somebody by their Christian name … (*Joe searches for the right words*) … you won't want to be you. Okay, quickly. (*pointing at the men as he gives them a name*) Mr Brown, Mr White, Mr Blond, Mr Blue, Mr Orange and Mr Pink.

Mr Pink Why am I Mr Pink?

Joe 'Cause you're a faggot. (*Everybody laughs*)

Mr Pink Why can't we pick out our own colour?

Joe I tried that once, it don't work. You get four guys fighting over who's gonna be Mr Black. Since nobody knows anybody else, nobody wants to back down.. So forget it, I pick. Be thankful you're not Mr Yellow.

Mr Brown Yeah, but Mr Brown? That's too close to Mr Shit. (*Everybody laughs*)

Mr Pink Yeah, Mr Pink sounds like Mr Pussy. Tell you what, let me be Mr Purple. That sounds good to me, I'm Mr Purple.

Joe You're not Mr Purple, somebody from another job's Mr Purple. You're Mr Pink.

Mr White Who cares what your name is? Who cares if you're Mr Pink, Mr Purple, Mr Pussy, Mr Piss …

Mr Pink Oh that's really easy for you to say, Mr White. You gotta cool-sounding name. So tell me, Mr White, if you think 'Mr Pink' is no big deal, you wanna trade? […]

Quentin Tarantino, extract from script, *Reservoir Dogs* (London: Faber and Faber, 1996) 91–2.

Subcomandante Insurgente Marcos
The Story of Colours//1996

[…] The macaw didn't used to be like this. It hardly had any colour at all. It was just grey. Its feathers were stunted, like a wet chicken – just one more bird among all the others who didn't know how he arrived in the world. The gods themselves didn't know who made the birds. Or why.

And that's the way it was. The gods woke up after Night had said to Day, 'Okay, that's it for me – your turn.' And the men and women were sleeping or they were making love, which is a nice way to become tired and then go to sleep.

The gods were fighting, because the world was very boring with only two colours to paint it. And their anger was a true anger because only the two colours took their turns with the world: the black which ruled the night and the white which strolled about during the day. And there was a third which wasn't a real

colour. It was the grey which painted the dusks and the dawns so that the black and the white didn't bump into each other so hard.

And these gods were quarrelsome but wise. They had a meeting and they finally agreed to make more colours. They wanted to make it more joyous for men and women – who were blind as bats – to take a walk or to make love.

One of the gods took to walking so that he could think better. And he thought his thoughts so deeply that he didn't look where he was going. And he tripped on a stone so big that he hit his head and it started to bleed.

And the god, after screaming and squawking for quite a while, looked at his blood and saw that it was a different colour, one that wasn't like the other two colours. And he went running to where the other gods were and showed them the new colour, and they called the colour *red*, the third colour to be born.

After that, another god looked for a colour to paint the feeling of hope. He found it, though it took him a little while, and he went to show it to the assembly of gods and they named this colour *green*, the fourth colour.

Another one started to dig deep into the earth. 'What are you doing?' asked the other gods. 'I'm trying to find the heart of the earth', he answered, throwing dirt all over the place. In time, he arrived at the heart of the earth and he showed it to the other gods and they called this fifth colour *brown*.

Another god went straight upwards. 'I want to see what colour the world is', he said, and kept climbing and climbing all the way up. When he got very high up, he looked down and saw the colour of the world, but he didn't know how to bring it to where the other gods were so he kept looking for a long while until he became blind, because the colour of the world stuck to his eyes. He came down as best he could, by fits and starts, and he arrived where the assembly of the gods was and said to them, 'I am carrying the colour of the world in my eyes', and they named the sixth colour *blue*.

Another god was looking for colours when he heard a child laughing. He sneaked up on the child quietly and, when the child wasn't paying attention, the god snatched his laugh and left him in tears. That's why they say that children can be laughing one minute and all of a sudden they are crying. The god stole the child's laugh and they called this seventh colour *yellow*.

By now the gods were tired and they drank some pozol and went to sleep, leaving the colours in a little box which they threw beneath the ceiba tree. The little box wasn't closed very tight and the colours escaped and started to play happily and to make love to one another, and more and different colours were made, new ones. The ceiba tree looked at them and covered them all to keep the rain from washing the colours away, and when the gods came back, there weren't just seven colours but many more.

They looked at the ceiba tree and said, 'You gave birth to the colours. You will

take care of the world. And from the top of your head we shall paint the world.'

And they climbed to the top of the ceiba tree, and from there they started to fling colours all over the place, and the blue stayed partly in the sky and partly in the water, the green fell on the plants and the trees, and the brown, which was heavier, fell to the ground, and the yellow, which was a child's laugh, flew up to paint the sun. The red dropped into the mouths of men and animals and they ate it and painted themselves red inside. And the black and the white were, of course, already in the world. And it was a mess the way the gods threw the colours because they didn't care where the colours landed. Some colours splattered on the men and women, and that is why there are people of different colours and different ways of thinking. And soon the gods got tired and went to sleep again. These gods just wanted to sleep. And then, because they didn't want to forget the colours or lose them, they looked for a way to keep them safe.

And they were thinking about that in their hearts when they saw the macaw, and they grabbed it and started to pour all the colours on it, and they stretched its feathers so that the colours could all fit. And that was how the macaw took hold of the colours, and so it goes strutting about just in case men and women forget how many colours there are and how many ways of thinking, and that the world will be happy if all the colours and ways of thinking have their place.

Subcomandante Insurgente Marcos, *La Historia de los colores* (Guadalajara, Mexico: Colectivo Callejero, 1996); reprinted edition, trans. Anne Bar Din, *The Story of Colours* (El Paso, Texas: Cincos Puntos Press, 1999) n.p.

Owada
Feeling Blue//1997

I'm feeling low
I'm feeling down
I'm feeling blue
I'm feeling brown

I'm feeling orange
I'm feeling green
I'm feeling purple
I'm feeling cream

:ling scarlet
eling loose
I'm feeling maroon
I'm feeling puce

I'm feeling black
I'm feeling dead
I'm feeling yellow
I'm feeling red

I'm feeling pink
I'm feeling light
I'm feeling buff
I'm feeling white

I'm feeling off-white
I'm feeling grey
I'm feeling mixed up
I'm feeling okay

Owada (Keiko Owada, Martin Creed, Adam McEwen; produced by David Cunningham), song from the album *Nothing* (Tyne and Wear: Piano, 1997).

Yoko Ono
On White//1997

Whiteness is the most conceptual colour ... it does not interfere with your thoughts.

Yoko Ono, untitled statement from interview with Chrissie Iles in *Yoko Ono: Have You Seen the Horizon Lately?* (Oxford: Museum of Modern Art, 1997) n.p.

Victoria Finlay
The End of the Rainbow//2002

How many shades can a walnut be? What is the colour of a healthy liver? How can you describe the ideal organic strawberry to a buyer on the other side of the world? What shade do you want your car to be? Or your hair? Or the sapphire in your engagement ring? How can you measure the colour of pies? Writing and researching this book have shown me how hard it is to describe colour – to explain the gleam of insect blood or the natural luminescence of a piece of precious Chinese green-ware or the ruby-like resonance of a glass of saffron tea. So I decided to end by meeting someone who had made it his business to do just that: work out how to describe the exact shade of a colour to somebody halfway across the world.

Lawrence Herbert is sometimes called the Colour King. 'Or even the Colour Magician', he volunteered, when I met him at the Pantone colour palace in a sprawling piece of industrial green belt just off the New Jersey Turnpike. Herbert's mission in life – ever since he took a temporary job at a small and ailing printing company (which produced colour charts) in 1956 and bought it out within six years – has been to create an internationally accepted standard of colours. 'My dream was that someone should be able to call a supplier in California from their home in Acapulco and say I'd like to buy rose pink paint, or whatever. And that when it arrived it was exactly right.'

In the natural world – where the colour of an ochre might depend on the exact place where it was mined, or where an 'indigo' dye could be dozens of different shades, depending on the dipping time, the alkalinity and even the sunniness of the day – making colours has traditionally been an imprecise although often highly symbolic activity. But at Pantone, which has grown to be the biggest colour-specification company in the world, colour is all about precision. Herbert and his colleagues started by dividing the world into fifteen basic colours, including black and white, making up about a thousand shades. He later introduced even more elaborate systems, including colours with evocative names like wood violet, moss tone, sulphur spring and doe. Pantone sells the basic 'catalogue' in fan-like books – and if you have one and your contact has one, then you can both know exactly what shade you are talking about. It started off as a service for printers, but the expanded system has proved to have myriad uses.

Pantone colour standards have been used for renovating the tiles in the mosaics of San Marco in Venice, for giving official definitions of the colours used in national flags, including the Union Jack and Japan's Rising Sun, and for

measuring the colour (and sometimes therefore the quality) of gemstones. But one of the company's proudest innovations is not to do with art or heraldry or jewellery but with medicine. 'We've just developed cards that can identify the fat content of a liver by colour prior to a transplant,' Herbert told me. The cards have already saved lives by cutting down on rejection rates. 'Previously measuring colour was based more on art than on science. Now we can be exact.'

The oddest colour-matching job he had ever accepted was a commission from a goldfish breeder to calibrate the different colours of the shimmering koi that are so valued throughout Asia. 'About twenty fish arrived in little bags, and I put each of them into a tank and moved them around until I'd put them in some kind of arrangement in terms of colour', he remembered. How would you assign names for twenty shades of fish, I mused, thinking of the famous story about the Inuit of Canada distinguishing between dozens of shades of snow (a story which is apocryphal but which has captured so many people's imagination that it is a phenomenon in itself), or of the amazing statistic that in Mongolia there are more than 300 words for the colours of horses. 'We won't do names any more', he said. 'In the next round we're eliminating them.'

I felt a little like John Keats, appalled at Newton's audacity in taking the magic out of the rainbow. 'But the names of colours are history', I said, thinking of how mummy brown and ultramarine and Scheele's green and Turner's yellow and so many colour names hold entire histories of deceit and adventure and experimentation in their syllables. 'But we are dealing with science and measurement', he explained patiently. 'This is a digital world now, and computers don't need names but numbers. People talk about "barn red" but they never saw a Scandinavian barn in their life. And what does "lipstick red" mean anyway?'

Today we can have our houses and our cars and our clothes any colour we like – without any reference to nature or to anything more symbolic than the fashion world's decisions about what colours are 'right' for next season. And so perhaps it is not strange that we do not seem to need or even want to be reminded of their history any more. I could understand what Herbert was saying – he needed to adapt to new demands from the computer and Internet market – but I was relieved that I had encountered him towards the end of my researches. And I felt glad that I had made my paintbox journeys when I could still explore worlds of approximation and poetry, before the colours began to lose their words.

Victoria Finlay, extract from *Colour: Travels through the Paintbox* (2002) (London: Hodder and Stoughton, 2002) 435–8.

Magnetic Fields
Reno Dakota//2000

Reno Dakota
There's not an iota
Of kindness in you.
You know you enthrall me
And yet you don't call me,
It's making me blue.
Pantone two-ninety-two.

Magnetic Fields, 'Reno Dakota' (2000), *69 Love Songs*, vol. 2, track 5, © 2000, Circus Music Ltd.

Rem Koolhaas
The Future of Colours is Looking Bright//1999

Somehow, for me, colour went out of colour somewhere in the late eighties.

There are two kinds of colours. The ones that are integral to a material, or a substance – they cannot be changed – and the ones that are artificial,, that can be applied and that transform the appearance of things. The difference between colour and paint.

After an initial outburst of the use of paint at the beginning of the century – was it the easiest way to transform, to get rid of history? – we are at the end of the twentieth century, committed to the authenticity of materials, or even more, to materials that announce their own dematerialization.

The idea of a 'range' has become tiresome and uninteresting. Paint now seems brutal as colour is given by glass, plastics, artificial light, translucencies and transparencies, a kind of universe of quietness and disappearance.

In the sixties, colour was crucial for the unfolding of daily life – cheerful at home, discreet for the corporation. Around '68, colour started to become ideological again: all colours at the same time, a permanent fireworks display, but no colour more prominent than all the others.

Then in the eighties, under the rise of postmodernism, colour suddenly became suspect. Postmodernism wanted to dignify the world with real materials

– granite, travertine, marble – only beige or a purplish colour like brick were considered 'classy' and sufficiently mature. Entire cities changed their colour palette overnight. Miami's violent blues and pinks became white and yellowish, all in the name of good taste.

At the same time, we have increasingly been exposed to luminous colour, as the virtual rapidly invaded our conscious experience – colour on TV, video, computers, movies – all potentially 'enhanced' and therefore more intense, more fantastic, more glamorous than any real colour on real surfaces. Colour, paint, coatings, in comparison somehow became matt and dull.

With minimalism in the nineties it was at most the inherent colour of materials themselves that was allowed to register – a kind of colourless colour of subtle hints and refined contrasts. As if anything more intense was too much for our nervous systems. But maybe colour could make a comeback – not the exuberant intensity of the sixties or seventies, but with more impact than the sedated nineties – simply through the impact of new technologies and new effects. In a world where nothing is stable, the permanence of colour is slightly naïve; maybe it could change. In a world where nothing is what it seems, the directness of colour seems simplistic – maybe it can create more complex effects.

When all OMA [Office for Metropolitan Architecture] people were asked to propose 'their' colours, to imagine a paint or a coating, only ten people actually chose a simple single colour. Most imagined their colours as a treatment, a way to affect reality in a more subtle way than mere paint: not simply a layer of colouring but a more subtle conditioning, a layer that alters the state of the painted wall or object, a colour that would interfere with the status of the painted object.

It is only logical that, with the incredible sensorial onslaught that bombards us every day and the artificial intensities that we encounter in the virtual world, the nature of colour should change, no longer just a thin layer of change, but something that genuinely alters perception.

In this sense, the future of colours is looking bright.

Rem Koolhaas, 'The Future of Colours is Looking Bright', originally published as the preface to a colour manual produced by OMA in 1999. Entitled *New Colours for a New Century*, the publication proposed 30 new colours each put forward by an OMA member of staff. The manual was sold mainly in AKZO Nobel paint shops and was published by V+K publishers. ISBN 9066115726.

David Batchelor
Chromophobia//2000

[...] The notion that colour is bound up with the fate of Western culture sounds odd, and not very likely. But this is what I want to argue: that colour has been the object of extreme prejudice in Western culture. For the most part, this prejudice has remained unchecked and passed unnoticed. And yet it is a prejudice that is so all-embracing and generalized that, at one time or another, it has enrolled just about every other prejudice in its service. If its object were a furry animal, it would be protected by international law. But its object is, it is said, almost nothing, even though it is at the same time a part of almost everything and exists almost everywhere. It is, I believe, no exaggeration to say that, in the West, since Antiquity, colour has been systematically marginalized, reviled, diminished and degraded. Generations of philosophers, artists, art historians and cultural theorists of one stripe or another have kept this prejudice alive, warm, fed and groomed. As with all prejudices, its manifest form, its loathing, masks a fear: a fear of contamination and corruption by something that is unknown or appears unknowable. This loathing of colour, this fear of corruption through colour, needs a name: chromophobia.

Chromophobia manifests itself in the many and varied attempts to purge colour from culture, to devalue colour, to diminish its significance, to deny its complexity. More specifically: this purging of colour is usually accomplished in one of two ways. In the first, colour is made out to be the property of some 'foreign' body - usually the feminine, the oriental, the primitive, the infantile, the vulgar, the queer or the pathological. In the second, colour is relegated to the realm of the superficial, the supplementary, the inessential or the cosmetic. In one, colour is regarded as alien and therefore dangerous; in the other, it is perceived merely as a secondary quality of experience, and thus unworthy of serious consideration. Colour is dangerous, or it is trivial, or it is both. (It is typical of prejudices to conflate the sinister and the superficial.) Either way, colour is routinely excluded from the higher concerns of the Mind. It is other to the higher values of Western culture. Or perhaps culture is other to the higher values of colour. Or colour is the corruption of culture. [...]

David Batchelor, extract from *Chromophobia* (London: Reaktion, 2000) 22–3.

aniel Buren
Interview with Jérôme Sans//2006

Daniel Buren For me, colour is pure thought, therefore totally incapable of being expressed in words. It is just as abstract as a mathematical formula or a philosophical concept. If a work of art (which can be a painting, a sculpture or an object which has yet to be defined) has a single reason for being, it is to show in the clearest, the most intelligible and the most sensual way its characteristics which cannot be described in words, and if possible, allow them to be shared.

Sans However, as you have emphasized, colour has often been banished, seen as deviating from the idea.

Buren It is certainly curious to note that colour has mainly been banished from the field of art. What is more, this timidity in the use of colour isn't really anything new. You just have to look at the coloured exuberance of the painters of the Middle Ages or from the Renaissance up to Poussin. It was necessary to wait until the end of the nineteenth century, and above all Cézanne, to see a use of colour reappear which had long since fallen into disuse. With minimalist art, then especially with conceptual art, I detected a spirit of allegiance. The majority of artists associated with this last tendency distrusted everything which could not be expressed verbally, first and foremost, colour. More than a paradox, this showed the limit of a process: to put an idea in black and white led in an almost literal way to the non-introduction of colour. Other artists pushed this attitude even further.

In the field of colour, one can note that few artists really manage to do something with it. Colour is a vast problem, it seems difficult to apply rules to it. There are no safeguards. On the other hand, to create a harmony which works is something which every designer, couturier or colour consultant manages to do very well. You just need a little bit of taste. While taste is something which can be acquired, it has nothing to do with colour in the field of art, when it makes itself pure thought. [...]

Daniel Buren, extract from 'Interview with Jérôme Sans: Daniel Buren on the Subject of...' (2006) in *Daniel Buren: Intervention II. Works in situ* (Oxford: Modern Art Oxford, 2006) n.p.

Ellsworth Kelly
On Colour//2007

My aim is to capture the light and energy of colour.

I find the colour in mixing; in mixing each colour, the results differ slightly from previous work.

No colour prejudices; all colour panels are dominant in themselves.

I use combinations of two, three and four colours: bright yellows, strong blues and reds and purples, etc., which are also used with white or black, the limits of colour.

I have painted full spectrums and grids of colours arranged by chance, and colour panels separated by the wall.

My single panel monochromes have unique shapes.

Paintings in colour are usually in sizes larger than myself.

Colour plus form is the content.

Colour has its own meaning.

Ellsworth Kelly, Statement for *Colour*, 2007.

Rachel Whiteread
On Colour//2007

When I was seven, I was allowed to choose the colours for my bedroom. Free will. 'Lilac and orange' was my chosen colour scheme. I loved it.
 When I was fourteen, I changed the colour scheme to dark blue and white. Ever since then I have lived and worked in white rooms.
 Colour confuses me. Every day, when I get up, I have to think about it.

vhat to wear, what colour. Black is always a good choice ...

Then I walk my boy to school, pretty bland colourwise – East End building sites and then a green park, all quite straightforward.

Then to work, the studio and house – all walls are white – easier that way.

Then thinking, making drawings, pencil, ink, white paint, easy enough not to get too worried. How did colour creep in, through materials? Form, sensation, emotion?

Collage – that's good for using other peoples' colour decisions. Does that mean I've been let off the hook?

I love colour, but there are too many decisions to make.

Am I an aesthete? Is colour about necessity for me in my work – or is it simply a product of what I am thinking about?

I try not to dwell on it; if I did, I would only ever use black and white.

Rachel Whiteread, Statement for *Colour*, 2007.

Linda Besemer
On Colour//2007

For me, the unpredictability of colour, its queerness, its silence, its decoration, its shameless excesses, its resistance to language, its elusiveness, its plasticity, the impossibility of its containment, and its inherent abstraction – are the exciting potentialities and promises of colour.

Linda Besemer, Statement for *Colour*, 2007.

Melanie Smith
On Colour//2007

The other day I went to get my hair cut. From the outside the place looked quite forbidding with bright lights and blue neons that flashed on and off. Opening the door, I was thrown into an electric blueness that pervaded the whole space from

the neon lights that seemed to duplicate their own reflection because of those countless mirrors that make it seem like there were a hundred people all having the same haircut. I looked at myself in the mirror and realized how grey I looked but was then reassured to see that the girl cutting my hair looked equally grey, or perhaps more because she was dressed in black and had black hair, as were all the other hairdressers with the exception of one who had peroxide blonde, which under the light looked more like a blue rinse reminiscent of my grandmother. The woman next to me – with her head already wrapped in silver foil, was busy trying to choose a 'natural shade' to dye her hair and I feared the outcome of 'natural' in this place. But what did it matter, authentic was the least problem. It was all getting quite Alice in Wonderlandish as I was mesmerized by the black and white chequered floor and the thumping white neons that flashed on and off to some unrecognizable dirge. Perhaps I was the one in my own small world.

White office neon
purple hair
computer blue glow
city orange in the sky at night
plastic red flowers
city sky in the yellow by day
grey faces
pink fur.

are all growing in my mind.

Yet all these blur into an insignificant grey, so amorphous and in need of a noun; so dim and so empty. In this chemical haze I search for something I can grasp. But gladly I'm disappointed.

Melanie Smith, Statement for *Colour*, 2007.

Beatriz Milhazes
La Leçon de peinture//2007

Figure allongée, tête dans le main, femme au chapeau. Nu bleu.
The waves. *Composition I*

Festoon of flowers with cartouche surrounding a landscape.
Plate of quinces, grapes, figs and plums.
White rose in glass, *manacá*.
Boy in a kitchen.
Composition II

The sense of order
Home sweet home
A couple
Summer night
Composition III with blue, yellow and white.

Beatriz Milhazes, Poem for *Colour*, 2007.

David Reed
Colour Game//2007

There's a game that I like to play to test my perceptions. At random times throughout the day, I pause and examine the colour that happens to be in my full field of vision. To better understand what I am seeing, I examine different aspects of the colour relations, one after the other: hue, value, temperature and intensity. The most ordinary, common scenes are best for this experiment. Every time I do the experiment I find something that is surprising and I realize how unaware I am of the colour relationships that surround me. I realize that I only see what I need to for the most mundane, practical purposes unless I force myself to see more. All this amazing colour is omnipresent, and it must be entering my senses, though the information seems to remain preconscious. What effect does all this colour, colour that I haven't brought to consciousness, have on me?

In *The World Viewed*, the philosopher Stanley Cavell writes: 'Recent films in colour, when that fact about them goes beyond the necessity of luxury or amusement and becomes a declared condition of a medium, also allow colour to create a world. But the world created is neither a world just past nor a world of make-believe. It is a world of an immediate future.' I have thought about this comment for years. I like the idea that colour can seem to be from the future, the 'immediate' future, perhaps a week or a few hours from now. I would like to do this with my paintings.

As I write this now, I can see the front of my studio. The storefront style windows are open and I can also see the sidewalk and street outside. There are spots of artificial colour – red from the tail lights of cars, especially intense if they are hit by sunlight. There is an intense blue on a printed real estate poster across the street and someone just walked by wearing a bright yellow t-shirt. In our world today we see many examples of how these colours made with new technologies of synthetic dyes and pigments are used in cloth, printing and plastics. Slowly these colours make their way into artists' paint.

Inside the studio I can see an intense turquoise and rose red on a painting in progress laid out horizontally on sawhorses. And there are many other areas of intense artificial colour on my paintings. Caravaggio would give his right arm for a tube of Phthalo green. Leaning against a column between the windows, facing me, there is a mark of intense artificial green on red, cut out against white – the kind of colours that Pontormo would have used if he had been able to use such pigments. This mark floats between the inside and the outside space. On the bottom of the painting juxtaposed to the mark are splatters of Davy's grey. Davy's grey is my favorite colour at the moment. It's a traditional neutral colour, made from ground slate, that can appear to be warm or cool, reddish or greenish, depending on what colour is next to it.

Just now a large truck drove by – a flash of white with shiny chrome glinting in the sun. The movement of the changing highlights on the truck caused shatteringly warm bursts of light to flash into the studio overcoming the cool fluorescent lighting that is normally inside. Marks wanted to jump and slide off the paintings. In our world today artificial and natural colours and light combine in ways that are more varied and complex than humans have ever experienced before. There are new colours and colour relationships in the world that don't yet have emotional connotations and we as painters can create them. How have I been changed by this new colour that is always swirling around me? It certainly inspires my paintings.

David Reed, 'Colour Game', for *Colour*, 2007.

Susan Hiller
On Colour//2007

To experience a hit of 'pure' colour, especially coloured light, is intoxicating. Like Walter Benjamin, I'm remembering glass prisms, kaleidoscopes, and La Sainte-Chapelle in Paris on a sunny day. But what about being invaded by colour, lost inside colour, like the fifteenth-century Sufi Lhaji Shamsodden who wrote, '… Mountains and deserts were a rainbow of coloured light, red, yellow, white, blue. I became as though struck by madness and was carried away by the violence of their persistence and the deep emotion I experienced …'? Fortunately, some artists know how to offer just the right dosage of colour to provide great pleasure without triggering the violence of total self-abandonment: I'm thinking of Giotto's Scrovegni Chapel, some paintings by Rothko, some works of Yves Klein. I've thought about colour quite a lot, and maybe the fear of overdoing it is why I've only rarely ventured to make it the focus of my work

In 1987 I made a slide/tape work called *Magic Lantern* because I was fascinated by the body's instinctive, creative response to colour. The visual element of *Magic Lantern* is based on simple scientific principles: disks of light in the three primary colours are produced from three separate slide projectors and they combine and re-combine to make other colours through overlapping. The visual sequence eventually ends in a large circle of white light, which can be created by overlapping all three primary colours. In fact, the full sequence of colour in *Magic Lantern* can't be documented because, of course, the projections of bright coloured light provoke after-images (for example, after a red circle projection you will see a green circle). These after-images, which become part of the choreography of the work, are created in your interior vision, in your retina. This phenomenon is well known but usually ignored by everyone except painters or scientists who study optics. In experiencing *Magic Lantern*, the visual aspects of the work are both objective, in the sense of being presented to the audience from 'outside', and subjective, being produced internally in each person's individual eyes and brain. I think *Magic Lantern* gives pleasure by both clarifying and destabilizing perception, and in this way provokes a kind of understanding that what we see is always a fluctuating combination of internal and external events.

Ten years later, I made an audio-visual work for the worldwideweb called *Dream Screens*, whose visual elements are 84 colour fields. This is a deceptively simple work, designed to make room for the reverie of an individual person amidst the competing activities and images of the Internet. The dream screens

are infinite sequences and permutations of monochrome colour fields, activated as the viewer clicks a mouse anywhere on the computer screen. This web browsing is an aimlessly pleasurable exploration of glowing colours and the often-surprising after-images that occur between them.

The 'help' map that underlies and structures the viewer's random selection of colour fields merges three kinds of maps. It's a web, like the Internet,/the worldwideweb. It's also a colour wheel, like a classical colour wheel. And it also resembles those ancient maps of the world with us at the bright centre, the known world, fading out to the periphery, the unknown world. At the centre is white light and, out on the edges, blackness, with the colours radiating from light to dark along the spectrum. If you prefer to navigate the colours randomly, you might never uncover the map or another potential tool for navigating *Dream Screens* – the colour list. This names the 84 individual colour options, with reference to the names of traditional pigments and paint colours. If you use the list to 'click' on an intriguing name – for instance, 'Dragons' blood' – you will produce a field of that colour on your computer screen. Having started off as a painter, I intended this litany of names to form a link between new media and the art histories that underlie them. Selecting a series of computer colour fields by using this list might even be a means of tracking the evolution of human creativity from the Paleolithic period (Sap green, Red ochre) to the present (Uranium yellow), via, for instance, Woad, Saffron, and Byzantium purple.

Susan Hiller, Statement for *Colour*, 2007.

James Welling
Notes on Colour//2007

Recently I taught a seminar, 'Notes on Colour', at UCLA. It was the first 'colour' class offered by the department of art in many years. As an art student at Cal Arts, I'd managed to go through five years of training without ever studying colour. But that was in the 1970s when art programmes were in upheaval. Now, 35 years later, UCLA offered no classes in 'colour'. This lack is written into UCLA's curriculum and probably into most art schools' programmes: drawing is the first class in the catalogue: 1A. Every art student must take drawing! My colour class was relegated to a three-digit designation, 170, far removed from the programme's core prerequisites.

Eight years ago I bought a computer and a scanner and started making colour photographs by compositing black and white negatives exposed through red, green and blue separation filters into Photoshop's RGB channels. This process produced crude but very vivid colour images. How the world, eye and brain all work together to produce an experience of colour is something that continues to fascinate me. After tinkering with Photoshop colour for a few years, I thought I'd consolidate what I knew about the subject by teaching a seminar on colour. Thinking about digital colour forces you, right from the start, to work with colour as a material mixture of red, green and blue light, which is the way our eye sees colour. Additive colour runs counter to the painter's subtractive primaries and, I suspect, to the more traditional ways in which colour is taught. After Photoshop, I didn't feel it appropriate to repeat the Bauhaus model of working with coloured paper squares found in Josef Albers' *Interaction of Colour* (1963).

The model that I sought to emulate was much closer to Johann Wolfgang von Goethe's thinking in his *Theory of Colours* (1810.) Goethe records a multitude of colour observations and augments these with a series of experiments. In spite of the candles and moonlight used for some of his tests, Goethe's text feels very much like a contemporary artist writing about vision. For the final project in 'Notes on Colour', I asked my students to keep a colour diary in the spirit of Goethe. Some students kept a diary over the course of a few days; others wrote reminiscences of colour experiences dating back to childhood. What follows are passages from my students' diaries. Each note is from a different student.

It's not lost on me that to work with colour for this class, you needed to write about it. I felt that the only way to hold on to fleeting and ephemeral moments of colour perception was permanently to set the experience in language.

During the daylight hours, with my blinds closed and turned up, the interior lights on the strips appear icy blue at the bottom edge of the blinds. The icy blue quickly fades into muddy purplish shadow down the wall.

My earliest memory is of a colour. I lived in Hawaii for the first three years of my life, and the only thing I remember is a mass of yellow. It has no definition as an object, but of a sort of glow. My parents recently verified that this was my bedroom wall.

I remember when I was seven or eight, my friends and I were in front of a small Japanese version of a 7-eleven called Shimizu, eating cups of ramen, when we noticed the giant moon right in front of us. Everything was pink, and the rice field was sparkling light, light pink, and the moon was shocking bright orange-red. I think we all stopped eating, and there was this moment of amazed silence.

I realized as I'm typing up the last entry that after staring at my laptop for a long period of time, looking at the highest corner of white walls in my room makes everything look violet. Actually, the first time I did it, everything turned to violet. I just did it again, and everything appeared reddish violet. Now one more time, and a yellow strip appears in the middle of everything.

I had an amazing bouquet of flowers with all colours, but now they are dead. Where did the pigments go? I am sure there is a simple answer; I just don't know it. How do the pigments turn brown? When flowers are 'dried' and they are hung upside down, the colour is still apparent, but the flowers that sit in the vase turn brown and die.

When I was a young girl, my parents made me take tennis lessons in the summer. I remember wearing a red visor. At some point during each lesson, I would inevitably get heat sickness and begin to see orange and blue spots and get all numb and have to sit out the rest of the lesson.

On days with direct, bright sunlight, the shadows cast on asphalt and concrete take on a purplish tone. This can be the effect of simultaneous contrast, whereby the yellow colour of the light source, the bright sun, causes the shadows to adopt a purple tinge.

I have been knocked unconscious twice. Both times, when I came around, my vision reset itself in the same way. Everything went from a plain white surface to the darker shades filling themselves in, black being the last colour to appear. A very interesting phenomenon that I've come to enjoy very much is looking into people's eyes, especially because people have different coloured eyes: green with a red ring around the pupil, a sharp piercing blue, deep brown. Hazel eyes seem to have a range of colours within them, from brown to yellow and even bright orange. Perhaps the fascination with people's eyes is less due to the colour and more to being transfixed by someone's organ of vision. [...]

Incandescent blue bulbs coat the room and all its occupants. A brilliant blue violet illuminates the salt-soaked faces of dancers in a nightclub: a trance-inducing, nullifying glow that unifies and uniforms all it falls on. It has a pulse distinct from the music, reminiscent of the buzz of fluorescent lights in hospital corridors. Mixed with the dull glisten of sweat – I imagine it yellowish – it produces a pasty look [...]

James Welling, 'Notes on Colour', for *Colour*, 2007.

1

Marcel Duchamp said somewhere that the title adds another **colour**. That's an interesting remark from an artist who didn't use a lot of **colour**. I don't think **colour** has a lot to do with language, but I do think about **colour** and titles in a similar way – both are about narrative, both open up the interpretation of the work, not directly but through memory and association.

2

Two years ago I did a **black and white** show. It was called 'Cartoon Garden'. The critics hated it, kept asking where is the **colour**? It was as if that was all they could see in my work. For me, it was a show about **colour**. I can't think about **black and white** without thinking about **colour**. All the issues of that work implied **colour**, even if it was not there in the literal sense. It was about emptying out the **colour**, but the **colour** was still there.

3

I think this is why I am suspicious of the conventional art-historical opposition of line and **colour**. I just can't buy into the idea that drawing is rational and structured, and that **colour** is about emotion and expression. I am attracted to artists who have tried to make **colour** more systematic, but I don't see this as bringing **colour** into the realm of rational thought. I love systems, and I use them, but for me **colour** is both order and expression. **Colour** is about desire, and I want this emotional charge that **colour** can bring, but it's not just inarticulate emotion. My systems are very intuitive, and for me using **colour** is so basic that it's almost impossible to think about working without it. It's not something I add to the work, in the sense that you add **colour** to structure – **colour** is structure for me. The system is there but it's invisible. It's both intuitive and formal, emotional and controlled. It's a harder mindset. Like music, it can be incredibly precise and specific without being 'named'.

Polly Apfelbaum, Statement for *Colour*, 2007

Yinka Shonibare
Colour: Imperialism, Race and Taste//2007

As a bicultural person who grew up in Nigeria and now lives in Britain colour for me has always carried a cultural and colonial baggage relating to taste and class. In my immigrant eyes then Britain for me on my arrival in 1980 symbolized grey and restrained good taste while the markets of Lagos in Nigeria which I experienced as a child symbolized the ultimate in aggressive colour eclecticism that assaults your senses at every turn in that brilliant tropical light. Of course the Britain of 1980 is quite different from the Britain of 2007, or perhaps I now see colour I could not see on my arrival in 1980. I have always been interested in colour as a vehicle for subversive exuberance that challenges race, class and taste as a radical political statement, a sort of colour insult to viewers with so called 'good taste'.

My encounter with the use of bold primary colours in Pop art and pop album covers produced in me a sense of new possibilities away from the stuffy colonial old bourgeois order in which my parents grew up in the fifties. In the work of the pop artists that would become a symbol of the blurring of the boundaries between design and art, likewise in their footsteps I would begin to use contemporary African textiles from the world of design to challenge the boundaries of class and taste, Black and grey Victoriana would be transformed by the bold primary colours, the blues, blacks and oranges of contemporary African textiles. I took inspiration from the works of Haim Steinbach, Saint Clair Cemin, Katherina Fritsch, Peter Halley and Robert Rauschenberg, for their use of bold primary colours usually associated with design.

On one occasion I dropped my passion for colour in a work of art for a period I see as a period of trauma and a failure of human political will to resolve global conflict in Iraq, the Middle East and beyond. For the flagpole commission at the South Bank Centre, London, I felt that the seriousness of the Iraq war and other global conflicts could best be expressed by a self-denial of colour, a kind of colour abstinence. I denied myself the pleasure of colour in the work *White Flag at Half Mast.*

Yinka Shonibare, MBE, 'Colour: Imperialism, Race and Taste', for *Colour*, 2007.

Jimmie Durham
On Colour//2007

We perceive colour when light strikes an object and is partially refracted. The band, or colour, that we perceive is that which is reflected from the object while the rest of the light is absorbed. Thus, a leaf appears to be green because the green part of the spectrum is reflected. We might therefore more correctly say that a leaf is anti-green.

There are two kinds of black. The first, more normal kind absorbs all of the light and therefore contains the entire colour spectrum. The second kind of black, often called 'blanc' (or 'blanco' in Spanish) is entirely reflective. In this instance the colour spectrum is neither absorbed nor reflected, but simply rejected.

Jimmie Durham, Statement for *Colour*, 2007.

Pedro Cabrita Reis
'Colour is not Coloured'//2007

It came back to me, I read it many years ago: 'Color no es colorido', a sentence atributed to Goya. Through the window I see the olive trees I planted around the house. When I paint I sometimes use a pigment designated as olive green (PR101, PY42, PG7). It doesn't match the colour of the trees. The two dogs are lying on the floor and they also look outside. It seems that they see the world in black and white. I wonder if it is the same world.

Pedro Cabrita Reis, Statement for *Colour*, 2007.

Mel Bochner
On Colour//2007

colourless, achromatic, neutral, cinereous, etiolated, anaemic, toneless, hueless, monotonous, unpigmented, pale, pallid, pasty, palefaced, fallow, faint, flaccid, vapid, blond, bland, bleary, bloodless, bleached, blanched, waxen, white, dull, dun, dingy, mealy, sickly, chalky, leaden, lukewarm, lacklustre, nebulous, wan, sallow, sapless, ashen, weak, wishy-washy, glassy, ghastly, cold, pale as ashes, pale as a ghost, pale as a corpse, cadaverous

Mel Bochner, Statement for *Colour*, 2007.

Tacita Dean
Magic Hour//2007

Learning that colour is a fiction of light is one of the primary shocks of growing up: that this hitherto deeply physical thing is just a reflection, and that nothing can keep its colour under the cover of darkness, are monstrous things to understand, even for my adult mind. Yet there is something about colour's frailty at its twilight moment of oblivion that also brings out its magnificence. At colour's juncture with night, everything is suddenly in climax. The world gleams like burnished metal; water like inlaid gold. The sky hangs like heavy weave tapestry. Detail is secondary and focus lost. The dullest window glows with evanescent glory and even streetlights dominate with an intensity normally unknown to them. Then you watch in thrill and panic as this vivid world is slowly tarnished by night. The bronze and the gold lose their lustre and the encroaching monochrome becomes the axiomatic blanket of night, both woolly and indistinct, denying finally the mysterious illusion of colour.

Tacita Dean, 'Magic Hour', for *Colour*, 2007.

Index

ACKNOWLEDGEMENTS

Editor's acknowledgements

I would like to thank the many people who helped with the conception of, conversations around, research into, development of, diversions from and production of this book, in particular: Polly Apfelbaum, Linda Besemer, Iwona Blazwick, Mel Bochner, Pedro Cabrita Reis, Carlos Cruz-Diez, Sean Cubitt, Tacita Dean, Jimmie Durham, Alex Farquharson, Ian Farr, Briony Fer, Ann Gallagher, Teresa Gleadowe, Susan Hiller, Tim Holmes, Ellsworth Kelly, Christy Lange, Caoimhín Mac Giolla Léith, Cuauhtemoc Medina, Beatriz Milhazes, Mark Nash, Hans Ulrich Obrist, Annalisa Palmieri, Mari Carmen Ramírez, David Reed, Al Rees, Melanie Smith, Paul Smith, Yinka Shonibare, Stuart Smith, Ann Temkin, Hannah Vaughan, James Welling and Rachel Whiteread. I couldn't have finished this book without the help of Daniela Perez, who sourced a great deal of the material, and research for this publication was supported by the Royal College of Art, London.

This book is dedicated to Mike Murphy.

Publisher's acknowledgements

Whitechapel is grateful to all those who gave their generous permission to reproduce the listed material. Every effort has been made to secure all permissions and we apologize for any inadvertent errors or ommissions. If notified, we will endeavour to correct these at the earliest opportunity.

We would like to express our thanks to all who contributed to the making of this volume, especially: all the artists who wrote new texts for this volume, and Carlos Cruz-Diez, Thomas Cuckle, Jack Flam, Peter Halley, Mike Kelley, Laura Knowles, Rem Koolhaas, Jim Lambie, Thomas Pynchon, Gerhard Richter, Bridget Riley, Carl Scarborough, Mandy Simms, Jessica Stockholder, Alexandra Truitt. We also gratefully acknowledge the cooperation of: The Albers Foundation; ARS; Artforum; Benteli verlag; A & C Black Publishers, Ltd; Blackwell Publishing; Georges Borchardt, Inc., Marilyn Brakhage; Bug Music; University of California Press; Cambridge University Press; Cincos Puntos Press; Sadie Coles HQ; Thierry de Duve; Umberto Eco; Giulio Einaudi Editore; Elsevier Ltd; Faber & Faber; Farrar, Straus & Giroux; David R. Godine; Marian Goodman Gallery; Hackett; Harcourt Brace; HarperCollins Publishers; Harvard University Press; Hodder & Stoughton; Aldous Huxley Estate; Donald Judd Foundation; Yves Klein Estate; Verlag der Kunst; Macmillan; Modern Art Oxford; Robert Morris; Kenneth Noland; Northwestern University Press; César Oiticica; Estate of Jules Olitski; Overlook Press, Peter Mayer Publishers, Inc; Penguin Books Inc; Philo Fine Arts; Random House; Éditions Seuil; Simon & Schuster; Suhrkamp Verlag; Thames & Hudson; VAGA; Verso; John Wiley & Sons Inc; Wylie Agency; Yale University Press.

Whitechapel Gallery is supported by
Arts Council England